RIGHT ABOUT NOW
Art & Theory since the 1990s

THE BODY
INTERACTIVITY
ENGAGEMENT
DOCUMENTARY STRATEGIES
MONEY
CURATING

Editors
Margriet Schavemaker
Mischa Rakier

Contributors
Jennifer Allen
Sophie Berrebi
Claire Bishop
Beatrice von Bismarck
Maaike Bleeker
Jeroen Boomgaard
Nicolas Bourriaud
Deborah Cherry
Hal Foster
Vít Havránek
Mischa Rakier
Margriet Schavemaker
Marc Spiegler
Olav Velthuis
Kitty Zijlmans

Valiz, Amsterdam

CONTENTS

5. MONEY

6. CURATING

INTRODUCTION

INTRODUCTION MARGRIET SCHAVEMAKER & MISCHA RAKIER

The art that has been produced in the last fifteen years has generated virtually no theoretical reflection or historical contextualization. The contrast with previous decades could scarcely be starker. In the 1960s artists and critics fell over each other to come up with names, complete with theory and genealogy, for each new trend. Pop Art, Op Art, Minimal Art, Conceptual Art – they all had to have their own story. As often as not, this had already been reported extensively in every conceivable medium before the art ever made it into a museum. Although this clamor for new images with associated stories gradually died down in the late 1970s and early 1980s, the art of the "postmodern" period also provoked much theorizing and contextualizing. After all, the author was "dead," at least according to the French philosopher Roland Barthes, and that presented the newly born reader with a tough task. It is therefore not surprising that many critics and academics took their inspiration from Marxist, semiotic and (post) Structuralist thought in order to interpret the jumble of symbols and layers of meaning, pastiches and appropriations that the artists of the time produced.

In the 1990s a new generation of artists appeared to have tired of all this theorizing. If we look, for example, at the work of the so-called Young British Artists, what we see, rather than symbols referring to symbols, are objects and installations that focus attention on the body of the observer and on experience. As John Welchman – incidentally one of the few art historians to have taken up the challenge of theorizing about this new art – has put it: "Theory, art as idea, anything from the outside that might bear with anterior

knowledge, are expelled from the vigorously self-substantial body of contemporary art, and remaindered as the ghostly spirit of an irrelevant past."[1] Welchman argued that the art of the 1990s no longer referred to other art or great theories, and hence did not constantly invite intellectual reflection. In the 1990s, it seems, it was the art itself, and the experience it provideed, that were key.

Yet it was also natural to interpret this "art-without-theory" on a theoretical level and to contextualize it historically. This was equally true of the work by the socially engaged artists who were to be seen in galleries and museums in the second half of the 1990s. Nor can it be denied that people wrote about these new developments – but rarely with an overall view or insight. The weighty catalogues published to accompany retrospectives like the *Documenta* in Kassel and the Biennale in Venice were cases in point. There was no coherent exposition; theory was constructed on platforms that ran parallel to the art and did not even cross it, let alone interpret it. The person looking at the art had to make connections and draw historical lines for him or herself.

The publication *Right about Now: Art and Theory since the 1990s* grew out of a desire to bring together the art and theory of recent years. It is not the book's intention to compensate for a lack of coherence and analysis by means of an all-embracing narrative, a linear history in which developments, interpretation and causal relationship are allocated a fixed place. Instead, six themes representing important aspects of the art of the past fifteen years have been chosen. Various criteria were used in their selection. One was to focus on those issues that *had been* subject to critical analysis by major authors in the 1990s. With this in mind, *the body* presented itself as an obvious theme, since it is one that has been widely studied. The theme of *interactivity* was selected because it can be considered as one of the few "new" trends in the 1990s, both in terms of the digital revolution and in the field of art.

Among the themes that emerged were some which seemed to have a degree of urgency at the beginning of the twenty-first century. The opportunities and restrictions of *engagement* in art have become relevant and much discussed subjects, particularly since 9/11. All-pervading mediatization has shifted the emphasis onto photographic media and hence onto questions concerning the medium of photography itself. How is photography used? And how does photographic truth compare with fiction? These subjects are explored in the *documentary strategies* chapter.

The editors of this publication are convinced that art must be placed

1. John Welchman, *Art after Appropriation: Essays on Art in the 1990s* (Amsterdam/London: G+B Arts International/ Routledge, 2001), p. 36.

in a wider social context. This brought us to the theme of *money*, given that the collapse of the art market in 1990 is usually described as the end of the "postmodern" era and the beginning of new "post-postmodern" developments. Aside from the market there is also the world of museums, which always functions as an important frame of reference for art. One characteristic of the 1990s, however, was that it was not so much museums that defined the image but rather (star) curators – most of them not formally associated with institutions – who presented the temporary, context-bound art of the 1990s at locations often outside the official museum circuit. In an age of biennales, triennales and art fairs, the apparent ubiquity of the curator in the present-day art world could not be ignored, and so the theme of *curating* has also been included in this publication. Obviously one could come up with many other interesting themes, such as the return of Modernism, or the recent focus on the concept and re-enactment of performances of earlier periods. The editors believe nonetheless that taken together the themes selected for publication provide a clear picture of the most fundamental aspects and developments characterizing the art of recent years – not least because of the authors who were prepared to work on it. What makes this publication unique is the fact that it was precisely these people – who in the course of the past few decades have endeavored, swimming against the tide, to give contemporary art an interpretation (for example, Hal Foster, Nicolas Bourriaud, Beatrice von Bismarck and Deborah Cherry) – who wanted to make a contribution. It is also gratifying that a new generation of academics and critics accepted the offer to work out their visions of the themes. This combination of established authors and those right at the start of their careers has generated fascinating ideas and debates that will fuel reflection on the meaning of the art of the present day and recent past for – it is to be hoped – as broad an audience as possible.

THE BODY

1. THE BODY. The installation and performance art of the 1990s focused on the physical experience of the observer and, in some cases, of the artist. In art theory this had its counterpart in countless analyses of "the body" and the usually "abject" and "traumatic" experience that this synaesthetic work succeeded in generating. The Modernist paradigm – in which art was to be observed purely visually and at a distance – appeared to have come to an end. The same thing seemed to apply to the postmodern world view, in which everything was seen as an idea or a construct. However, it emerges from the following contributions that the issues are more complicated than that. For example, *Deborah Cherry* cautions that "it is all too easy to propose a new sensory avant-garde that will triumph over an older optical order." Her contribution, like that of *Maaike Bleeker*, shows that the focus on the body cannot be detached from either the visual or the conceptual, and uncovers the intertextual layers of meaning with which the theme proves to be riveted to the modern and postmodern past.

DEBORAH CHERRY
A SEA
OF SENSES

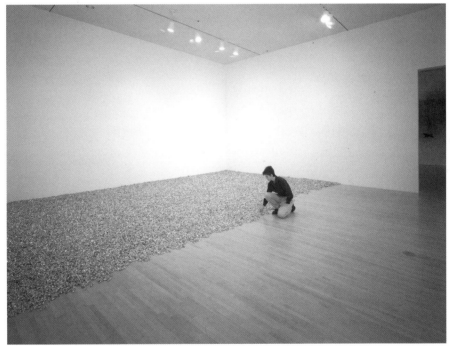

Innumerable, identical candies wrapped in gold cellophane are spread on the floor in the shape of a long rectangle. This is Felix Gonzalez-Torres' *"Untitled" (Placebo – Landscape – for Roni)* of 1993. The arrangement offers a shimmering surface that sparkles as the curved and twisted shapes catch the light capriciously. The work changes over time: as visitors pick up a sweet or two, as little bits are taken away, so *"Untitled" (Placebo – Landscape – for Roni)* is replenished in an endless supply which may maintain the ideal weight of the candies at 1200 pounds (544 kg).[1] The work exists in an ebb and flow between those who take it and those who remake it, those who regard and those who touch. Its dimensions vary with each installation of the

work: shown at the Museum of Contemporary Art, Los Angeles in 1994, the candies spilled forward to an irregular outline like the waves of the sea; elsewhere they have come to rest behind a border over which they do not regularly drift.

Born in Guáimaro in Cuba in 1957, Felix Gonzalez-Torres grew up in Puerto Rico. He migrated to the United States of America, where he studied, lived and worked in, becoming an American citizen in 1976.[2] Favorably received in the American press, his work met with an enthusiastic reception in Europe, and it was widely displayed and collected by museums, galleries and private collectors. Eliciting appraisals from "an all-star cast of critics, artists and writers,"[3] his art was frequently exhibited, catalogued, illustrated. His art was collected together in a two-volume catalogue raisonné, published in 1997. More recently it has been considered and contextualized in the collection of essays edited by Julie Ault.[4] At the Venice Biennale of 2007, the United States pavilion, entitled *America* (organized by the Solomon R. Guggenheim Museum of New York and curated by Nancy Spector) showcased the art of Felix Gonzalez-Torres.

During his life time, Gonzalez-Torres's art was perceived as edgy, exciting and provocative, very much of the moment. Here was an openly gay artist, well-read in contemporary critical theory, who liked to talk about his art, his politics, the state of the nation. Here was an articulate artist, generous with interviews, who reached out to engage to his audiences on a range of contemporary issues – like gun control, violence, US domestic and foreign policy, AIDS and homophobia – through an art that is visually attractive and offers seductive sensory pleasures: the candy spills offer seas of color in blue, green, silver, gold, black, or gleaming heaps of multi-colored candies. Sparkling surfaces which enchant the eyes are accompanied by myriad sounds – the crisp twists of sweet papers, the rustle of bodily movement – as well as the silken touch of the wrappings and the sweet, saccharine taste of the candies.

But what does this art mean now? Like many of his contemporaries, Gonzalez-Torres made persistent reference to his "now," the later 1980s and 1990s. What is it, then, to rethink his art for a new century? As so often with installation, any return often comes through photographs.[5] Standing in-between, mediating sensory and bodily experience, translating it into an encounter with a printed page, these "illustrations" convey little of the works material presence, their corporeal affect. Felix Gonzalez-Torres's art may also be perceived through memory, an experience of viewing inserted into the twisted skeins of the everyday, the recollection

1. Michelle Reyes has indicated that the weight of the candies is at the discretion of the curator and/or institution. She suggests that "This is a stipulation that is included by Felix deliberately to lend flexibility to the works." She also states that an individual work "does not necessarily have to be installed at the 'ideal weight' - it can be any other weight that is chosen to reproduce the work." She considers that some of the certificates provided by the artist "are open to interpretation." Email correspondence with the author, July 2007.

2. Gerardo Mosquera has pointed out that Félix González Torres has become translated into Felix Gonzalez-Torres. Gerardo Mosquera, "Remember my name," in: Julie Ault (ed.), *Felix Gonzalez-Torres* (New York Steidl Publishers, 2006), pp. 204–207.

3. *Felix Gonzalez-Torres*, (Washington: Hirschhorn Museum and Sculpture Garden, Smithsonian Institution / Los Angeles: Museum of Contemporary Art Los Angeles / Chicago: Renaissance Society at the University of Chicago 1994).

4. Dietmar Elger, Andrea Rosen and Felix Gonzalez-Torres, *Felix Gonzalez-Torres*, (Ostfildern-Ruit: Hatje Cantz Verlag, 1997); Ault (ed.), op. cit.

5. On the significance of photography in documenting installation, see: Julie H. Reiss, *From Margin to Center: The Spaces of Installation* (Cambridge: MIT, 1999).

of a place – any of these memories, and indeed others, shape an encounter with a work, our interactions with it. So much depends on the point of view, in all senses.

Felix Gonzalez-Torres was a varied, inventive and experimental artist, who produced a vast array of work in a relatively short life: beaded curtains, billboards, light-strings, candy pieces, stacks (of paper), portraits and other works. I focus here on the candy pieces, made over a period of three to four years. In *"Untitled" (Placebo – Landscape – for Roni)* the candies are most often spread out on the floor. Some installations allow all-round access: when *"Untitled" (Placebo)* (1991, New York: Museum of Modern Art), was displayed at the Serpentine Gallery in 2000, the strict rectangle of candies in silver cellophane was offset on all four sides by the dark polished wood of the floor. Sometimes, the bonbons are heaped in a corner. In both cases, there is a critical edge, a line that shifts over time, that is approached and apprehended by the visitor. On occasion, the candies scatter as they are re-arranged by participants stepping through and over them. The artist's works seem to invite interaction and participation. Critical writing emphasizes this aspect, suggesting that it is through participation that the viewer becomes a socially engaged, or at least a socially informed, actor. As the curators of the 1994 exhibition succinctly put it: "Felix has given us the freedom to complete his work through the memories we bring to each piece, and as with every freedom there is a corresponding responsibility."[6] But I want to suggest that the candy pieces, like so much of Gonzalez-Torres' art, entice the senses and elicit sense memories; they bid us, now, to reflect on the urgent issues of our own times: displacement, migration, cultural transmission.

"Untitled" (Placebo – Landscape – for Roni), 1993, has been remade in a variety of spaces. Although not strictly site-specific, the artist's works depend upon site as well as the spatial choices made by curators. Peter Osborne has drawn attention to the double meaning of "installation," as an end product – the work of art – and as a process that embraces the praxis of installing, of fixing the work into its temporary position.[7] And Thomas Crow has reminded us that for many artists, including most famously Joseph Beuys, installation may be nothing more than a set of instructions.[8] Felix Gonzalez-Torres devised certificates of ownership or authenticity, which provide, according to the 1997 catalogue raisonné, "specific guidelines for recreating and maintaining the works."[9] If they make demands, and are open to interpretation, they also offer an absurd quirkiness. The artist playfully tested the ownership of art in a global market in

6. Amada Cruz, Ann Goldstein and Susanne Ghez, in: *Felix Gonzalez-Torres*, 1994, op. cit. pp. 9–10.

7. Peter Osborne, "Installation, Performance, or What," in: *Oxford Art Journal*, Vol. 24, No.2, 2001, pp. 147–154.

8. See: Thomas Crow, *Modern Art in the Common Culture* (New Haven/London: Yale University Press, 1996).

9. Dietmar Elger, in: Elger, Rosen, Gonzales-Torres, 1997, op. cit., 1:14. For the candy spills, the certificate cites the original format, the original candies, sometimes the brand or the color of the candy or wrapper, with the note that "If this exact candy is not available, a similar candy may be used." Refills may also be needed (only if desired), it is admitted, for freshness. The certificates also state: "A part of the intention of the work is that third parties may take individual candies from the piece" and they advise the owner that he or she "has the right to replace, at any time, the quantity of candies necessary to regenerate the piece back to the ideal weight" of the candies, which is usually given (1:15). See also note 1.

which artworks as much as candies, light bulbs or paper circulate as goods, in which he created art with readily-available, everyday objects, ordinary things, familiar pleasures.

While these certificates are invisible counterparts to the work's display, the title and label have remained distinctive features of the viewing landscape, distinct and identifiable parts of the architecture of affect. Whereas the reiterated "Untitled," reprised from Minimalism, sanctions disregard, the subtitles – which may be construed as supplementary in the sense eloquently theorized by Jacques Derrida[10] – add to, undo and displace the work of "Untitled." They provoke a curiosity that prompts the visitor to attempt a connection, however elusive or fugitive, one that is embodied in a corporeal movement, across the room, between the two. There are declarations and dedications, places and people, objects and addresses, and, throughout, the returns of the *Bloodwork/s* -series. *"Untitled" (Placebo – Landscape – for Roni)*, too, may intimate AIDS or controlled drugs trials. As several writers suggest, the word "placebo" when used in the artist's title, may relate to the sweet itself, promising so much, yet delivering so transitory and ephemeral a pleasure, and one that can bring unpleasurable consequences.[11] But nothing is secure or secured, and the artist's titles unravel as much as they delimit meaning: if the title sets a border which defines and contains, the setting of a *bord* or border also precipitates an overflowing or *débordement*, a dispersal and deferral that spills over and "spoils all these boundaries and divisions."[12]

To interact with the candy spills, most mobile adult viewers and older children will bend down, dip towards the work, even kneel on the floor, shifting focus, perception and perspective. While the work's installation depends on the space, site too effects the ways in which visitors see it, walk round it, interact with it. Some will remove a candy or two. What legitimizes an action that is all too often debarred in the museum or gallery, where touching the artwork can damage its surface irrevocably and taking it away is usually construed as theft? This kind of licensed removal and anticipated dispersal, which was encouraged by the artist and permitted by the venues, is at odds with the unlicensed scattering of Thomas Hirschhorn's *Raymond-Carver Altar*. Installed in 1999 on a Glasgow housing estate, the work disappeared overnight, although the altar mimicked a wayside shrine to a sudden death, an urban memorial that is usually undisturbed.[13] This disappearance had not been anticipated and when the artist reinstalled the altar, changing the site, he decided to secure its elements. That Hirschhorn's work

10. Jacques Derrida, *The Truth in Painting* (trans. G. Bennington and I. Macleod) (Chicago: University of Chicago Press, 1987), pp. 69–74.

11. Charles Merewether likens the sweet to Derrida's *pharmakon*: remedy and poison, see: "The Spirit of the Gift," *Felix Gonzalez-Torres*, 1994, op. cit., p. 72.

12. Jacques Derrida, "Living On, Borderlines," in: Peggy Kamuf (ed.), *Between the Blinds: A Derrida Reader* (Hemel Hempstead: Harvester Wheatsheaf, 1991), pp. 256–257.

13. See: Deborah Cherry, "Statues in the Square: Hauntings at the Heart of Empire," *Art History*, 2006, pp. 660–697, Vol. 29, No.4, September.

has been vandalized, dismantled and subject to "random acts of acquisition" speaks of the risks - identified by Benjamin Buchloh - that Hirschhorn takes in working outside the museum, "without any evidence of a legitimizing institutional or discursive frame."[14] In contradistinction to Gonzalez-Torres, who asserted that "I need the viewer, I need the public's interaction. Without a public these works are nothing, nothing. I need the public to complete the work. I ask the public to help me, to take responsibility, to become part of my work, to join in."[15] Hirschhorn has vigorously refuted interactivity as part of a politically charged practice, stating: "I want to force the audience to be confronted with my work. This is the exchange I propose. The art works don't need participation; it's not an interactive work. It doesn't need to be completed by the audience; it needs to be an active autonomous work with the possibility of implication."[16]

The museum sets the frame for actions in which viewers may take away a little bit of a work by Felix Gonzalez-Torres, but not all of it, and in which they may dispense, only temporarily and to only a small degree, with the learned rituals of museum visiting. Curators have commented on the ways in which this art challenges the decorum of conventional viewing and critiques the nature of authorship and ownership. Lisa Corrin asks: "Will we dare to violate the museum's usual protocols by touching and even disturbing the presentation of a work of art? Will we agree to "own it" by taking it home?"[17] In recent years, although a number of protocols have been developed to permit or excuse the removal of a portion of a work of art – from licensed abstraction to surreptitious stealth (diminutive cut-out figures are pocketed when Michael Landy's *Scrapheap Services* is installed at Tate Modern in London in 1995) – museums began to express concern at the quantity of paper taken from Gonzalez-Torres's stacks. At one point the artist signalled an increasing discomfort in seeing people extract candies or paper: "He felt that it was an invasion of his self, like the demise of his own body."[18] Writings on the artist usually define interaction with his art in terms of a bodily activity – taking a sweet, moving a piece of paper, walking through a curtain or dancing to music. But neither the senses nor memory specifically depend upon a physical action (though they may be triggered by one),[19] and sensory engagement with a work of art can occur without any corporeal connection to it.

"Untitled" (Placebo – Landscape – for Roni), 1993, first incites vision, then comes touch and perhaps, depending on the visitor, sound, smell and taste: if the sweet is unwrapped, the cellophane crackles and

14. Benjamin Buchloh. "Thomas Hirshhorn," in: Benjamin H.D. Buchloh, Alison Gingeras and Carlos Basualdo, *Thomas Hirshhorn* (Oxford: Phaidon, 2004), p. 74.

15. Felix Gonzalez-Torres interviewed by Tim Rollins, in: *Felix Gonzalez-Torres* (Los Angeles: A.R.T. Press, 1993), p. 23.

16. Thomas Hirschhorn, interviewed by Alison Gingeras, in: Buchloh, Gingeras, Basualdo, op. cit., p. 26.

17. Lisa Corrin, "Self Questioning Monuments," in: *Felix Gonzalez-Torres* (London: Serpentine Gallery, 2000), n.p.

18. Andrea Rosen, "Untitled (The Never-ending Portrait)," in: Elger, Rosen, Gonzales-Torres, op. cit., pp. 46–47.

19. On "the centrality of memory" in the artist's work, see: Russell Ferguson, "The Past Recaptured," in: *Felix Gonzalez-Torres*, 1994, op. cit., p. 30; Ferguson makes an analogy to Proust's famous passage in *Swann's Way* on memory and the *madeleine* cake dipped in tea.

the heady aroma of sweetness foretells the sickly, sticky taste of a bonbon that is made to slip into the mouth and dissolve on the tongue – the artist does not choose chewy bars. Perhaps there is an erotic *frisson*: the artist hinted as much when he said: "I'm giving you this sugary thing; you put it in your mouth, and you suck on someone else's body. [...] For just a few seconds, I have put something sweet in someone's mouth and that is very sexy."[20]

Felix Gonzalez-Torres's candy spills are sensory works, but their sensory affects may come all together or one by one, for we could delay opening the sweet-paper, defer its anticipated pleasures, or never open it at all. Or, triggered by the sight of the candy, we might simply imagine the sensations of its consumption. Or refuse them. Sensory responses to a single work of art can be extraordinarily diverse and they are not shared by visitors in equal capacity. The candy spills may elicit physical and/or sensory encounters, they may evoke some or all the five senses of sight, touch, hearing, smell and taste; whether we eat one or not, the candies may engage sense memories, recalling perhaps childhood experiences or desires, perhaps never fulfilled to this degree, a satiety of sweet, a sensory *débordement*. For while the work of art can offer sensory experience, it can equally tease, conjure sensory responses or the memory of them, invoking the senses only to confound them. Hal Foster pointed out that bodily detritus appeared in abject art of the 1990s, but in substitute forms rather than as dollops of raw excreta or slashes of fresh blood, with their characteristic aromas.[21]

Equally, artworks such as the candy spills can provoke a sensory disgust, a distaste for the sweet taste, a sense of nausea as much social as somatic, a sensory and physical revulsion triggered by a glut of these medicinal look-alikes. It is not a question, then, of the presence or absence of the senses - in the art or in responses to it – nor of authenticity or simulacra but of the interaction of senses, memory and the body.

An interest in the senses has entered critical practice and cultural debate. From the later 1950s and 1960s and particularly in recent decades, artists have offered sensory encounters and enveloping sensory environments, from Richard Wilson's *20/50* (Saatchi Gallery, London, 1987) in which a corten-steel walkway projects into a vast pool of sump oil, to more recent works such as Ernesto Neto's *Walking in Venus Blue Cave* (Tanya Bonakdar Gallery, New York, 2001), where the viewer, no longer even upright, lies suspended on a vast blue curvaceous surface, looking up at pendulous forms filled with aromatic spices; or Olafur Eliasson's *The Mediated Motion* (Kunsthaus

20. Felix Gonzalez-Torres in: Nancy Spector, *Felix Gonzalez-Torres* (New York: Guggenheim Museum, 1995), p. 150. Claire Bishop considers that the AIDS crisis provoked a "heightened anxiety around bodily fluids," including saliva. See: Claire Bishop, *Installation Art: A Critical History* (London: Tate Publications, 2005), p. 139, note 32.

21. Hal Foster, *The Return of the Real* (Cambridge: MIT, 1996).

Bregenz, 2001) or *The Weather Project* (Tate Modern, London, 2003-2004). Susan Hiller's *Witness* (Tate Britain, London, 2000) offered an intense visual pleasure, though not one to be captured in a single glance, in the dazzling array of tiny speakers suspended on wires. But there was also an invitation to enter, to pick up a speaker and listen, to stand still or to move around. Offering a subtle matrix of sensory interaction, *Witness* solicited touch and hearing as well as sight, sometimes together, sometimes sequentially, sometimes at variance. Anya Gallaccio's *Red on Green* (ICA, London, 1992) prompted visitors to bend down to savor the scent of 10,000 English tea roses laid on a bed of thorns. Like Gonzalez-Torres she has created a number of works in which materials laid on a floor – coins, salt, graphite – are disturbed by visitors walking over them. This artist too creates works with a tendency to change or to disappear over time. If the sensory interactions of works such as *Witness* can be anticipated by the visitor, others deliberately conjure the unexpected: walking through Ann Hamilton's *Between Taxonomy and Communication* (1991), visitors cracked panes of glass laid beneath sheep fleeces; in *Tropos* (1993–1994) visitors encountered the pungent smell of horse hair laid on a floor subtlety altered to create an even more uneven terrain, and by moving around the space they activated an audio component. These installations bring together senses and sensations, invoking perceptions, experiences and recollections as auditory, tactile, aromatic and somatic as they are visual. Overwhelmed with sound, overpowered with scent, alive to touch, viewers may be transformed into participants whose senses and bodies are caught into the work and whose actions are part of it. Sensory art takes place in the here and now, yet these art works may change dramatically over time and extend well beyond the gallery – not only may a sweet from a candy spill be carried away, but its smell, taste, touch, look and sound, as well as the memories of them, may last well beyond the gallery visit.

But attention to the senses in art and critical practice is not without its pitfalls. It is all too easy to propose a new sensory avant-garde that will triumph over an older optical order.[22] Or to romanticize the senses as transgressive and liberating, to simplify the complex and often unexpected relations between the senses in artistic practice and everyday experience. The senses are embedded in, and mediated by, social practice and cultural representation. Singling out one sense can work against the multi-sensory nature of an artwork: installation art often operates on several sensory registers at once and on the interplay between them.

2. Michael Bull and Les Back (eds.), *The Auditory Culture Reader* (Oxford: Berg, 2003).

The turn to the senses has also coincided with a re-examination of vision and a re-appraisal of theories of the haptic, embodiment and surfaces, particularly skin, with its proximities to touch, smell and taste.[23] In *The Skin of the Film* (2000), Laura Marks proposes a theory of intercultural cinema in which the senses are invoked and haptic forms of viewing are engaged by artists making and showing films which deal particularly and prominently with the experiences of being, living and moving between several cultures.[24] She speaks of the importance of sense memories, contending that they communicate when little else can. She considers that sense memories are important for the artist and the audience, since the work of art may activate, deliberately or unconsciously, sense memories in its viewers as well as in its maker. For Marks, the senses are important forms of transmission, between and across cultures, although, as she is aware, potential meanings may or may not migrate. There is, therefore, an equal potential for unintelligibility, for meanings, memories and associations to be lost in translation, or to transmit in unexpected or surprising ways. Marks offers a compelling account of "haptic visuality" and embodied vision in recent art and film, recalling and reworking the interest in this field in the writings of Alois Riegl, Bernard Berenson and Walter Benjamin, attentive to Riegl's tracing of "haptic" from *haptein*, to fasten. Alert to texture rather than outline, she offers the haptic as a mode of perception that is close-up, intimate, proximate, a kind of viewing which emphases the senses and attachment, by contrast to Modernism's "opticality," its fascination with surveillance and distance viewing.

Marks's propositions return us to the question of cultural transmission. As art works circulate through the globalized circuits of international exhibitions, publications and collections, installed in "one place after another,"[25] they address differentiated audiences, bodies and sensory regimes, calling into question not only art's intelligibility but also its sensory impact. A number of artists have deployed the senses to conjure sense memories and to probe their transmission between cultures. Vong Phaophanet's *Neon Rice Field* (1993), for example, released a warm sweet scent of rice, redolent of Laos, the artist's homeland. Others have heightened the sensory elements to point to the trauma of migration. For Edward Said, the "strangely awry rooms" of Mona Hatoum's *Homebound* (Tate Britain, London, 2000), with their "menacing and radically inhospitable objects" illuminated by irregular bursts of light and accompanied by loud hums, buzzes and crackling crescendos of noise, spoke of

23. Deborah Cherry, "Troubling Presence: Body, Sound and Space in Installation Art of the Mid-1990s," *Canadian Art* 1–2, 1998 [2001]; Peter Osborne (ed.), *From an Aesthetic Point of View: Philosophy, Art and the Senses* (London: Serpents Tail, 2000); Elizabeth Edwards, Chris Godsen and Ruth Phillips, *Sensible Objects: Colonialism, Museums and Material Culture* (Oxford: Berg, 2006); David Howes (ed.), *Empire of the Senses: The Sensual Culture Reader* (Oxford: Berg, 2004).

24. Laura Marks, *The Skin of the Film* (Durham: Duke University Press, 2000).

25. Miwon Kwon, *One Place after Another: Site-specific Art and Locational Identity* (Cambridge: MIT, 2002).

dispossession and displacement.[26] Its title redolent of return, the un-homely home of *Homebound* signified that home is neither a final destination nor a point of origin, neither a place of refuge nor a haven of safety but a space that is unfixed, temporary and contingent. When lead curator of *Documenta 11* in 2002 Okwui Enwezor characterized the de-territorialized domain of the contemporary globalized art world identifying the ways in which "vast distances and unfamiliar places, strange places and cultures" are collapsed in favor of "the terrible nearness of distant places."[27] Wenda Gu's *United Nations – China Monument: Temple of Heaven* (PS1 Contemporary Art Center, New York, 1998), is one of a number of installations that assail the senses and conjure sense memories in a raft of unpredictable ways, so prompting reflection on un-translatability in these circuits of transnational curating. The *Temple of Heaven* brings together human hair (collected from 325 barbershops around the world), Ming furniture made of huang hua li wood, TV monitors, twelve lamp chairs, eight spring stools and two tea tables. The walls and ceiling are inscribed with invented unreadable characters from scripts based on Chinese, Arabic, English and Hindi.

The little sweets chosen by Felix Gonzalez-Torres offer promise and elicit all five senses. As the sweet dissolves – in the mouth, or forgotten in a pocket[28] – its meanings diffuse, resisting capture and any certainty that the work's sensory affect will have a further effect. Will the interaction with the candy spills prompt further action or a heightened awareness? This depends perhaps on the sensory memories that they trigger. The wrapped candies are all too familiar: little signs of pleasure, reward, childish recollection, comfort, maybe. Characteristic of the West, the sense memories conjured by these bonbons are produced and packaged in their industrialized manufacture, in the worldwide circulation of raw and processed materials, notably sugar, which are so often unfairly traded, the producing countries of the Caribbean still positioned in an asymmetric relation to Western consumers. This "sugary thing," to reprise the artist, is redolent of colonial and neo-colonial trade and sea crossings. As a sensory sign it carries not only sweet memories, but larger social memories and historical relations embedded in the present, memories carried along the trading links and the migrational patterns of modernity, like those traced by the artist himself, over the seas from Cuba to Puerto Rico, to the US. A landscape this field of sweets may be, but it is also curiously like the sea, ebbing and receding like the tide, lapping at the edge.

26. Edward Said, "The Art of Displacement," in: *Mona Hatoum: The Entire World as a Foreign Land* (London: Tate Publications, 2000), p. 15.

27. Okwui Enwezor, "The Black Box," In: *Documenta 11_Platform 5. Catalogue* (Ostfildern-Ruit: Hatje Cantz Verlag, 2002), p. 44.

28. Susan Tallman wittily remarks of the paper stacks: "with each removal it moves out from the concrete block into the broad dilute space of the edition, spread over a hundred walls, drawers, refrigerators (what do people do with these things when they get home?), and there assumes a life both linked to the original sculpture and independent of it." In: "The Ethos of the Edition," *Arts Magazine*, Vol. 66, No. 1, September 1991, p. 14.

Thanks: My special thanks to the editors for the invitation and their judicious and careful editing of the essay, and to my colleagues and students in Amsterdam. I am particularly appreciative of the kind assistance given by Michelle Reyes of the Felix Gonzalez-Torres Foundation.

MAAIKE BLEEKER MAKE THE MOST OF NOW
BODIES, MAYFLIES AND THE FEAR OF REPRESENTATION

"Make the Most of Now" was the motto of an advertising campaign run by telecommunications company Vodafone at the time the lecture series on which this book is based took place. I am referring here to the campaign which invites us to identify with a mayfly as the ultimate example of living in the here and now. The here and now of this mayfly is set in a wondrous, forest-like landscape with pools and waterfalls, where we first witness the mayfly's watery birth. We hear birds and other forest sounds, and a voice-over informs us: "The common mayfly has a life expectancy of just one day. But is it miserable about it? Not one bit. And that is because it fills its day with the things it loves. It savors every moment." We see the mayfly buzzing around energetically to the rhythm of a cheerful piece of music. Apparently the fly is having great fun. "Maybe," the voice-over continues, "maybe there is a lesson in this for us, longer living creatures. Just think: if we embrace life like a mayfly, what a life that would be! Vodafone. Make the most of now." What does this mayfly have to do with the theme the organizers of this lecture series invited me to address, "the body in art and theory"? The connection, I shall argue, is to be found in the now. More precisely, it is to be found in the desire for an intensified here-and-now-experience that somehow exceeds the limitations of the actual time and place in which we – the viewers – find ourselves. Ironically, such an experience requires a certain forgetting of the actual here and now in which one is living. The Vodafone advertisement nicely illustrates the paradoxical character of such a now. However

short the life of the mayfly may be, one thing is remarkably absent from Vodafone's account: its death. The ad ends with a romantic image of the mayfly embracing another mayfly while looking at the sunset. The day ends, and so does the mayfly one might think; but instead of accounting for this ending, the ad leaves us with an image that presents the promise of a new beginning, a reference to the eternal cycle of life as a denial of temporality and finality. The now of the mayfly is not represented as a fleeting, transitory present marked by death and other limitations but as an "eternal now"; just as the life-world of the mayfly is an idealized represen-tation of nature as another time and history. The animation explic-itly addresses us with an invitation to forget our actual position as viewers in the historical order of the here and now, to become im-mersed in this other world. On the Vodafone website, the viewer is literally invited to loose him or herself in this world by creating his or her own mayfly, which from this moment on will continue to live within the amazing world represented in the ad: a fly with one's name on it, living in the eternal now of the digitally created dreamscape.

The address presented to us by the advertisement reads (probably unintentionally) as both an illustration of and an ironic com-mentary on Diderot's descriptions of his experience as a viewer of landscape paintings, especially those by his contemporary Joseph Vernet; as Diderot writes:

> "O nature, how overwhelming you are. O nature, how impos-ing, majestic and wonderful. More was I unable to express, and this only in the depths of my soul. How can I ever convey the multitude of delightful sensations that accompanied these words, with the same words repeated in countless variations? These sensations could undoubtedly be read on my face and heard in the sound of my voice, first faintly, then powerfully. Sometimes I raised my arms and my eyes to the heavens, some-times my arms hung to my side as though drawn down through exhaustion. I also, I believe, shed a few tears. How long was I in this state of enchantment? I don't know. I think I would have been in it forever had I not been disturbed and called back by the sound of voices."[1]

Diderot, overcome by the painting, finds himself in a state of en-chantment outside normal space and time. He could have stayed

1. Diderot, quoted in: Michael Fried, *Absorption and Theatricality: Painting and Beholder in the Age of Diderot* (Berkeley/London: University of California Press, 1980), p. 123.

there forever were he not called back by voices reminding him of his position as an embodied viewer in real time, in front of a painted representation of a landscape. He gives detailed descriptions of what is to be seen in the landscape and how the beauty of the landscape moves him. So absorbed is Diderot with the landscape represented in the painting that he forgets that he is actually looking at a work of art. For the one thing remarkably absent from his description is a commentary on the status of the painting as painting, that is to say: as a *representation* of a landscape. Diderot describes his experience as if he has stepped over the picture frame and found himself within the landscape instead. The painting mediates in the experience of an expanded here-and-now-ness that makes him forget that he himself is actually located in time and space. His "now" becomes bigger, perhaps even boundless, as the work mediates in a certain alienation from his position outside the painting, the place where his body is located.

According to Michael Fried, Diderot's reflections mark a crucial moment in the development of modern art and the philosophy of aesthetic experience. Fried describes how, in the middle of the eighteenth century, tension began to grow between the notion of a painting as something made to be looked at, that is to say: made for a viewer, and a simultaneous discomfort with this condition. The status of the painting as a visual sign addressing the viewer became visible, but this very visibility then provoked a desire to annul this very condition. Fried calls the moment at which this paradox became apparent "a momentous event." It was, in his words, "one of the first in the series of losses that together constitute the ontological basis of modern art."[2] Fried shows how this loss manifests itself in the mid-eighteenth century in a series of painterly strategies aimed at making the painting appear as an autonomous thing-in-itself, detached from both maker and viewer. It is this autonomy that is meant to make possible experiences like those described by Diderot: experiences in which nature and art seem to become almost synonymous, with both standing for overwhelming experiences that seize the viewer and alienate him from himself.

With this reading of Diderot (and others), Fried presents an historical perspective on the relationship between a certain fear of representation that made itself felt in the course of the eighteenth century and the intensified here and now of modern art. In so doing, he gives a new dimension to what in an earlier text, "Art and Objecthood" of 1967, he had termed the "presentness" of modern art. In this text, Fried comments on recent developments in the art

2. Fried, op. cit., p. 61.

RIGHT ABOUT NOW | THE BODY | Maaike Bleeker | Make the Most of Now

of the 1960s. More precisely, he argues against Minimalism (or, as he calls it, "literalist art") for the ways in which it addresses the viewer: that is, in such a way as to make us aware of our position relative to the work, and of seeing as a process that takes time and involves the self as an embodied presence engaged in an interaction with the object seen. He dismisses such works as theatrical. Fried opposes the experience of Minimalist works to that of modern artworks, which are characterized by instantaneousness and what he terms "presentness." "Presentness is grace," reads the final line of his text, for "presentness" lifts us above the perverted theatrical mode of being to which we are confined for most of our lives.[3]

I will now take Fried's account of the relationship between the here and now of modern art and the fear of representation as a starting point for some observations on the here and now of the body in art and theory. I will approach this "now" of the body from both the development of Minimalism and Conceptual Art – with their focus on the here and now of cognitive perception or perceptual cognition – and the historical perspective of Body Art and Performance of the 1960s and 70s – with their strong interest in the here and now of the physical and embodied presence of the performer. Of course, these two developments are not isolated. They are intertwined in many ways, and these interrelations are what fascinate me. I am particularly interested in how these connections and relations invite a rethinking of the relationship between the conceptual and the perceptual, or of perception as analysis in action and the perceived "thing" as a sensible concept, as Brian Massumi puts it.[4] This sensible concept is a materialized idea, embodied not so much in the perceiver or the perceived considered separately as in their "between," in their felt conjunction. Such an understanding of art in terms of a sensible concept therefore not only involves a reconsideration of the object of art, but also of the subject of the art experience, and both from the relationship between them. This involves a radical relationality.

Important here is to note that my use of the term "relationality" differs from that of Nicolas Bourriaud in his *Relational Aesthetics*.[5] Bourriaud uses relationality to describe – as the title of his book already indicates – a particular type of aesthetics. In my use, relationality does not describe any particular aesthetics, but rather refers to a condition of being. Or, more precisely, to a particular understanding of this condition: the conviction that we can only understand who or what we are from our relationship with the world that sur-

3. Michael Fried, "Art and Objecthood," in: Gregory Battcock (ed.), *Minimal Art: A Critical Anthology* (New York: E.P. Dutton & Co, 1968), p. 147.

4. See: Brian Massumi, *Parables for the Virtual: Movement, Affect, Sensation* (Durham: Duke University Press, 2002).

5. Nicolas Bourriaud, *Relational Aesthetics* (Dijon: Les presses du réel, 2002 [1998]).

rounds us; and, vice versa, we can only understand the world (including works of art) as it appears to us from how we relate to it. This means that the relationality of any given work of art does not depend upon the particular aesthetic strategies used by the artist, nor does the viewer necessarily experience it in a conscious manner. Even a work of art that gives the impression of existing independently from a viewer – as is the case with so-called autonomous art – is only seen or perceived in this way as result of the relationship between the viewer's culturally and historically specific ways of looking and the characteristics of the work of art itself; that is: the kind of address it presents to the viewer. It is within this relationship between work and viewer – here and now – that the work of art comes into being.

This notion of relationality is at odds with the intensified here-and-now-ness that played such an important role in the history of modern art – the sense of presence, or "presentness," as Fried puts it. In order to happen, "presentness" requires a certain forgetting of precisely the condition of relationality as a result of which the work of art can appear to exist autonomously, in itself. The autonomous art object is valued for its uniqueness, its authenticity, its un-repeatability, for its being here and now, essentially independent of the context of its making and the context of its being perceived.

6. Rosalind Krauss, *Passages in Modern Sculpture* (Cambridge: MIT, 1980), p. 240.

The publication of Fried's "Art and Objecthood" marks the moment that experiments with performance and theatricality inspired a rethinking of the presuppositions underlying Modernist conceptions of art and the aesthetic experience. Here, theatricality and performance functioned as what Rosalind Krauss has termed an "operational divide," alerting the viewer to the relational character of the art experience.[6] The explicitness with which a theatrical work of art addresses the viewer undermines the "condition of grace" and instead draws attention to the here and now of the viewing situation, to the process of reception and the interaction between the viewer and the work of art. Krauss points out how the impetus for this development can already be seen in the work of Rodin, and in early twentieth-century sculptures by Picasso, Brancusi, Giacometti and others. The real change however, she argues, took place with Minimalism and Land Art, with artworks that not only require the spectator's active participation but often also generate explicit awareness of this activity, for example by leaving it to the spectator to make connections between the different elements comprising the work. This is very literally the case in Land Art, where some of the works are so large that they cannot be taken in at a single glance,

meaning the spectator has to walk around, on, or through the work in order to get the whole picture. Sometimes it may be because the work actually consists of separate pieces which the spectator needs to join, or because work changes over time.

The works described by Krauss not only involve the viewer's mental capacities to grasp the concept represented by the work, they also address the viewer as body. As Krauss puts it:

> "The abstractness of Minimalism makes it less easy to recognize the human body in those works and therefore less easy to project ourselves into the space of that sculpture with all our settled prejudices left intact. Yet our bodies and our experience of our bodies continue to be the subject of this sculpture – even when a work is made of several hundred tons of earth."[7]

Krauss ends her book with the big Land-Art projects of Robert Smithson and Richard Serra; nonetheless, it is not difficult to see how the development she describes is continued in more recent installation art that explicitly addresses the spectator as body, often through a combination of senses simultaneously. Perhaps not surprisingly, Nicolas de Oliveira titled his overview of recent installation art *Installation Art in the New Millennium. The Empire of the Senses* (2004).[8] The final chapter is devoted to "the body of the audience."

At about the same time that Minimalism and Land Art direct attention towards the relationship between artwork and audience – that is, to the audience as a body present in relation to the work – other artists, often grouped together under the header of Body Art and Performance, began to highlight the presence of the other body involved: the body of the artist. Throughout history, Tracy Warr observes, artists have drawn, sculpted and painted the human form.[9] Body Art and Performance, however, reveal a significant shift in the artist's perceptions of the body, which is here used not simply as the content of the work but also as canvas, brush, frame and platform. This development, too, involves a different attitude towards time and temporality.

> "The idea of the physical and mental self as a stable and finite form has gradually eroded, echoing influential twentieth-century developments in the fields of psychoanalysis, philosophy, anthropology, medicine and science. Artists have investigated the temporality, contingency and instability of the body and

7. Ibid., p. 279.

8. Nicolas De Oliveira, *Installation Art in the New Millennium: The Empire of the Senses* (London: Thames & Hudson, 2004).

9. See: Tracy Warr and Amelia Jones, *The Artist's Body* (London: Phaidon Press, 2000), p. 11.

have explored the notion that identity is 'acted out' within and beyond cultural boundaries, rather than being an inherent quality."[10]

Amelia Jones, in her contribution to *The Artist's Body* (2000), understands these developments in terms of a critique of Modernism. Modernist art history and criticism are derived from Kantian aesthetic discourse, and are predicated upon the suppression of the particular, embodied, desiring subject; the artist and the critic must be transcendent rather than immanent (embodied).[11] This repression of the body, Jones argues, marks Modernism's refusal to acknowledge that all cultural practices and objects are embedded in society, as it is the body that inexorably links the subject to his or her social environment. Body Art and Performance highlight bodies and bodily actions previously kept from sight, thus making the body present as the site of the self.

> "The body, which previously had to be veiled to confirm the Modernist regime of meaning and value, has more and more aggressively surfaced during this period *as a locus of the self and the site where the public domain meets the private, where the social is negotiated, produced and made sense of*."[12]

10. Ibid., p. 11.

11. Ibid., p. 20.

12. Ibid., p. 21 (italics in the text).

In *The Artist's Body*, Warr and Jones have brought together an impressive collection of documentation of artist's actions and performances. This material indeed testifies to how these works show aspects of the body and embodiment that had previously remained out of sight, and how this often happened in ways that might be described as rather aggressive. But does that mean that these works show the body as the locus of the self? Looking carefully at the documents and the descriptions collected in *The Artist's Body*, it seems that many of the descriptions and images of the actions actually suggest a certain distance between the self and the body as the site where "the social is negotiated, produced and made sense of." Take for example Otto Mühl and Günter Brus' *Piss Action* (1969). During a screening of Mühl's films, Mühl and Brus unexpectedly got up on stage and took off their clothes in front of the audience; Mühl then urinated in Brus' mouth. The performance highlights a bodily action that was previously (and still is) usually kept from sight. It is possible indeed to read this action as a demonstration of an aspect of embodied, desiring subjectivity, suppressed in artistic Modernism, and, more generally, in twentieth-century Western society.

But does this action present Mühl's body as the site of the self? Or is the harshness of the action rather to be understood as what Alain Badiou has termed the "passion for the real"; an ultimate and defining moment of the twentieth century manifesting itself in the longing for something more authentic and inescapable, a thing "beyond," something for which violence and subversion is the price to be paid? Is subversion here a means of criticizing the particular consequences of Modernism and global capitalism, or is the subversion of Modernism and global capitalism (also) a means of reaching some kind of (imagined) "existential beyond"? A beyond that rather than confirming the body as the site of self involves a certain alienation from the body by means of a transgression of its limits, as well as a transgression of the ways in which the body limits our existence to a particular moment in time and space?

Subversive bodies involved in artistic acts are also the subject of the theater performance *Who's Afraid of Representation?* (2005) by the Lebanese artist Rabih Mroué, which reads as a response to Amelia Jones and Tracy Warr's account of Body Art and Performance. As the performance begins, a man and a woman enter and sit down at a small table on the right-hand side of the stage, next to a huge screen. The woman is holding a copy of *The Artist's Body*; she opens the book, (supposedly) at random, and reads the name of an artist and the page number: for example, "page 49: Günter Brus." The man repeats the name of the artist and turns the page number into a time: "Günter Brus: 49 seconds." The woman steps behind the screen, on which the audience now sees her projected, facing and talking to them. We hear the voice of the woman – live – describing (by means of a first person narration) the things the artist did, mainly to his or her body. The texts are based on descriptions of artists' actions and performances as recorded in *The Artist's Body*, although now reformulated in the first person. Günter Brus' monologue, for example, goes as follows:

> "In 1969, I went to Munich with my friend Mühl, who was exhibiting his films in a theater … we got up together on the stage … in front of everyone we took off our clothes, and I lay down on the ground and let him urinate in my mouth … piss. We repeated the performance another time in a nightclub in Germany, but in another city … chaos broke out … they closed the club and the cops chased after us."[13]

13. *Who's Afraid of Representation?* Text/director: Rabih Mroué; with: Lina Saneh and Rabih Mroué; stage design: Samar Maakaroun; production: The Lebanese Association for Plastic Arts (Ashkal Alwan), Beirut; Hebbel Theater, Berlin – Siemens Art Program, Germany; Centre National de la Dance, Paris – with support of TQW, Vienna; seen: September 9 & 10, 2005, Rotterdamse Schouwburg, Rotterdam.

When the set time has passed the man gives a signal, the woman stops talking, steps from behind the screen and returns to the table. The process is repeated with (among others) Gina Pane:

> "Gina Pane: I pinched myself. I punched myself. I made myself bleed. I got this ladder and put sharp nails and razors on each rung. I took my shoes of and climbed the ladder barefoot. I slashed myself. Once I ate raw meat. I bought half a kilo of spoiled raw meat. It stank. I started to eat it … I ate and ate and kept eating until I vomited everything I ate and then I ate anew until I vomited again, a second time, a third time, a fourth …"[14]

These narratives of extreme artistic actions, told as if they were business as usual, without any visual representation except the woman standing and talking to the audience, transmutes the activities of these body artists into a weird kind of imaginary theater that prevents the audience from being absorbed into the moment of the immediate action – like Diderot in his landscape – and instead opens up space for reflection and awe. Who are these people going to such lengths to self-inflict pain, or to have themselves humiliated? The first person narratives create a more personal and individual version of the "objective" descriptions in *The Artist's Body*. At the same time, linking back to an "I" as speaker results in a certain depersonalization. Listening to this series of confessions, all spoken by one and the same actress, one cannot help asking why all these artists were looking for more or less the same ultimate experience. And, why were they all looking in more or less the same places, utilizing more or less the same means?

The title *Who's Afraid of Representation?* frames these actions in terms of a shared ambiguous attitude towards representation, characteristic of much discourse surrounding Body Art and Performance. Matter and material action are favored over representation, the instable and transitory character of action over the stability of more traditional work. Things are what they are, here and now, and if representation is involved, it is usually only to be criticized or subverted – as in the many performances dealing with issues of gender, sexuality and/or the conventional role of the artist.

This suspicion of representation also manifests itself in an ambiguous attitude towards documentation. The temporary and ephemeral character of much of the work made it dependent on documentation to be known and seen outside the often very limited audience present at the time and place of its realization. Yet this

4. Rabih Mroué: *Who's Afraid of Representation?*

very ideology of ephemerality and instability makes documentation suspect. Performance theorist Peggy Phelan argues, for example, that Performance is about disappearance rather than preservation and about valuing what is lost. It demands authentic witnessing and cannot be adequately represented. Such claims, nevertheless, stand in sharp contrast to the actual impact made by Body Art and Performance, which came mainly through the documentation of these events (as in books like *The Artist's Body*). Generations of artists have been influenced by actions that only a very few people ever witnessed, and which took place before they were born, in countries far away. Through documentation the influence of these performances has become worldwide, no longer strictly local to their original site of manifestation. Through documentation these performances have become points of reference for audiences around the world.

The complex relationship between the status of performance as ungraspable moment and documentation as permanent record is nicely expressed in Chris Burden's "testimony" to his famous action *Shoot* (1971):

> "It was a very simple performance, hinging on a single moment. 15. Ibid.
> A moment that went down in history. November 29, 1971, a year
> and some after Black September. At a gallery in California, at
> a quarter to eight, a small audience assembled. I entered with
> two friends, one carrying a camera, the other carrying a gun.
> The three of us stood there, the audience watched. I screamed
> out: Shoot! And one friend shot film as the other shot me in the
> hand. It was severed, blown away. Blood spraying everywhere.
> A gorgeous moment. This is the moment I am talking about.
> The second the bullet entered my hand, the image entered into
> history."[15]

The description in *The Artist's Body* fails to mention the camera, whereas Mroué's interpretation makes it emphatically part of the action, highlighting the intimate connection between the status of this unique, fleeting moment of artistic action and the method of documentation, both represented by the title *Shoot*. Of course, the documentation can never fully represent what happened; yet this incomplete representation is instrumental to the status this performance attained, as well as to its construction as ephemeral. After five or six "testimonies," a new element is introduced. The "testimonies" of the artists begin to include references to what

was happening in Lebanon at the time of the performances, or to suggest that the artists responded with their work to the war, or even carried out their actions in Lebanon. For example, Marina Abramovic says:

> "When the Battle of the Hotels began in downtown Beirut, I set out this table and placed 72 items on it, like: scissors, a saw, a razor, a fork, knives, glass bottles, a tube of lipstick, a whip, pins, bread, an axe, a bottle of perfume, paint, matches, candles, nails, a comb, a newspaper, a mirror, needles, honey, grapes, tape, a real gun, and actual bullets ... and I put up a huge sign which said: On this table are 72 items for your use on my body as you see fit.
>
> For six hours these items would be displayed and the audience was allowed to use them in any way they wanted. After the first three hours my clothes were all ripped. Some people cut my clothes ... tore them into bits, some stripped me, some tried supposedly to 'dress me,' some put lipstick on me, some threw water on me, stuck me with the pins ... Until one guy picked up the gun, put a bullet in it, cocked it and put it to my head. People got really scared. I got scared. But I didn't move and didn't show it. Someone lunged at the guy and shoved the gun away from me ... they got into a fight, punching and yelling. People got involved in the fight and it turned into a big brawl. Here I got really scared that the bullet might hit someone from the audience ... it's a huge responsibility. I stopped the performance. Not too long after that the massacre at Damour took place."[16]

Did Marina Abramovic actually say this? Was Marina Abramovic ever in Lebanon? Does it matter? Is this performance about the war in Lebanon? Could it be? What does it mean to say that Marina Abramovic's action was about the war in Lebanon?

Some readers will have recognized the description as one of Abramovic's most famous and controversial performances: *Rhythm 0*. And although many may not remember where exactly this performance took place (Studio Morra, Naples), most people will know it was not in Lebanon. Could it have happened in Beirut? Would this have changed the meaning of the performance? Does it matter that it took place in Naples? The description in *The Artist's Body* does not make any reference at all to the time and place it occurred, apart from mentioning the name of the gallery, the city, and the year. Could it have happened anywhere? Anywhere, but any par-

16. Ibid.

ticular place, like Lebanon? The "testimony" of Abramovic in *Who's Afraid of Representation?* implies a meaningful relationship between the performance and the situation in Lebanon. The performance could be about Lebanon, but also: as soon as it is about Lebanon, it is no longer about all the other possible places it could have been.

Is this what is so scary about representation: that it threatens the mythical fullness of the moment – Barnett Newman's famous "The Sublime is Now" – by making it traceable to a point of view, a time, a place? The title of Mroué's *Who's Afraid of Representation?* brings to mind Newman's *Who's Afraid of Red Yellow and Blue?* This painting, famous for its bold abstractness, is nothing more and nothing less than a color field with stripes. A painting which, as Lyotard claims, does not represent or tell anything, but is only now, in the moment – the painting as happening. A painting, furthermore, that would become even more famous for its destruction by a visitor who attacked it with a knife, and for the discussions surrounding its restoration.[17] Did restorer Goldreyer use a brush to carefully restore Newman's original handwork, or had he simply painted over the whole thing using a paint roller? And if so, does it matter? For, as some argued, is Newman's painting not after all a conceptual work, and can we therefore not simply repaint it to the same effect? No, argued others: the work may be conceptual in some ways, but this concept is perceptual and the way it was originally painted is part of this perceptual concept.

Mroué changes *Who's Afraid of Red Yellow and Blue?* into *Who's Afraid of Representation?* and uses this as the title for a theater piece that deals not with abstract painting but consists instead of a series of reconstructions, or re-enactments, painted (metaphorically speaking) with a paint roller and in a way that Goldreyer could hardly have done better. Mroué reduces the perceptual fullness of the original to basic concepts, explained to us by an actress impersonating the artists. He turns the performances into speech acts in which a speaking "I" addresses us as spectators, explaining the outline of the event. It is up to us to fill in the blanks, using our own corporeal imagination to fill in the imaginary theater presented to us. Mroué shows the works "described" to be "gestures of exposure,"[18] gestures that are revealing about both the "I" making the gesture and the "you" addressed by it. He demonstrates how, here too, theatricality can be deployed as an operational divide, alerting the viewer to the relational character of the art experience. The set up of the event suggests the woman is speaking to us directly, addressing us, while

17. Newman made several paintings with the title *Who's Afraid of Red, Yellow and Blue.* I am referring here to *Who's Afraid of Red, Yellow and Blue III*, which is in the collection of the Stedelijk Museum in Amsterdam. In 1986, a visitor slashed the painting with a knife.

18. Mieke Bal, *Double Exposures: The Subject of Cultural Analysis* (New York/London: Routledge, 1996).

at the same time we are made aware that this is not the case. The woman, shown from head to toe projected on the screen and facing us, is in fact standing with her back to the audience, facing a camera. The sense of being directly spoken to is an effect of both camera and projection mediating between her address and our response. *Who's Afraid of Representation?* reads as a commentary on Newman's claim for a way of looking "without the nostalgic glasses of history," suggesting that such a desire to free oneself (and others) from the impediments of memory, association, nostalgia, legend, myth, etc. is itself the product of a nostalgic desire. In his essay "The Sublime is Now" Newman writes:

> "We are reasserting man's natural desire for the exalted, for a concern with our relationship to the absolute emotions. We do not need the obsolete props of an outmoded and antiquated legend. We are creating images whose reality is self-evident and which are devoid of the props and crutches that evoke associations with outmoded images, both sublime and beautiful. We are freeing ourselves of the impediments of memory, association, nostalgia, legend, myth, or what have you, that have been the devices of Western European painting. Instead of making cathedrals out of Christ, man or 'life,' we are making [them] out of ourselves, out of our own feelings. The image we produce is the self-evident one of revelation, real and concrete, that can be understood by everyone who will look at it without the nostalgic glasses of history."[19]

9. Barnett Newman, "The Sublime is Now," in: John P. O'Neill (ed.), *Barnett Newman: Selected Writings and Interviews* (New York: Alfred A. Knopf, 1990), pp. 170–173.

Mroué speaks from a position outside, yet as his work makes clear this does not free him from the weight of European and American culture and art history, nor does it make his work self-evident. Instead of claiming for art the ability to create a reality that is self-evident, he uses his art to question this desire for self-evidence, and in particular the ways in which this desire for self-evidence beyond, or before, the nostalgic glasses of history gets identified with destruction, with exaltation, with ecstasy as a truthful manifestation of the absolute.

At this point, Fried's elaborations on Diderot may be helpful, as they offer a historical perspective on the relationship between this desire for an intensified sense of the here and now and the fear of representation. From this perspective, representation and presence (or "presentness") do not appear as antagonists or binary opposites. Instead, Fried's reading of Diderot allows for an understanding of

RIGHT ABOUT NOW | THE BODY | Maaike Bleeker | Make the Most of Now

the intensities associated with presence as the effect, or result, of how works of art address their viewers, and how this address, on the one hand, appeals to the desire to transcend the limitations of our local, historical, embodied point of view, while, on the other doing so by means of an address that is highly culturally and historically specific. Seen this way, being afraid of representation is the fear of being confronted with one's position relative to what is seen, with the particularities of one's (embodied) point of view, or the point of view implied by the work. Or, to put it differently: the resistance to representation is fuelled by the longing to be freed from the limitations of a historically and culturally specific point of view, to reach for the existential beyond. Mroué's performance, on the other hand – instead of absorbing his audience in an experience that makes them forget the difference between self and work, expression and reception – highlights the address presented to the audience, and how this address presents an appeal to their corporeal imagination to make the work happen.

INTERACTIVITY

2. INTERACTIVITY. With the coming of the digital revolution, the democratization process in art appears to have reached its apotheosis. Modern digital media have made it possible for everyone to produce their own works of art at home and distribute them online. It appears that Joseph Beuys's credo "Jeder Mensch ein Künstler" (everyone is an artist) has finally become reality. However, these new developments receive scant attention in the art world. This is not to say that interaction and participation have not played a central role in the "official" art circuit of the past fifteen years. On the contrary: interactivity has proven to be a crucial aspect. For example, in the wake of the cooking events staged by Thai artist Rirkrit Tiravanija, *Nicolas Bourriaud* introduced the term "relational aesthetics" in the mid 1990s, which refers to a kind of "social art" that is, it was argued, automatically political and emancipating because of its interaction with the spectator. *Claire Bishop* is one of the few art historians who not only accepts Bourriaud's controversial theory but also subjects it to critical analysis, particularly because of its focus on ethics rather than aesthetics.

NICOLAS BOURRIAUD RELATIONAL AESTHETICS
ART OF THE 1990S

Art of the 1990s

Participation and Transitivity

A metal gondola encloses a gas ring that is lit, keeping a large bowl of water on the boil. Camping gear is scattered around the gondola in no particular order. Stacked against the wall are cardboard boxes, most of them open, containing dehydrated Chinese soups to which visitors are free to add the boiling water and eat.

This piece, by Rirkrit Tiravanija, produced for *Aperto 93* at the Venice Biennale, remains around the edge of any definition: is it a sculpture? An installation? A performance? An example of social activism? In the last few years, pieces such as this have increased considerably in number. At international exhibitions we have seen a growing number of stands offering a range of services, works proposing a precise contract to viewers, and more or less tangible models of sociability. Spectator "participation," theorized by Fluxus happenings and performances, has become a constant feature of artistic practice. As for the space of reflection opened up by Marcel Duchamp's "art coefficient," attempting to create precise boundaries for the receiver's field of activity in the artwork, this is nowadays being resolved in a culture of interactivity which posits the transitivity of the cultural object as a *fait accompli*. As such, these factors merely ratify a development that goes way beyond the mere realm of art. The share of interactivity grows in volume within the set of communication vehicles. On the other hand, the emergence of new technologies like the Internet and multimedia systems points to a collective desire to create new areas of conviviality and introduce new types of transaction with regard to the cultural

object. The "society of the spectacle" is thus followed by the "society of extras," where everyone finds the illusion of an interactive democracy in more or less truncated channels of communication.

Transitivity is as old as the hills. It is a tangible property of the artwork. Without it, the work is nothing more than a dead object, crushed by contemplation. Delacroix wrote in his journal that a successful picture temporarily "condensed" an emotion that it was the duty of the beholder's eye to bring to life and develop. This idea of transitivity introduces into the aesthetic arena that formal disorder which is inherent to dialogue. It denies the existence of any specific "place of art" in favor of a forever unfinished discursiveness and a never-recaptured desire for dissemination. It was the closed conception of artistic practice, incidentally, against which Jean-Luc Godard rebelled when he explained that "it takes two to make an image." This proposition may well seem to borrow Duchamp's, putting forward the notion that "it's the beholder who makes pictures," but it actually takes things a step further by postulating dialogue as the actual origin of the image-making process. At the outset, negotiations have to be undertaken and the Other presupposed ... Any artwork might thus be defined as a relational object, like the geometric place of a negotiation with countless correspondents and recipients. It seems possible, in our view, to describe the specific nature of present-day art with the help of the concept of creating relations outside the field of art (in contrast to relations inside it, offering it its socio-economic underlay): relations between individuals and groups, between the artist and the world, and, by way of transitivity, between the beholder and the world.

Pierre Bourdieu regards the art world as a "space of objective relations between positions," in other words: a microcosm defined by power plays and struggles whereby producers strive to "preserve or transform it."[1] Like any other social arena, the art world is essentially relational, insofar as it presents a "system of differential positions" through which it can be read. There are many ways of stating this "relational" reading. As part of their networking works, the Ramo Nash Club (Devautour collection artists) thus suggests that "art is an extremely co-operative system. The dense network of interconnections between members means that everything that happens in it will possibly be a function of all members." This gives them a chance to assert that "it's art that makes art, not artists." The latter are thus mere unwitting instruments in the service of laws that exceed them, like Napoleon or Alexander the Great in

1. Pierre Bourdieu, *Raisons pratiques: Sur la théorie de l'action* (Paris: Editions du Seuil, 1994), p. 68.

Tolstoy's *Theory of History*… I don't go along with this cyber-deterministic position, for if the inner structure of the art world actually outlines a limited set of "Possible," this structure relies on a second order of external relations, producing and legitimizing the order of internal relations. In a word, the "Art" network is porous and it is the relations of this network with all the areas of production that determine its development.

It would be possible, furthermore, to write a history of art that is the history of this production of relations with the world by naively raising the issue of the nature of the external relations "invented" by artworks. To give a broad historical picture, let us say that artworks were first situated in a transcendent world, within which art aimed at introducing ways of communicating with the deity. It acted as an interface between human society and the invisible forces governing its movements, alongside a nature that represented the model order. An understanding of this order made it possible to draw closer to divine designs. Art gradually abandoned this goal and began to explore the relations existing between Man and the world. This new, relational, dialectical order developed from the Renaissance on, a period that attached great importance to the physical situation of the human being in his world (even if this world was still ruled by the divine figure) with the help of new visual tools such as Alberti's perspective, anatomical realism, and Leonardo da Vinci's *sfumato*. Art's purpose was not radically challenged until the arrival of Cubism, which attempted to analyze our visual links with the world by way of the most nondescript everyday objects and features (the corner of a table, pipes and guitars), based on a mental realism that reinstated the moving mechanisms of our acquaintance with the object.

The relational arena opened up by the Italian Renaissance was thus gradually applied to more and more limited objects. The question "What is our relationship to the physical world?" had a bearing, first and foremost, on the entirety of the real, then on limited parts of this same reality. Needless to say, this is in no way a linear progression. One finds painters like Seurat, the rigorous analyst of our ocular ways of perceiving, living at the same time as someone like Odilon Redon, who tried to see through our relations with the invisible. Essentially, though, the history of art can be read like the history of successive external relational fields, propped up by practices determined by the internal development of these fields. It is the history of the production of relations with the world, as publicized by a class of objects and specific practices.

Today, this history seems to have taken a new turn. After the area of relations between humankind and deity and then between humankind and the object, artistic practice is now focused upon the sphere of inter-human relations, as illustrated by artistic activities that have been in progress since the early 1990s. Now the artist sets his sights more and more clearly on the relations that his work will create among his public and on the invention of models of sociability. This specific production determines not only an ideological and practical arena but new formal fields as well. By this I mean that over and above the relational character intrinsic to the artwork, the figures of reference of the sphere of human relations have now become fully-fledged artistic "forms." Meetings, encounters, events, various types of collaborations between people, games, festivals and places of conviviality – in a word, all manner of encounters and relational inventions today represent aesthetic objects likely to be looked at as such, with pictures and sculptures regarded here merely as specific cases of a production of forms with something other than a simple aesthetic consumption in mind.

Typology
Connections and Meetings
Pictures and sculptures are characterized by their symbolic availability. Beyond obvious material impossibilities (museum closing times, geographical remoteness), an artwork can be seen at any time. It is there before our eyes, offered to the curiosity of a theoretically universal public. These days, contemporary art is often marked by non-availability, by being viewable only at a specific time. The example of performance is the most classic case of all. Once the performance is over, all that remains is documentation, which should not be confused with the work itself. This type of activity presupposes a contract with the viewer, an "arrangement" whose clauses have tended to become more and more diversified since the 1960s. The artwork is thus no longer to be consumed within a "monumental" time frame, open for a universal public; rather, it elapses within a factual time, for an audience "summoned by" the artist. In a nutshell, the work prompts meetings and invites appointments, managing its own temporal structure. Meetings with a public are not necessarily involved. Marcel Duchamp, for example, invented his "Rendez-vous d'art" by arbitrarily ordaining that at a certain time of the day the first object within his reach would be transformed into a readymade. Others have summoned the public to observe a specific phenomenon, the way Robert Barry

did when he announced that at "a certain moment during the morning of the 5th of March 1969, half a cubic meter of helium [would be] released into the atmosphere" by him.

The spectator is thus prompted to move in order to observe the work, which only exists as an artwork by virtue of this observation. In January 1970 Christian Boltanski sent a few acquaintances an SOS letter that was sufficiently vague in its content to be a standard letter, like On Kawara's telegrams informing their addressees, likewise from 1970 onwards, that he was "still alive." Today, the form of the visiting card (used by Dominique Gonzalez-Foerster, Liam Gillick and Jeremy Deller) and the address book (some of Karen Kilimnik's drawings), the growing importance of the opening as part of the exhibition program (Parreno, Joseph, Tiravanija, Huyghe) and the originality endeavors made in the production of invitations (handover from mail art) illustrate the importance of this "rendez-vous" in the artistic arena, and which forms its relational dimension.

Conviviality and Encounters

Cf. the writings of Lucy Lippard, such as *Dematerialization of the Artwork*, and Rosalind Krauss, *Sculpture in the Expanded Field*, etc.

A work may operate like a relational device containing a certain degree of randomness, or a machine provoking and managing individual and group encounters. To mention just a few examples from the past two decades, this applies to Braco Dimitrijevic's *Casual Passer-by* series, which exaggeratedly celebrates the name and face of an anonymous passer-by on an advertisement-sized poster or alongside the bust of a celebrity. In the early 1970s, Stephen Willats painstakingly mapped the relationships existing between the inhabitants of an apartment block. And Sophie Calle's work consists largely in describing her meetings with strangers. Whether she is following a passer-by, rummaging through hotel rooms after being employed as a chambermaid or asking blind people what their definition of beauty is, she formalizes, after the fact, a biographical experience which leads her to "collaborate" with the people she meets. Let us further mention On Kawara's *I Met* series, the *Food* restaurant opened in 1971 by Gordon Matta-Clark, the dinners organized by Daniel Spoerri and the ludic shop called *La cedille qui sourit* (*The Smiling Cedilla*) opened by George Brecht and Robert Filliou in Villefranche. The constitution of convivial relations has been an historical constant since the 1960s. The generation of the 1990s took up this set of issues, though it had been relieved of the matter of the definition of art, so pivotal in the 1960s and 70s. The issue no longer resides in broadening the boundaries of art,[2] but in experiencing art's

capacities of resistance within the overall social arena. Based on one and the same family of activities, two radically different set of problems emerge: formerly, the stress lay on relations inside the art world, within a Modernist culture attaching great importance to the "new," and called for linguistic subversion; today, the emphasis put on external relations is part of an eclectic culture where the artwork challenges the mill of the "society of the spectacle." Social utopias and revolutionary hopes have given way to everyday micro-utopias and imitative strategies; any stance that is "directly" critical of society is futile if based on the illusion of a marginality that is nowadays impossible, not to say regressive. Almost thirty years ago Félix Guattari was already advocating those hands-on strategies that underpin present-day artistic practices: "Just as I think it is illusory to aim at a step-by-step transformation of society, so I think that microscopic attempts of the community and neighborhood committee type, the organization of day-nurseries in the faculty and the like play an absolutely crucial role."[3]

Traditional critical philosophy (the Frankfurt School, in particular) now only fuels art in the form of archaic folklore, a magnificent but ineffectual toy. The subversive and critical function of contemporary art is now achieved in the invention of individual and collective vanishing lines, in those temporary and nomadic constructions whereby the artist models and disseminates disconcerting situations. Hence the present-day craze for revisited areas of conviviality, crucibles where heterogeneous forms of sociability are worked out. For her show at the CCC in Tours, Angela Bulloch set up a café. When a certain number of visitors sat down on the seats these latter set off the broadcast of a piece of music by Kraftwerk (1993) ... For the *Restaurant* exhibition in Paris, in October 1993, Georgina Starr described the anxiety she felt about "having supper on her own," and wrote a text that was handed out to lone diners in the restaurant. Ben Kinmont, for his part, proposed to randomly selected people that he would do their washing-up and kept an information network around his works. On several occasions Lincoln Tobier has set up a radio station in art galleries and invited the public to a discussion that was then broadcast over the airwaves. Philippe Parreno has been particularly inspired by the notion of the party. His exhibition project at Le Consortium in Dijon (January 1995) consisted in "occupying two hours of time rather than square meters of space," which involved organizing a party where all the ingredients ended up producing relational forms – clusters of individuals around art objects in situation ... Rirkrit Tiravanija, on

3. Félix Guattari, *Molecular Revolution* (New York: Penguin, 1984).

the other hand, has explored the socio-professional aspect of conviviality by including in the *Surfaces de réparation* show (Dijon, 1994) a relaxation area intended for the artists in the exhibition, equipped in particular with a table football game and a full fridge ... To wind up these convivial situations being developed as part of a "friendship" culture, let us mention the bar created by Heimo Zobernig for the exhibition *Unité*, and Franz West's *Passtücke*. But other artists are suddenly emerging in the relational fabric in a more aggressive way. Douglas Gordon's work, for example, explores the "wild" dimension of interactivity by acting parasitically and paradoxically in the social space. He thus phoned the customers in a café and sent multiple "instructions" to selected people. The best example of untimely communication upsetting communication networks is probably Angus Fairhurst's piece, for which, with the help of airwave-pirating equipment, he linked two art galleries together telephonically. Each person at the other end of the line thought it was the other person who had called, so that their exchanges would end up in an improbable misunderstanding ... As creations and explorations of relational schemes, these works form relational micro-territories displayed in the depth of the contemporary "socius": experiences publicized by surface-objects (Liam Gillick's boards, Pierre Huyghe's posters made in the street and Eric Duyckaerts' video-lectures) or else given over to immediate experience (Andrea Fraser's exhibition tours).

Collaborations and Contracts
Those artists proposing as artworks a) moments of sociability or b) objects producing sociability also sometimes use a relational context defined in advance so as to extract production principles from it. The exploration of relations existing between, for example, the artist and his/her gallery owner may determine forms and a project. Dominique Gonzalez-Foerster, whose work deals with the relations that link lived life with its media, images, spaces and objects, has thus devoted several exhibitions to the biographies of her gallery owners. *Bienvenue à ce que vous croyez voir* (*Welcome to What You Think You're Seeing*, 1988) included photographic documentation about Gabrielle Maubrie, and *The Daughter of a Taoist* (1992) used a set inspired by intimism to mix Esther Schipper's childhood memories with objects formally organized according to their evocative potential and their color range (here a predominant red). Gonzalez-Foerster thus explores the unspoken contract that binds the gallery owner to "his/her" artist, the former being an integral part of the other's personal

history and vice versa. It goes without saying that these fragment-
ed biographies, where the main factors are provided in the form of
"hints" and "clues" by the person commissioning the work, conjure
up the portrait tradition, where the commission formed the social
bond at the root of artistic representation. Maurizio Cattelan has
also worked directly on the bodies of his gallery owners: by design-
ing a phallic rabbit costume for Emmanuel Perrotin, which he had
to wear throughout the exhibition, and by earmarking clothes for
Stefano Basilico that created the illusion that he was carrying gal-
lery owner Ileana Sonnabend on his shoulders ... In a more circu-
itous way, Sam Samore asks gallery owners to take photographs,
which he then selects and reframes. But this artist/curator pair-
ing, which is an intrinsic part of the institution, is just the literal
aspect of inter-human relations likely to define an artistic produc-
tion. Artists take things further by working with spectacle figures:
whence Dominique Gonzalez-Foerster's work with the actress
Maria de Medeiros (1990) or the series of public activities organized
by Philippe Parreno for the imitator Yves Lecoq, through which it
was his intent to refashion, from within, the image of a television
personality (*Un homme public,* Marseille, Dijon, Ghent, 1994–1995).
Noritoshi Hirakawa, for his part, produces forms based on set up
meetings. For his show at the Pierre Huber Gallery in Geneva (1994)
he published a small ad to recruit a girl who would agree to travel
with him in Greece, a journey that would be the material for the
show. The images he exhibits are always the outcome of a specific
contract drawn up with his model, who is not necessarily visible
in the photos. In other instances, Hirakawa uses a particular cor-
porate body, as when he asked several fortune-tellers to predict his
future; he recorded their predictions, which could then be listened
to on a Walkman, alongside photos and slides conjuring up the
world of clairvoyance. For a series entitled *Wedding Piece* (1992), Alix
Lambert investigated the contractual bonds of marriage: within
six months she got married to four different people, divorcing
them all in record time. In this way, Lambert put herself inside the
"adult role-playing" represented by the institution of marriage,
which is a factory where human relations are reified. She exhib-
its objects produced by this contractual world – certificates, official
photos and other souvenirs, etc. The artist here becomes involved
in form-producing worlds (visit to the fortuneteller, officialization
of a liaison, etc.) that pre-exist him or her, material that is avail-
able for anyone to use. Some artistic events, with *Unité* still the best
example (Firminy, June 1993), enabled artists to work in a form-

less relational model like the one offered by the residents of a large housing complex. Several of those taking part worked directly on modifying and objectivizing social relations, one such being the Premiata Ditta group, which systematically questioned the inhabitants of the building where the exhibition was being held so as to compile statistics. Then there was Fareed Annaly, whose installation based on sound documents included interviews with tenants that could be listened to with headphones. Clegg & Guttman, for their part, presented in the middle of their work a kind of bookshelf unit, the shape of which suggested the architecture of Le Corbusier and which was designed to hold on tapes each inhabitant's favorite pieces of music. The cultural customs of the residents were thus objectified by an architectonic structure, and grouped on tape, floor by floor, thus forming compilations that could be consulted by all and sundry throughout the exhibition ... As a form fuelled and produced by collective interaction, Clegg & Guttman's *Record Lending Library*, whose principle was once again used for *The Backstage Show* at the Hamburg Kunstverein in that same year, embodies in its own right this contractual system for the contemporary artwork.

Professional Relations: Clienteles
As we have seen, these various ways of exploring social bonds have to do with already existing types of relations, which the artist fits into so that he/she can take forms from them. Other practices are aimed at recreating socio-professional models and applying their production methods. Here, the artist works in the real field of the production of goods and services, and aims to set up a certain ambiguity within the space of his activity between the utilitarian function of the objects he is presenting and their aesthetic function. It is this wavering between contemplation and use that I have tried to identify by the term "operative realism,"[4] with artists as diverse as Peter Fend, Mark Dion, Dan Peterman and Niek van de Steeg in mind, as well as more or less parody-oriented "businesses" like Ingold Airlines and Premiata Ditta. (The same term might be used for pioneers such as Panamarenko and John Latham's "Artist's Placement Group.") What these artists have in common is the modeling of a professional activity, with the relational world issuing there from as a device of artistic production. These make-believe phenomena, which imitate the general economy – as was the case with Ingold Airlines, Servaas Inc. and Mark Kostabi's "studio" – are limited to a construction of replicas of an airline company, a fishery and a production workshop, but without learning any ideological

. On this concept, we hould mention two writings: "Qu'est-ce que le éalisme opératif," in the catalogue for *Il faut construire Hacienda*, CCC Tours, anuary 1992; "Produire les rapports au monde", n the catalogue for *Aperto*, Venice Biennale, 1993.

and practical lessons from doing so and thus being restricted to a parody-like dimension of art. The example of the *Les ready-mades appartiennent à tout le monde* (*Ready-mades Belong to Everyone*) agency, headed by the late Philippe Thomas, is a bit different. He did not have time to proceed in a credible way to a second stage because his signature casting project ran somewhat out of steam after the *Feux Pâles* (*Pale Fires*) exhibition at the Capc in Bordeaux (1990). But Philippe Thomas' system, in which the pieces produced are signed by their purchaser, shed light on the cloudy relational economics that underpin the relations between artist and collector. A more discreet narcissism lies at the root of the pieces shown by Dominique Gonzalez-Foerster at the ARC in Paris and the Capc in Bordeaux.[5] These were "Biographical Offices" where, with no more than an appointment, the visitor came to divulge the salient facts of his life, with a view to a biography that would then be formalized by the artist.

Through little services rendered, artists fill in the cracks in the social bond. Form thus really becomes the "face looking at me." This is Christine Hill's modest aim when she becomes involved in the most menial of tasks (giving massages, shining shoes, working at a supermarket check-out, organizing group meetings, etc.), driven by the anxiety caused by a feeling of uselessness. Through little gestures, art is like an angelic program, a set of tasks carried out beside or beneath the real economic system so as to patiently re-stitch the relational fabric. Carsten Höller, for his part, applies his high-level scientific training to the invention of situations and objects which involve human behavior: inventing a drug that releases a feeling of love, Baroque sets and para-scientific experiments. Others, like Henry Bond and Liam Gillick in the *Documents* projects, embarked upon in 1990, adjust their function to a precise context. Using information just as it "came through" on press agency tele-printers, Bond and Gillick would hasten to the places where the event was happening at the same time as their "colleagues," bringing back an image that was completely out of synch when compared with the usual criteria of the profession. In any event, Bond and Gillick strictly applied the production methods of the mainstream press, just as Peter Fend with his OECD company and Niek van de Steeg put themselves in the architect's working conditions. By conducting themselves inside the art world on the basis of the parameters of "worlds" that are heterogeneous to it, these artists here introduce relational worlds governed by concepts of clientele, order or commission, and project. When Fabrice Hybert exhibited at the Musee d'Art Moderne de la ville de Paris in February 1995 all

5. Exhibitions *L'Hiver de l'amour* (ARC Paris, 1994) and *Traffic* (CAPC Bordeaux, 1996).

the industrial products actually or metaphorically contained in his work, as directly dispatched by their manufacturers and earmarked for sale to the public through his company "UR" (Unlimited Responsibility), he put the beholder in an awkward position. This project, which is as removed from Guillaume Bijl's illusionism as from an imitative reproduction of mercantile trade, focuses on the desiring dimension of the economy. Through his import-export activity dealing with seating bound for North Africa, and the transformation of the Musée d'Art Moderne de la ville de Paris into a supermarket, Hybert defined art as one social function among others, a permanent "digestion of data," the purpose of which is to rediscover the "initial desires that presided over the manufacture of objects."

How to Occupy a Gallery
The exchanges that take place between people in the gallery or museum space turn out to be equally likely to act as the raw matter for an artistic work. The opening is often an intrinsic part of the exhibition set-up, and the model of an ideal public circulation, a prototype of this being Yves Klein's *L'exposition du vide* in April 1958. From the presence of Republican guards at the entrance to the Iris Clert Gallery to the blue cocktail offered to visitors, Klein tried to control every aspect of the routine opening protocol by giving each one a poetic function defining its object: the void. Thus, to mention a work still having repercussions today, the work of Julia Scher (*Security by Julia*) consists in placing surveillance apparatus in exhibition venues. It is the human flow of visitors and its possible regulation which thus becomes the raw material and the subject of the piece. Before long, it is the entire exhibition process that is "occupied" by the artist.
In 1962, Ben lived and slept in the One Gallery in London for a fortnight, with just a few essential props. In Nice, in August 1990, Pierre Joseph, Philippe Parreno and Philippe Perrin also "lived in" the Air de Paris Gallery, literally and figuratively, with their show *Les Ateliers du Paradise*. It might be hastily concluded that this was a remake of Ben's performance, but the two projects refer to two radically different relational worlds, which are as different in terms of their ideological and aesthetic foundation as their respective period can be. When Ben lived in the gallery, it was his intent to signify that the arena of art was expanding, and even included the artist's sleep and breakfasts. On the other hand, when Joseph, Parreno and Perrin occupied the gallery, it was to turn it into a production workshop, a "photogenic space" jointly managed by the viewer in

accordance with very precise rules of play. At the opening of *Les Ateliers du Paradise*, where everyone was rigged out in a personalized T-shirt ("Fear," "Gothic," etc.), the relations that were struck up among visitors turned into a while-you-wait script, written live by the film-maker Marion Vernoux on the gallery computer. The interplay of inter-human relations was thus materialized in compliance with the principles of an interactive video game, a "real time film" experienced and produced by the three artists. A lot of outside people thus helped to build a space of relations, not only other artists but also psychoanalysts, coaches, friends … This type of "real time" work, which tends to blur creation and exhibition, was taken up in the exhibition *Work, Work in Progress. Work* at the Andrea Rosen Gallery (1992), with Felix Gonzalez-Torres, Matthew McCaslin and Liz Larner, and then by *This Is the Show and the Show Is Many Things*, which was held in Ghent in October 1994, before finding a more theoretical form with the *Traffic* exhibition that I curated. In each instance, the artist was at leisure to do what he/she wanted throughout the exhibition, to alter the piece, replace it or to propose performances and events. With each modification, as the general setting evolved, the exhibition played the part of a flexible matter "informed" by the work of the artist. The visitor here had a crucial place as well, because his interaction with the works helped to define the exhibition's structure. He was faced with devices requiring him to make a decision. In Gonzalez-Torres' *Stacks* and piles of sweets, for example, the visitor was authorized to take away something from the piece (a sweet, a sheet of paper), but it would purely and simply disappear if every visitor exercised this right. The artist thus appealed to the visitor's sense of responsibility, and the visitor had to understand that his gesture was contributing to the break-up of the work. What position should be adopted when looking at a work that hands out its component parts while trying to hang on to its structure? The same ambiguity awaited the viewer of his *Go-Go Dancer* (1991), a young man wearing a g-string on a minimal plinth, or the person looking at the personnages *vivants à réactiver* whom Pierre Joseph has accommodated at the opening of his exhibitions. Looking at *The Female Beggar Brandishing Her Rattle* (*No Man's Time*, Villa Arson, Nice, 1991), it is impossible not to avert one's eye, enmeshed in its aesthetic designs, which reifies, no precautions taken, a human being by assimilating it to the artworks surrounding it. Vanessa Beecroft juggles with a similar chord, but keeps the beholder at a distance. At her first one-woman show, with Esther Schipper in Cologne (November 1994), the artist took photos among a dozen girls all wear-

ing identical thin polo-neck sweaters and panties and all in blonde wigs, while a barrier preventing entrance to the gallery enabled two or three visitors at a time to check out the scene from a distance. Strange groups of people, under the curious gaze of a voyeur-viewer: Pierre Joseph characters coming from a fantastic popular imaginary – two twin sisters exhibited beneath two pictures by Damien Hirst (Art Cologne, 1992); a stripper performing her show (Dike Blair); a walker walking on a moving walkway, in a truck with see-through sides following the random itinerary of a Parisian (Pierre Huyghe, 1993); a stallholder playing a barrel-organ with a monkey on a lead (Meyer Vaisman, Jablonka Gallery, 1990); rats fed on "Bel Paese" cheese by Maurizio Cattelan; poultry rendered inebriated by Carsten Höller with the help of bits of bread soaked in whisky (collective video, *Unplugged*, 1993); butterflies attracted by glue-steeped monochrome canvases (Damien Hirst, *In and Out of Love*, 1992); animals and human beings bumping into each other in galleries acting as test-tubes for experiments to do with individual and social behavior. When Joseph Beuys spent a few days locked up with a coyote (*I like America and America Likes Me*), he gave himself over to a demonstration of his powers, pointing to a possible reconciliation between man and the "wild" world. On the other hand, as far as most of the above-mentioned pieces are concerned, their author has no preordained idea about what would happen: art is made in the gallery, the same way that Tristan Tzara thought that "thought is made in the mouth."

This article was first published in: Nicolas Bourriaud, *Relational Aesthetics* Dijon: Les Presses du Réel, 2002) [*Esthétique relationelle* Dijon: Les Presses du Réel, 1998)], chapter/essay: "Art of the 1990s," pp.25-40.

CLAIRE BISHOP
THE SOCIAL TURN
COLLABORATION AND ITS DISCONTENTS

"All artists are alike. They dream of doing something that's more social, more collaborative, and more real than art." - Dan Graham

Superflex's internet TV station for elderly residents of a Liverpool housing project (*Tenantspin*, 1999); Annika Eriksson inviting groups and individuals to communicate their ideas and skills at the Frieze Art Fair (*Do You Want an Audience?*, 2004); Jeremy Deller's *Social Parade* for over twenty social organizations in San Sebastian (2004); Atelier van Lieshout's *A-Portable* floating abortion clinic (2001); Jeanne van Heeswijk's project to turn a condemned shopping mall into a cultural center for the residents of Vlaardingen, Rotterdam (*De Strip*, 2001-2004); Lucy Orta's workshops in Johannesburg (and elsewhere) to teach unemployed people new fashion skills and discuss collective solidarity (*Nexus Architecture*, 1997–present); Temporary Services' improvised neighborhood environment in an empty lot in Echo Park, Los Angeles (*Construction Site*, 2005); Pawel Althamer sending a group of "difficult" teenagers from Warsaw's working-class Bródno district (including his two sons) to hang out at his retrospective in Maastricht (*Bad Kids*, 2004).

The above-mentioned projects are just a sample of the recent surge of artistic interest in collectivity, collaboration, and direct engagement with specific social constituencies. Although for the most part these practices have had a relatively weak profile in the commercial art world – collective projects are more difficult to market than works by individual artists and they are also less likely to be

"works" than social events, publications, workshops or perform-
ances – they nevertheless occupy an increasingly conspicuous pres-
ence in the public sector. The unprecedented expansion of the bien-
nial is one factor that has certainly contributed toward this shift,
as is the new model of commissioning agencies dedicated to the
production of experimental engaged art in the public realm.[1] In *One
Place After Another: Site-Specific Art and Locational Identity* (2002), Miwon
Kwon argues that community-specific work takes critiques of
"heavy metal" public art as its point of departure to address the site
as a *social* rather than formal or phenomenological framework. The
intersubjective space created through these projects becomes the
focus – and medium – of artistic investigation.

This expanded field of relational practices currently goes under a va-
riety of names: socially engaged art, community-based art, experi-
mental communities, dialogic art, littoral art, participatory, inter-
ventionist, research-based, or collaborative art. These practices are
less interested in a relational *aesthetic* than in the creative rewards
of collaborative activity – whether in the form of working with pre-
existing communities or establishing one's own interdisciplinary
network. Many artists now make no distinction between their work
inside and outside the gallery, and even highly established and
commercially successful figures like Francis Alÿs, Pierre Huyghe,
Matthew Barney and Thomas Hirschhorn have all turned to social
collaboration as an extension of their conceptual or sculptural prac-
tice. Although the objectives and output of these various artists and
groups vary enormously, all are linked by a belief in the empower-
ing creativity of collective action and shared ideas.

This mixed panorama of socially collaborative work arguably forms
what avant-garde we have today: artists using social situations to
produce dematerialized, anti-market, politically engaged projects
that carry on the Modernist call to blur art and life. For Nicolas
Bourriaud in his book *Relational Aesthetics* (1998), the defining text of
relational practice, "art is the place that produces a specific sociabil-
ity," precisely because "it *tightens the space of relations*, unlike TV." For
Grant Kester, in another key text, *Conversation Pieces: Community and
Communication in Modern Art* (2004), art is uniquely placed to counter a
world in which "we are reduced to an atomized pseudo-community
of consumers, our sensibilities dulled by spectacle and repetition."
For these and other supporters of socially engaged art, the creative
energy of participatory practices re-humanize – or at least de-alien-
ate – a society rendered numb and fragmented by the repressive
instrumentality of capitalism. But the urgency of this *political* task

1. Artangel in London, SKOR
in the Netherlands and
Nouveau Commanditaires
in France are just a few
that come to mind.

has led to a situation in which socially collaborative practices are all perceived to be equally important *artistic* gestures of resistance: there can be no failed, unsuccessful, unresolved or boring works of socially collaborative art, because all are equally essential to the task of strengthening the social bond. While broadly sympathetic to the latter ambition, I would argue that it is also crucial to discuss, analyze and compare this work critically *as art*.[2]

The emergence of criteria by which to judge social practices is not assisted by the present-day stand-off between the non-believers (aesthetes who reject this work as marginal, misguided and lacking artistic interest of any kind) and the believers (activists who reject aesthetic questions as synonymous with the market and cultural hierarchy). The former condemn us to a world of irrelevant painting and sculpture, while the latter self-marginalize to the point of inadvertently reinforcing art's autonomy, thereby preventing any productive rapprochement between art and life. Is there ground on which the two sides can meet?

What serious criticism has arisen in relation to socially collaborative art has been framed in a particular way: the social turn in contemporary art has prompted an ethical turn in art criticism. This is manifest in a heightened attentiveness as to *how* a given collaboration is undertaken. In other words, artists are increasingly judged by their working process – the degree to which they supply good or bad models of collaboration – and criticized for any hint of potential exploitation that fails to "fully" represent their subjects, as if such a thing were possible. This emphasis on process over product (that is to say: means over ends) is justified as oppositional to capitalism's predilection for the contrary. The indignant outrage directed at Santiago Sierra is a prominent example of this tendency, but it has been disheartening to read the criticism of other artists that also arises in the name of this equation: accusations of mastery and egocentrism are leveled at artists who work with participants to realize a project instead of allowing it to emerge through consensual collaboration.

The writing around the Turkish artists' collective Oda Projesi provides a clear example of the way in which aesthetic judgments have been overtaken by ethical criteria. Oda Projesi is a group of three artists who since 1997 have based their activities around a three-room apartment in the Galata district of Istanbul (*oda projesi* is Turkish for "room project").[3] The apartment provides a platform for projects generated by the group in cooperation with their neighbors,

. This critical task is particularly pressing in Britain, where New Labour use a rhetoric almost identical to that of socially engaged art to steer culture toward policies of social inclusion. Reducing art to statistical information about target audience and "performance indicators," the government prioritizes social effect over considerations of artistic quality.

. See: www.odaprojesi.com.

such as a children's workshop with the Turkish painter Komet, a community picnic with the sculptor Erik Göngrich, and a parade for children organized by the Tem Yapin theater group. Oda Projesi argue that they wish to open up a context for the possibility of exchange and dialogue, motivated by a desire to integrate with their surroundings. They insist that they are not setting out to improve or heal a situation – one of their project leaflets contains the slogan "exchange not change" – though they clearly see their work as gently oppositional. By working directly with their neighbors to organize workshops and events, they evidently want to produce a more creative and participatory social fabric. The group talks of creating "blank spaces" and "holes" in the face of an over-organized and bureaucratic society, and of being "mediators" between groups of people who normally do not have contact with each other.

Because much of Oda Projesi's work exists on the level of art education and community events, we can see the three artists as dynamic members of the community, bringing art to a wider audience. It is important that they are opening up the space for non-object-based practice in Turkey, a country whose art academies and art market are still largely oriented toward painting and sculpture. And one may also be pleased, as I am, that it is three women who have undertaken this task. But their conceptual gesture of reducing the authorial status to a minimum ultimately becomes inseparable from the community arts tradition. Even when transposed to Sweden, Germany and the other countries where Oda Projesi has exhibited, there is little to distinguish their projects from other socially engaged practices that revolve around the predictable formulae of workshops, discussions, meals, film screenings and walks. Perhaps this is because the question of aesthetic value is not valid for Oda Projesi. When I interviewed the group and asked what criteria they based their own work on, they replied that they judge it by the decisions they make about where and with whom they collaborate: dynamic and sustained relationships provide their markers of success, not aesthetic considerations.[4] Indeed, because their practice is based on collaboration, Oda Projesi consider "the aesthetic" to be "a dangerous word" that should not be brought into discussion. To me this seemed to be a curious response: if the aesthetic is dangerous, is that not all the more reason it should be interrogated?

Oda Projesi's ethical approach was adopted by the Swedish curator Maria Lind in a recent essay on its work. Lind is one of the most articulate supporters of political and relational practices, and she undertakes her curatorial work with a trenchant commitment to

4. Claire Bishop, "What We Made Together," interview with Oda Projesi, *Untitled,* Spring 2005.

the social. In her essay on Oda Projesi, she notes that the group is not interested in showing or exhibiting art but in "using art as a means for creating and recreating new relations between people."[5] She discusses the collective's project in Riem, near Munich, in which the group collaborated with a local Turkish community to organize a tea party, guided tours led by the residents, hairdressing and Tupperware parties, and the installation of a long roll of paper that people wrote and drew on to stimulate conversations. Lind compares this endeavor to Thomas Hirschhorn's *Bataille Monument*, his well-known collaboration with a mainly Turkish community in Kassel for *Documenta 11* (2002). Lind observes that Oda Projesi, contrary to Thomas Hirschhorn, are the better artists because of the equal status they give to their collaborators: "[Hirschhorn's] aim is to create art. For the *Bataille Monument* he had already prepared, and in part also executed, a plan on which he needed help to implement. His participants were paid for their work and their role was that of the 'executor' and not 'co-creator.'" Lind goes on to argue that Hirschhorn's work, by using participants to critique the art genre of the monument, was rightly criticized for "exhibiting" and making exotic marginalized groups and thereby contributing to a form of a social pornography." By contrast, she writes, Oda Projesi "work with groups of people in their immediate environments and allow them to wield great influence on the project."

It is worth looking closely at Lind's criteria here. Her judgment is based on an ethics of authorial renunciation: the work of Oda Projesi is better than that of Thomas Hirschhorn because it exemplifies a superior model of collaborative practice. The conceptual density and artistic significance of the respective projects are sidelined in favor of a judgment on the artists' relationship with their collaborators. Hirschhorn's (purportedly) exploitative relationship is compared negatively to Oda Projesi's inclusive generosity. In other words, Lind downplays what might be interesting in Oda Projesi's work *as art* – the possible achievement of making dialogue a medium, or the significance of dematerializing a project into social process. Instead her criticism is dominated by *ethical* judgments on working procedure and intentionality.

Similar examples can be found in the writing on Superflex, Orta, Eriksson and many other artists working in a socially ameliorative tradition. It finds support in most of the theoretical writing on art that collaborates with "real" people (that is to say, those who are not the artist's friends or other artists).[6] In these examples, autho-

. Maria Lind in: Claire Doherty (ed.), *Contemporary Art: From Studio to Situation* (London: Black Dog Publishing, 2004).

. For example, Lucy Lippard, concluding her book *The Lure of the Local* (1997), presents an eight-point "ethic of place" for artists who work with communities. Grant Kester's *Conversation Pieces* (2004), while lucidly articulating many of the problems associated with such practices, nevertheless advocates an art of concrete interventions in which the artist does not occupy a position of pedagogical or creative mastery. In *Good Intentions: Judging the Art of Encounter* (Amsterdam: Fonds BKVB, 2005), the Dutch critic Erik Hagoort argues that we must not shy from making moral judgments on this art: "we must weigh up the presentation and representation of an artist's good intentions."

rial intentionality (or a humble lack thereof) is privileged over a discussion of the work's conceptual significance as a social and aesthetic form. Paradoxically, this leads to a situation in which not only collectives but also individual artists are praised for their authorial renunciation. And this may explain, to some degree, why socially engaged art has been largely exempt from art criticism: emphasis is shifted away from the disruptive *specificity* of a given work and onto a *generalized* set of moral precepts.

In his book *Conversation Pieces* (2004), Grant Kester argues that consultative and "dialogic art" art necessitates a shift in our understanding of what art is – away from the visual and sensory (which are individual experiences) and toward "discursive exchange and negotiation." He challenges us to treat communication as an aesthetic form but ultimately he fails to defend this and seems perfectly content to allow that a socially collaborative art project could be deemed a success if it works on the level of social intervention even though it founders on the level of art. In the absence of a commitment to the aesthetic, Kester's position adds up to a familiar summary of the intellectual trends inaugurated by identity politics: respect for the other, recognition of difference, protection of fundamental liberties and an inflexible mode of political correctness. As such, it also constitutes a rejection of any art that might offend or trouble its audience – most notably the historical avant-garde, within whose lineage Kester nevertheless wishes to situate social-engagement as a radical practice. He criticizes Dada and Surrealism, which sought to "shock" viewers into being more sensitive and receptive to the world, because they assume that the artist is a privileged bearer of insights. I would argue that such discomfort and frustration – along with absurdity, eccentricity, doubt or sheer pleasure – can, on the contrary, be crucial elements of a work's aesthetic impact and are essential to gaining new perspectives on our condition. The best examples of socially collaborative art give rise to these – and many other – effects, which must be read alongside more legible intentions, such as the recovery of a fantasmatic social bond or the sacrifice of authorship in the name of a "true" and respectful collaboration. Some of these projects are well known: Thomas Hirschhorn's *Musée Précaire* (2004) and *24h Foucault* (2004), Aleksandra Mir's *Cinema for the Unemployed* (1998), Francis Alÿs' *When Faith Moves Mountains* (2003). Rather than positioning themselves within an activist lineage in which art is marshaled to social change, these artists have a closer relationship to avant-garde theater, performance or even architectural theory. As a consequence,

perhaps, they attempt to think the aesthetic and the social/political *together*, rather than subsuming both within the ethical.

The British artist Phil Collins fully integrates these two concerns in his work. Invited to undertake a residency in Jerusalem, he decided to hold a disco-dancing marathon for teenagers in Ramallah, which he recorded to produce the two-channel video *They Shoot Horses* (2004). Collins paid nine teenagers to dance continually for eight hours, on two consecutive days, in front of a garish pink wall to an unrelentingly cheesy compilation of pop hits. The teenagers are mesmerizing and irresistible as they move from exuberant partying to exhaustion. The sound track's banal pop lyrics of ecstatic love and rejection acquire poignant connotations in the light of the kids' double endurance of the marathon and of the interminable political crisis in which they are trapped. It goes without saying that *They Shoot Horses* is a perverse representation of the "site" that the artist was invited to respond to: the Occupied Territories are never shown explicitly, but are ever-present as a frame. This use of the *hors-cadre* has a political purpose: Collins' decision to present the participants as generic globalized teenagers becomes clear when we consider the puzzled questions regularly overheard when watching the video in public: How come Palestinians know Beyoncé? How come they are wearing Nikes? By voiding the work of direct political narrative, Collins demonstrates how swiftly this space is filled by fantasies generated by the media's selective production and dissemination of images from the Middle East. By using pop music as familiar to Palestinian as to Western teens, Collins also provides a commentary on globalization that is considerably more nuanced than most activist-oriented political art. *They Shoot Horses* plays off the conventions of benevolent socially collaborative practice (it creates a new narrative for its participants and reinforces a social bond) but combines this with the visual and conceptual conventions of reality TV. The presentation of the work as a two-screen installation lasting a full eight-hour working day subverts both genres in its emphatic use of seduction on the one hand and grueling duration on the other.

The work of Polish artist Artur Zmijewski, like that of Collins, often revolves around the devising and recording of difficult, and sometimes even excruciating, situations. In Zmijewski's video *The Singing Lesson I* (2001), a group of deaf students are filmed singing Maklakiewicz's 1944 Polish Mass in a Warsaw church. The opening shot is staggeringly hard: an image of the church interior, all elegant neoclassical symmetry, is offset by the cacophonous distorted voice of a young girl. She is surrounded by fellow students who,

unable to hear her efforts, chat with one another in sign language. Zmijewski's editing draws constant attention to the contrast between the choir and their environment, suggesting that religious paradigms of perfection continue to inform our ideas of beauty. A second version of The Singing Lesson was filmed in Leipzig in 2002. This time the deaf students, together with a professional chorister, sing a Bach cantata to the accompaniment of a baroque chamber orchestra, in a church where Bach once served as cantor. The German version is edited to reveal a more playful side of the experiment. Some students take the task of performing seriously; others abandon it in laughter. Their gestures of sign language in rehearsal are echoed by those of the conductor: two visual languages that serve to equate the two types of music produced by Zmijewski's experiment – the harmonies of the orchestra and the strained wailing of the choir. The artist's stylized editing, compounded by my inability to understand sign language, seem integral to the film's point: we can only ever have limited access to others' emotional and social experiences, and the opacity of this knowledge obstructs any analysis founded on such assumptions. Instead we are invited to read what is presented to us – a perverse assemblage of conductor, musicians and deaf choir that produces something more complex, troubling and multi-layered than the release of individual creativity.

It will be protested that both Collins and Zmijewski produce videos for consumption within a gallery, as if the space outside it were automatically more authentic – a logic that has been definitively unraveled by Kwon in One Place After Another. Her advocacy of art that "unworks" community might usefully be applied to the practice of British artist Jeremy Deller. In 2001 he organized the re-enactment of a key event from the English miners' strike of 1984 – a violent clash between miners and the police in the village of Orgreave in Yorkshire. The Battle of Orgreave was a one-day re-enactment of this clash, performed by former miners and policemen together with a number of historical re-enactment societies. Although the work seemed to contain a twisted therapeutic element (in that both miners and police involved in the struggle were involved, some of them swapping roles), The Battle of Orgreave did not seem to heal a wound so much as to reopen it. Deller's event was both politically legible and utterly pointless: it summoned the experiential potency of a political demonstration, but only to expose a wrong seventeen years too late. It gathered the people together to remember and replay a disastrous event, but this remembrance took place in circumstances more akin to a village fair, with a brass band, food stalls and

children running around. This contrast is particularly evident in the only video documentation of *The Battle of Orgreave*, which forms part of a feature-length film by Mike Figgis, a left-wing filmmaker who explicitly uses the work as a vehicle for his indictment of the Thatcher government. Clips of Deller's event are shown between emotional interviews with former miners, and the clash of tone is disconcerting. The involvement of historical re-enactment societies is integral to this ambiguity, since their participation symbolically elevated the relatively recent events at Orgreave to the status of English history, while drawing attention to this eccentric leisure activity in which bloody battles are enthusiastically replicated as a social and aesthetic diversion. The whole event could be understood as contemporary history painting that collapses representation and reality.

Deller, Collins and Zmijewski do not make the "correct" ethical choice, they do not embrace the Christian ideal of self-sacrifice; instead, they act on their desire without the incapacitating restrictions of guilt. In so doing, their work joins a tradition of highly authored situations that fuse social reality with carefully calculated artifice. This tradition still needs to be written, beginning, perhaps, with the "Dada-Season" in the spring of 1921 – a series of manifestations that sought to involve the Parisian public. The most salient of these events was an "excursion" to the church of Saint Julien le Pauvre, which drew more than one hundred people despite the pouring rain. The inclement weather cut the tour short and prevented an "auction of abstractions" from being realized. In this Dada excursion, as in the examples given above, inter-subjective relations were not an end in themselves, but rather served to unfold a more complex knot of concerns about pleasure, visibility, engagement and the conventions of social interaction.

The discursive criteria of socially engaged art are, at present, drawn from a tacit analogy between anti-capitalism and the Christian "good soul." In this schema, self-sacrifice is triumphant: the artist should renounce authorial presence in favor of allowing participants to speak through him or her. This self-sacrifice is accompanied by the idea that art should extract itself from the "useless" domain of the aesthetic and be fused with social praxis. As the French philosopher Jacques Rancière has observed, this denigration of the aesthetic ignores the fact that the system of art as we understand it in the West – the "aesthetic regime of art" inaugurated by Schiller and the Romantics and still operative to this day – is predicated precisely on a confusion between art's autonomy (its position

at one remove from instrumental rationality) and heteronomy (its blurring of art and life).[7] Untangling this knot – or ignoring it by seeking more concrete ends for art – is slightly to miss the point, since the aesthetic is, according to Rancière, the ability to think contradiction: the productive contradiction of art's relationship to social change, characterized precisely by that tension between faith in art's autonomy and belief in art as inextricably bound to the promise of a better world to come. For Rancière, the aesthetic does not need to be sacrificed at the altar of social change, as it already inherently contains this ameliorative promise. The best art manages to fulfill the promise of the antinomy which Schiller saw as the very root of aesthetic experience and not surrender itself to exemplary (but relatively ineffectual) gestures. The best collaborative practices of the last ten years address this contradictory pull between autonomy and social intervention and reflect on this antinomy, both in the structure of the work *and* in the conditions of its reception. It is to this art – however uncomfortable, exploitative, or confusing it may first appear – that we must turn for an alternative to the well-intentioned homilies that today pass for critical discourse on social collaboration.

7. Jacques Rancière, "The Aesthetic Revolution and Its Outcomes," in: *New Left Review*, No. 14, March/April 2002, pp. 133–151.

ENGA
GEM
ENT

3. ENGAGEMENT. Is increasing globalization leading to a renewed acquaintance with the world around us? What is our relationship with the Other? And how does this find expression in art? In *The Return of the Real* (1996), *Hal Foster* argued that in the art of the 1990s a return to reality, to real life, could be discerned. Art was no longer turned in on itself, as it had been during the previous decade, but was busy investigating relevant social phenomena (the artist as anthropologist). Art was going out into the world, creating platforms and entering into dialogue. This development appears to have become even more relevant since 9/11. In 2006, however, *Hal Foster* was no longer so sure of his ground, as so-called "engaged" projects today seem to be divorced from political and social reality and are instead bound up in a culture of consumption and service. *Jeroen Boomgaard* is also critical of the current engagement in art. Whereas the interaction with the public and the world outside art still meant something in the 1960s and 1970s, now it seems only to be about the principle. It is "engagement for engagement's sake," but people are not really listening to one another.

HAL FOSTER (DIS)ENGAGED ART

This paper attempts three things: 1) revisit what has come to be called "relational aesthetics"; 2) probe what I take to be its "archival" dimension; and 3) specify this dimension through the test-case of a single artist, Joachim Koester.

I: Chat Rooms

Visiting an art gallery over the last decade you might have happened on one of the following: a room empty except for a stack of identical sheets of paper, printed with a simple image of an unmade bed or birds in flight, or a mound of identical sweets wrapped in brilliant colored foil, the sweets, like the paper, free for the taking. Or a space where office contents were dumped in the exhibition area and a couple of pots of Thai food were on offer to visitors puzzled enough to linger, eat and talk. Or a scattering of bulletin boards, drawing tables and discussion platforms, some dotted with information about an important figure from the past. Or, finally, a kiosk cobbled together from plastic and plywood and filled, like a homemade study-shrine, with images and texts devoted to a modern artist, writer or philosopher. Such works, which fall somewhere between a public installation, an obscure performance and a private archive, can also be found outside art galleries, which renders them all more difficult to decipher in aesthetic terms. Nonetheless, they can be taken to indicate a distinctive turn in recent art. In play in the first works – by Felix Gonzalez-Torres and Rirkrit Tiravanija respectively - is a notion of art as an ephemeral offering, a precarious gift; and in the second two pieces – by Liam Gillick and Thomas Hirschhorn – a notion of art as an informal probing into a specific figure or event in history or politics, fiction or philosophy. The prominent practitioners of this art draw on a wide range of

precedents: the everyday objects of Nouveau Réalisme, the humble materials of Arte Povera, the participatory strategies of Lygia Clark and Hélio Oiticica, among others. But these artists have also transformed the familiar devices of the readymade object, the collaborative project and the installation format. For example, some treat entire films as found images: Pierre Huyghe has re-shot parts of the Al Pacino movie *Dog Day Afternoon* with the real-life protagonist (a reluctant bank robber) returned to the lead role, and Douglas Gordon has adapted a couple of Hitchcock films in drastic ways (most notoriously in his *24 Hour Psycho*). Gordon calls such pieces "time readymades" – that is, given narratives to be sampled in large image-projections (a pervasive medium in contemporary art) – while Nicolas Bourriaud champions such work under the rubric of "post-production." This term underscores secondary manipulations (editing, extra effects and the like) that are almost as pronounced in such art as in film. The word also suggests a changed status of the "work" of art in the age of information; and, in a world of "shareware," information can indeed appear as the ultimate readymade, as data to be reprocessed and sent on; and some of these artists do work, as Bourriaud says, "to inventory and select, to use and download," to revise not only found images and texts, but also given forms of exhibition and distribution.[1]

One upshot of this way of working is a "promiscuity of collaborations" (Gordon), in which the Post-modernist complications of originality and authorship are pushed beyond the pale. Take a collaborative work such as *No Ghost Just a Shell*, led by Huyghe and Philippe Parreno. Several years ago they discovered a Japanese animation company wanted to sell some of its minor characters; they bought one such person-sign, a girl named Annlee, and invited other artists to use her in their work. Here the artwork becomes a "chain" of pieces: for Huyghe and Parreno, *No Ghost Just a Shell* is "a dynamic structure that produces forms that are part of it"; it is also "the story of a community that finds itself in an image." This "community" can also have a dark side. Consider another group project that adapts a readymade product to unusual ends: in this work, Joe Scanlan, Dominique Gonzalez-Foerster, Gillick, Tiravanija and others show you how to customize your own coffin from Ikea furniture; its title is *DIY, or How to Kill Yourself Anywhere in the World for under $399*. The tradition of readymade objects, from Marcel Duchamp to Damien Hirst, is often mocking of high and/or mass culture, or both; in these examples it is mordant about global capitalism as well. Yet the prevalent sensibility of this new work is innocent and

1. All Bourriaud quotations are from Nicolas Bourriaud, *Postproduction* (New York: Lukas & Sternberg, 2001); all other quotations (unless otherwise specified) are from Hans Ulrich Obrist, *Interviews: Volume I* (Milan: Charta, 2003).

expansive, even ludic – again an offering to other people and/or an opening to other discourses. At times a benign image of globalization is advanced, and there are utopian moments too: Tiravanija, for example, has organized a "massive-scale artist-run space," called *The Land* in rural Thailand, which is designed as a collective "for social engagement." More modestly, these artists aim to turn passive viewers into a temporary community of active interlocutors. In this regard, Hirschhorn, who once worked in a Communist collective of graphic designers, sees his makeshift monuments to artists and philosophers as a species of passionate pedagogy – they evoke the agit-prop kiosks of the Russian Constructivists as well as the obsessive constructions of Kurt Schwitters. Hirschhorn seeks to "distribute ideas," "radiate energy" and "liberate activity" all at once: he wants not only to familiarize his audience with an alternative public culture, but to libidinize this relationship as well. Other artists, some of whom were trained as scientists (such as Carsten Höller) or architects (Stefano Boeri), adapt a model of collaborative research and experiment closer to the laboratory or the design firm than the studio. "I take the word 'studio' literally," Gabriel Orozco remarks, "not as a space of production but as a time of knowledge." "A promiscuity of collaborations" has also meant a promiscuity of installations: installation is the default format and exhibition the common medium of so much art today – a tendency in part driven by the increased importance of huge shows around the world. Entire exhibitions are often given over to messy juxtapositions of projects – photos and texts, images and objects, videos and screens – and occasionally the effects are more chaotic than communicative. Nonetheless, discursivity and sociability are central concerns of the new work, both in its making and in its viewing. "Discussion has become an important moment in the constitution of a project," Huyghe comments, and Tiravanija aligns his art, as "a place of socialization," with a village market or a dance floor. "I make art," Gordon says, "so that I can go to the bar and talk about it." Apparently, if the model of the avant-garde was once the Party à la Vladimir Lenin, today it is a party à la John Lennon.

In this time of mega-exhibitions, the artist often doubles as curator. "I am the head of a team, a coach, a producer, an organizer, a representative, a cheerleader, a host of the party, a captain of the boat," Orozco says, "in short, an activist, an activator, an incubator." The rise of the artist-as-curator has been complemented by that of the curator-as-artist; maestros of large shows have become dominant players in the art world. Often the two groups

share models of working as well as terms of description. Several years ago, for example, Tiravanija, Orozco and other artists began to speak of projects as "platforms" and "stations," as "places that gather and then disperse," in order to underscore the casual communities they sought to create. In 2002, *Documenta 11*, curated by an international team led by Okwui Enwezor, was also conceived in terms of "platforms" of discussion, scattered around the world, on such topics as "Democracy Unrealized," "Processes of Truth and Reconciliation," "Creolité and Creolization," and "Four African Cities"; the exhibition held in Kassel, Germany, was only the final such "platform," And in 2003 the Venice Biennale, curated by another international group headed by Francesco Bonami, featured sections called "Utopia Station" and "Zone of Urgency," both of which exemplified the informal discursivity of much art-making and curating today.

Like "kiosk," "platform" and "station" might call up the Modernist ambition to modernize culture in accordance with industrial society (El Lissitzky spoke of his Constructivist designs as "way-stations between art and architecture"). Yet today these terms evoke the electronic network and many artists and curators are seduced by the Internet rhetoric of "interactivity," though the means applied to this end are usually far more funky and face-to-face than any chat room on the Web. The results tend to oscillate between an exemplary instance of interdisciplinarity on the one hand and a Babelesque confusion of tongues on the other. Now, along with the emphasis on discursivity and sociability in this work, there is also a concern with the ethical and the everyday: art is "a way to explore other possibilities of exchange" (Huyghe), a model of "living well" (Tiravanija), a means of being "together in the everyday" (Orozco). "Henceforth," Bourriaud declares, "the group is pitted against the mass, neighborliness against propaganda, low tech against high tech, and the tactile against the visual. And above all, the everyday now turns out to be a much more fertile terrain than pop culture." These possibilities of "relational aesthetics" seem clear enough, but there are problems, too. Sometimes politics are ascribed to such art on the basis of a shaky analogy between an open artwork and an inclusive society, as if a desultory form might evoke a democratic community or a non-hierarchical installation predict an egalitarian world. Hirschhorn sees his projects as "never-ending construction sites," while Tiravanija rejects "the need to fix a moment where everything is complete." But surely one thing art can still do is to take a stand, and to do this in a concrete register that brings together

the aesthetic, the cognitive and the critical in a precise constellation. In any case, formlessness in society might be a condition to contest rather than to celebrate in art – a condition to make over into form for the purposes of reflection and resistance (as some Modernist painters attempted to do). The artists in question frequently cite the Situationists, but the Situationists valued precise intervention and rigorous organization above all things.

"The question," Huyghe argues, "is less 'what?' than 'to whom?' It becomes a question of address." Bourriaud also sees art as "an ensemble of units to be reactivated by the beholder-manipulator." In many ways this approach is another legacy of the Duchampian provocation, but when is such "reactivation" too great a burden to place on the viewer, too ambiguous a test? As with previous attempts to involve the audience directly (for example, in some Process and Conceptual art), there is a risk of illegibility here, which might serve only to reintroduce the artist as the principal figure and the primary exegete of the work. At times, "the death of the author" has meant not "the birth of the reader," as Roland Barthes famously speculated, so much as the befuddlement of the viewer. Furthermore, when has art, at least since the Renaissance, not involved discursivity and sociability? To underscore them might risk a weird formalism of discursivity and sociability pursued for their own sakes. Collaboration, too, is often regarded as an end in itself: "Collaboration is the answer," the curator Hans Ulrich Obrist has remarked, "but what is the question?" Art collectives in the recent past, such as those formed around AIDS activism, were political projects; today simply getting together sometimes seems to be enough. Here we might not be too far from an art-world version of "flash mobs" – of "people meeting people," as Tiravanija says, as its own purpose.

Perhaps discursivity and sociability are foregrounded in art today because they appear scarce elsewhere (I speak, of course, as a North American). The same goes for the ethical and the everyday, as the briefest glance at our craven politicians and hectic lives might suggest. It is as though the mere idea of community has taken on a utopian tinge. Even an art audience cannot be taken for granted but must be conjured up every time, which might be why contemporary exhibitions often feel like remedial work in socialization: "come look, talk and learn with me." If participation appears threatened in other spheres, its privileging in art might be compensatory – a pale, part-time substitute. Bourriaud almost suggests as much: "Through little services rendered, the artists fill in the

cracks in the social bond." In fact only when he is at his most grim does Bourriaud hit home: "The society of the spectacle is thus followed by the society of extras, where everyone finds the illusion of an interactive democracy in more or less truncated channels of communication."[2]

For the most part these artists and curators see discursivity and sociability in rosy terms. As the critic Claire Bishop has argued, this tends to drop contradiction out of dialogue and conflict out of democracy; it is also to advance a version of the subject free of the unconscious (even the gift is charged with ambivalence, according to Marcel Mauss). At times everything seems to be happy interactivity: among "aesthetic objects" Bourriaud counts "meetings, encounters, events, various types of collaboration between people, games, festivals and places of conviviality, in a word all manner of encounter and relational invention." To some readers such "relational aesthetics" will sound like a truly final end of art, to be celebrated or decried. For others it will seem to aestheticize the nicer procedures of our service economy ("invitations, casting sessions, meetings, convivial and user-friendly areas, appointments"). There is the further suspicion that, for all its discursivity, "relational aesthetics" might be sucked up in the general movement for a "post-critical" culture – an art and architecture, cinema and literature "after theory."

2. Nicolas Bourriaud, *Relational Aesthetics* (Dijon: Les presses du réel, 2002 [1998]), p. 26.

II: Archival Spaces

One aspect of this practice does interest me, however, and that is its archival dimension. This aspect is hardly new: it was variously active in the prewar period when the repertoire of sources for art was extended both politically and technologically (for example, in the photo files of Alexander Rodchenko and the photomontages of John Heartfield), and it was even more variously active in the postwar period, especially as appropriated images and serial formats became common idioms (for example, in the pin-board aesthetic of the Independent Group, remediated representations from Robert Rauschenberg through Richard Prince, and the informational structures of Conceptual Art, institutional critique and feminist art). Yet an "archival impulse" with a distinctive character of its own is again pervasive – enough to be considered a tendency in its own right.

In the first instance, archival artists – elsewhere I have looked at the work of Tacita Dean, Thomas Hirschhorn and Sam Durant in these terms – seek to make historical information, often lost or displaced,

physically present. To this end they elaborate on the found image, object or text and favor the installation format as they do so. As already noted, some practitioners, such as Douglas Gordon, gravitate toward "time readymades." Often these sources are familiar, drawn from the archives of mass culture (for example, films by Hitchcock, Scorsese and others) in order to ensure a legibility that can then be disturbed or *detourné*; but sometimes, too, they are obscure, retrieved in a gesture of alternative knowledge or counter-memory. The latter will be my focus here.

Perhaps the ideal medium of archival art is the mega-archive of the Internet, and yet the archives at issue here are not databases in this sense; they are recalcitrantly material, fragmentary rather than fungible, and as such they call out for human interpretation not machinic reprocessing. Although the contents of this art are hardly indiscriminate they remain indeterminate, like the contents of any archive, and often they are presented in this fashion – as so many notes for further elaboration or prompts for future scenarios (a key term of this work). In this regard archival art is as much "pre-production" as it is "post-production": concerned less with absolute origins than with obscure traces (perhaps "*an*archival impulse" is the more appropriate phrase), these artists are often drawn to unfulfilled beginnings or incomplete projects – in art and history alike – that might offer points of departure once again.

If archival art differs from Internet, it is also distinct from art focused on the museum. Certainly the figure of the artist-as-archivist follows that of the artist-as-curator, and some archival artists continue to play on the category of the collection. Yet they are not as concerned with critiques of representational totality and institutional integrity: that the museum is ruined as a coherent system in the public sphere is generally assumed, not triumphantly proclaimed or melancholically pondered, and some of these artists suggest other kinds of ordering – within the museum and without. In this respect the orientation of archival art is often more "institutive" than "destructive," more "legislative" than "transgressive" (I borrow these sets of terms from Jacques Derrida and Jeff Wall respectively). The work in question is archival since it not only draws on informal archives but produces them as well, and does so in a way that underscores the nature of all archival materials as found yet constructed, factual yet fictive, public yet private. Further, it often arranges these materials according to a quasi-archival logic, a matrix of citation and juxtaposition, and presents them in a quasi-archival architecture, a complex of texts and objects (again, platforms,

stations, kiosks ...). Thus Tacita Dean speaks of her method as "collection," Sam Durant of his as "combination," Thomas Hirschhorn of his as "ramification" – and much archival art does appear to ramify like a weed or a "rhizome" (a Deleuzean trope that other artists employ as well). Perhaps all archives develop in this way, through mutations of connection and disconnection, a process that this art also serves to disclose. "Laboratory, storage, studio space, yes," Hirschhorn remarks, "I want to use these forms in my work to make spaces for the movement and endlessness of thinking ..." Such is artistic practice in the archival field today.

What drives much archival art (and here Hirschhorn is exemplary) is a will to connect what cannot be easily connected. This is not a will to totalize so much as a will to relate – to probe a misplaced past, to collate its different signs, to ascertain what might remain for the present. This is why such work sometimes appears tendentious, even preposterous. Indeed its will to connect can betray a hint of paranoia – for what is paranoia if not a practice of forced connections and bad combinations, of "my own private archive," of my own "notes from the underground," put out on display? On the one hand, these private archives do question public ones: they can be seen as perverse orders that aim to disturb the symbolic order at large. On the other hand, they might also point to a general crisis in this social law – or to an important change in its workings, whereby the symbolic order no longer operates through apparent totalities. For Freud the paranoiac projects meaning onto a world ominously drained of significance (systematic philosophers, he liked to imply, are closet paranoiacs). Might archival art emerge out of a similar sense of a failure in cultural memory, of a default in productive traditions? For why else connect so feverishly if things did not appear so frightfully disconnected in the first place? Perhaps the paranoid dimension of archival art is the other side of its utopian ambition – its desire to turn belatedness into becomingness, to recoup failed visions in art, literature, philosophy and everyday life into possible scenarios of alternative kinds of social relations, to transform the no-place of the archive into the no-place of a utopia. This partial recovery of the utopian demand is unexpected: not so long ago this was the most despised aspect of the modern(ist) project, condemned as totalitarian gulag on the Right and capitalist *tabula rasa* on the Left. The move to turn "excavation sites" into "construction sites" is welcome in another way, too: it suggests a shift away from the dominance of a melancholic culture that tends to view the historical as little more than the traumatic.

III: Blind Spots

My remarks on archival art are quite abstract, but they can be made a little more concrete with a test case – the work of the Danish artist Joachim Koester (1962). Koester works along the borders between documentary and fiction. Typically, he begins with an obscure story bound up with a particular place, a sited tale that is somehow broken or layered through time. Then, usually in a photo sequence or a film installation, he works to piece the story together, but never to the point of resolution: a historical irony persists, one that can be elaborated further, or an essential enigma remains, one that can be used to test the limits of what can be seen, represented, narrated, known. Like others involved in an archival approach to art-making (such as Dean), Koester often accompanies his images with texts, but these serve less as factual captions than as imaginative legends of his own mapping of spaces, his own "ghost-hunting" of subjects.[3]

Frequently his spaces are far-flung and his subjects long-gone (they include late nineteenth-century explorers, early twentieth-century occultists and post-1968 radicals). Koester is especially drawn to adventurers whose quests have failed, sometimes disastrously so (but then what counts as success in the category of utopia?). For example, a 2000 photo sequence takes up the story of the Canadian arctic town of Resolute, which begins with the search for the Northwest Passage, passes through the politics of the Cold War, and deteriorates with the discordant claims of planners, Inuits and other residents in the present. Clearly, the borders that Koester works are also political and economic.

In two works Koester has treated Christiania, a military base in his native Copenhagen proclaimed a free city by anarchist squatters in 1971. *In Day for Night, Christiania 1996* he photographed different sites with a blue filter (used in film to shoot night scenes during the day), split the titles between military designations and squatter names, and so re-marked the transformations of Christiania at the level of image and language alike. Then, in *Sandra of the Tuliphouse or How to Live in a Free State* (2001), a five-screen video installation produced with Matthew Buckingham, Koester used black-and-white photos drawn from archives and color footage shot on location in order to present, through the voiceover of the fictional Sandra, a range of ruminations on Christiania, Copenhagen, the fate of armor in the age of gunpowder, the rise of heroin and the decline of wolves. The piece is perspectival in a Nietzschean sense, with the audience forced to sort out the various viewpoints on the fly. Both

Joachim Koester, "Lazy airvoyants and Future ..diences: Joachim Koester Conversation with ..ders Kreuger," *Newspaper ..Mot* No. 43-44, August ..5, n.p. For more on this ..hival approach see my: ..n Archival Impulse," ..tober, No. 110, Fall 2004.

works juxtapose the utopian promise and the grim actuality of Christiania (Dean again comes to mind), and both are structured through a particular kind of montage – internal in the case of the split-captioned photos of *Day for Night*, immersive in the case of the installation space of *Sandra of the Tuliphouse*. Such montage is the formal analogue of the parallactic model of history that Koester advances in all his work – a combination of times *within* the space of each piece. "You can really grasp time as a material through this simple act of comparison," Koester writes.[4]

In other works focused on adventurers Koester also uses temporal frames to highlight historical ruses. In *From the Travel of Jonathan Harker* (2003) he retraced the journey of the English protagonist of *Dracula* through the Borgo Pass, only to find, in fabled Transylvania, suburban tracts, illegal logging and a tourist hotel called Castle Dracula. Among actual explorers Koester has taken up the Swedish scientist Nils Nordenskiöld, the first European to venture deep into the Greenland ice cap. Nothing is more Northern Romantic than a fascination with explorations gone awry (the emblem here is the *The Wreck of the Hope* by Caspar David Friedrich from 1821), and his recent exhibition at the Greene Naftali Gallery in New York included another piece about a polar expedition titled *Message from Andrée* (first seen at the 2005 Venice Biennale). "On July 11th 1897," Koester tells us, "Andrée, Fraenkel, and Strindberg took off from Spitsbergen, with the intention of circumnavigating the North Pole in a balloon."[5] Yet the balloon soon crashed and the explorers vanished on the pack ice; only 33 years later was a box of exposed negatives found. Some contained images, but most were "almost abstract, filled with black stains, scratches, and streaks of light"; out of this "visual noise" Koester produced a short 16mm film, "pointing to the twilight zone of what can be told and what cannot be told, document and mistake." As Koester reinscribes it, then, "the message from Andrée" is fundamentally ambiguous: an archival photo of the balloon just underway suggests the late nineteenth-century dream of the expedition – that the world can be readily mastered à la Jules Verne – while the film, like a message in a bottle worn away by exposure, points to the implacability of natural accidents as well as, perhaps, the indecipherability of historical events.

Two recent photo sequences – one concerns a notorious figure of the occult, the other a celebrated philosopher of the Enlightenment – are also broken allegories that query the significance of historical traces in the midst of continuous transformations. In *Morning of the Magicians* (2005) Koester documents his search for the home of

4. Koester, op. cit. This internal montage is not a function of digital manipulation; hence the image retains its documentary effect (even as that effect might also be questioned). The result of the juxtaposition is a kind of "third meaning" that also interests some contemporaries (for example, Pierre Huyghe).

5. Unless otherwise specified, all citations are from the texts written by Koester to accompany the three works in the *Greene Naftali* show.

the occultist Aleister Crowley (1875–1947) and his followers outside the Sicilian town of Cefalù. Closed in 1923 by order of Mussolini, "The Abbey of Thelema" was abandoned for more than 30 years, only to be rediscovered by the filmmaker Kenneth Anger who, supported by the sexologist Alfred Kinsey, exposed the original murals evocative of the tantric practices, sexual rites and drug use of the Crowley group. This layering of "pieces of leftover narratives and ideas from the individuals that once passed through this place" is almost too good to be true, but it also produces a narrative "knot," and Koester conveys this obscurity with shots of the exterior overgrown with brush and of the interior marked by graffiti (it proved difficult even to find the house). The occult is thus the subject here in a few senses of the word. First come the actual practices of the Crowley group, which, if the murals are any indication, ranged from the magical through the ribald to the hokey (two images show "The Room of Nightmares," where stoned initiates were placed overnight "to contemplate every possible phantom that can assail the soul"). Then the occult also interests Koester as an instance of an obscure activity within official culture. And finally there is the occlusion that comes not only of "the individuals that once passed through" (including Anger), but also of the modernity that continues to encroach (once a fishing village, Cefalù has become a "booming beachside town").

This multiple occlusion is again the deep subject of the other photo sequence, *The Kant Walks*. Kant lived in Königsberg, and at the end of his life the great philosopher of reason suffered from hallucinations; subsequently his hometown was also wracked by irrationalities: brutalized by the Nazis in the Kristallnacht of 1938 and bombed to rubble by the RAF in 1945, it was annexed by the Soviet Union and renamed Kalingrad (after a Stalin associate). In his photo sequence Koester seeks to evoke these intertwined histories through a tracing of the daily walks taken by Kant, yet here again the path was not easy to discover. "One has to place two maps on top of each other, that of Königsberg and that of Kalingrad, to find the locations today," Koester writes, and then his own route was further disrupted by old bombs, postwar constructions, and official amnesia. *The Kant Walks* suggests a *terrain vague* of different orders of social space in collision; especially telling is one photo of a Soviet cultural center constructed in the early 1970s on the site of an old castle. The castle tunnels made the new building unstable, so it was simply left, unoccupied, to deteriorate. Koester calls these symptomatic places "blind spots": "Detours, dead ends, overgrown

streets, a small castle lost in an industrial quarter, evoked history as a chaos, a dormant presence far more potential than tidy linear narratives used to explain past events."[6]

Even as modernization obliterates history, it can also produce "points of suspension" that expose its uneven development – or, perhaps better, its uneven devolution into so many ruins. Such are the "blind spots" that intrigue Koester. An oxymoron of sorts, the term suggests sites that, normally overlooked, might still provide insights; and, as Koester captures them, they are unsettled, an unusual mix of the banal and the uncanny, evocative of an everyday kind of historical unconscious (his image of the Kalingrad center is a good example). Walter Benjamin once remarked that Atget photographed his deserted Paris streets as if they were crime scenes, and Koester has a forensic gaze, too, though the crimes in his unpopulated images are the familiar ones of junk space, state suppression and general oblivion. He uses the indexical nature of the photograph to seize "the 'index' of things," both as they emerge in time and as they fall back into it. Such is his double interest in "how history materializes," and how it decays into enigmatic precipitates.[7] In *The Kant Walks* Koester evokes the Situationist practice of "psychogeography," but Robert Smithson is the more important reference for him (as for many other artists today). In some ways Koester travels to Kalingrad and elsewhere as Smithson ventured to Passaic, New Jersey – in search of inadvertent monuments in which "history or time [becomes] material." This allegorical attention to "the index of things" again recalls Benjamin as well as, perhaps, W.G. Sebald (a key figure for Dean); but in this allegorical mode, Benjamin tends to redemptive hope and Sebald to melancholic resignation, while Koester is relatively free of both. In this regard he is closer in spirit to Alexander Kluge, parts of whose *Die Lücke, die der Teufel lässt* was recently translated as *The Devil's Blind Spot*.[8] Kluge also works along the borders of documentary and fiction, and he, too, is drawn to blind spots in which the turns that history has taken, and might still take, are sometimes revealed to us.[9] For Kluge, these spots appear when the devil is napping, and so leave the door open, if not to the Messiah (as Benjamin hoped), at least to the possibility of change. This is how Koester intends his work to serve as well – as "a scene for potential narratives to unfold." But in Koester, as in Kluge, the blind spots remain the devil's, and so whatever change might befall us is not necessarily for the better.

6. Koester continues: "Nowhere in Europe are the traces after World War Two more visible than in Kalingrad. Hauntings from a war that shaped lives and destinies for generations to come. Including my own – like many, affected by the 'third generation syndrome,' I have always felt as if I was pulled towards an empty space: 'that which has not been said.'" It might seem that this kind of archival art is part of "the memory industry," but in fact it underscores the *difficulty* of such memory. Given its concern with histories in tension with official history, it has more affinities with new historicism – with which it might share a sometimes problematic attraction to anecdotal stories.

7. There is a connection here to the often banal photographs that appear in Surrealist novels; see: Denis Hollier, "Surrealist Precipitates," *October* No. 69, Summer 1994. "In novels like *Nadja*," Hollier writes, "indexical signs leave doors ajar through which the *demain joueur*, the gambling tomorrow, does or does not make its entry." (p. 126)

8. At one point Kluge has this internal dialogue that, with the necessary transpositions, might apply to Koester as well: "- And what do you mean by this metaphor? Why are you, a Germanist, acting as an historian?
- It shows the parallelism of events. As one epoch overlaps with another.
- Imperceptibly?
- Well, none of the contemporary witnesses noticed it."
See: Alexander Kluge, *The Devil's Blind Spot: Tales from the New Century* (trans. Martin Chalmers and Michael Hulse) (New York: New Directions, 2004), p. 132.

9. There is another rub here for this kind of archival art. "If you go to a show now you will have to adjust to the work each time," Koester remarks in his conversation with Anders Kreuger. "You need to find the manual for the show, and sometimes it does need a manual, and I don't see anything bad about that." The defensive tone at the end underscores the problem that Koester attempts to bracket here, a problem that Kreuger identifies as a gap between research and presentation, but that might also be understood in terms of an enigmatic sign or story that is simply too arbitrary or too involuted to become significant. Archival art is all about epistemological curiosity: Here is a story (or fragments thereof), it says; here is what it might tell us about our (in)abilities to see, represent, narrate, understand. But often the effect is rather an epistemological dilemma: Do I (the viewer) want to enter this archival story, and work on its puzzle? Must I? The prospect can be intriguing, but it can also be off-putting, for "nothing in the world," Koester acknowledges, "is more boring than participating in a game when you don't know the rules." At least he is aware of the problem and sometimes almost thematizes it ("the narrative is embedded or enmeshed in all those blots," he writes in *Message from Andrée*). "I am looking for an audience," Koester tells Kreuger. "An audience that I don't necessarily have." (I am indebted to Mignon Nixon for her insight into this dilemma.)

JEROEN BOOMGAARD TALK TO THE HAND

ON THE ART OF LISTENING IN A TIME OF TALKING

. The expression and the and sign originated in frican-American youth ulture in the 1990s. It ecame popular through its equent use on shows like *erry Springer*, *Jenny Jones* and *icki Lake*.

. I refer here to: Rutger Volfson (ed.), *Nieuwe symbolen oor Nederland* (Amsterdam: aliz, 2005). See for a ritical review of this amphlet: Lex ter Braak, The New Freemasonry," a: "(In)tolerance: Freedom f Expression in Art and `ulture," *Open*, No. 10, 2006, *p. 130–140.

. The raised fist, the white peace dove, even he Socialist red rose all eem to be out of date.

One of the most powerful images of class solidarity and resistance is the image of a hand raised as a stop sign by John Heartfield, designed as a poster for the German Communist Party in 1928. The image is powerful because it so strongly symbolizes the voice of the working classes demanding to be heard. The image returned in the 1980s in a French campaign against racism. Here the hand was raised over a caption reading: "Touche pas à mon pôte" (hands off my friend). In general, the image signifies the demarcation of a terrain by a group seeking to take control against hostile forces. Today, however, the same image carries a completely different meaning, and anyone wanting to use it in the more traditional sense is in for a surprise. Especially for a younger generation, "the raised hand" now stands for a refusal to listen, not from the perspective of a group but from a strictly individual point of view. "Talk to the hand, because the ear's not listening" is the caption common to the sign now.[1]

If one wants to rekindle art's potential as symbolic language or political statement, knowledge of the volatile character of such signs is a prerequisite.[2] But it is very much the question whether art can currently play a role like that at all. Unambiguous symbols are not in demand, and are even regarded with mistrust.[3] The so-called "white marches," which all over Europe have become the almost standard response to acts of violence, tend to avoid any form of symbol, with the obvious exception of the color white. In this way, they keep their distance from all political affiliations, at the same

time using a symbol that is so prevalent as to be devoid of meaning, an empty screen for the projection of strong emotions.

The reversal in meaning undergone by the symbol of the raised hand brings me to yet another aspect of the role art can (or could) play in society. One of the more dominant tendencies in the public art of the last ten to fifteen years has been to involve members of the community in process-based works that often harbor a social intention. These works, which aim for "intersubjective relations instead of detached opticality" (as Claire Bishop has put it), fit into the field of relational aesthetics.[4] They share a focus on the experience of time rather than space, on service instead of distance, and they go in search of a public rather than waiting for one. The positive result of these kinds of works may well be that they provide affirmative symbolic signs: although the communal action they provoke or stimulate does not lead to actual change, through their performative nature they at least demonstrate that change is possible. There is, however, a downside to this type of work: its emphasis on the public, on participation and service is part of a general tendency that pushes art to function along the lines of a more explicit economic model. This demand for utility not only brings with it the danger that any form of art that has no clear purpose will no longer receive support, but also that art may lose its ability to widen the field of expectations by offering something that is *not* in demand.[5] The service model also raises the question of who benefits from the service the artwork provides. At first sight, the people involved – the group the work targets – seem the most obvious beneficiaries. The bodies that commission the work, however, must get something from it as well, otherwise they would not spend money on it. One of the reasons for commissioning the work is, of course, that it may succeed in creating social cohesion in a location where social fragmentation is seen as a considerable problem. The reasoning may even be that the artwork might succeed where all other means have failed. And, if should both the social process *and* the artwork fail, there is still is a work of art that sheds a positive light on the commissioners' cultural ambitions. But the work may also be asked to function in the line of an even more complex agenda. To understand what this means, it is necessary to make a short digression into the current situation in the Netherlands today.

The last ten years have witnessed a gradual transformation from a consensus-based society to a neo-liberal system. This has resulted in a hybrid form in which the old consensual model is combined with free-market strategies. The result is a society in which every

4. Claire Bishop, "Antagonism and Relational Aesthetics," *October*, No. 110 Fall 2004, pp. 51–79.

5. Jeroen Boomgaard, "Radical Autonomy: Art in the Era of Process Management," in: "(In)tolerance: Freedom of Expression in Art and Culture," op. cit., pp. 30–38.

decision is endlessly debated by all parties involved, while the outcome of all this deliberation is no longer guided by a government policy on the development of the common good but rather by a conflict of interest that can only be resolved by choosing the most rational, instrumental or power-driven solution. Because any interest involved is regarded as a private interest, consultation becomes negotiation.[6] And in this negotiation the power of money usually gets its way, simply because it has the largest interest at stake. The outcome of all the talking is not the best solution, but the solution that is best for at least one of the parties involved. Complaining about this is futile, because officially everyone has been heard, although in fact no one has actually been listening.

It may be clear that this neo-liberal-consensus-hybrid is not a very seductive model for participation. Non-participation, however, is not possible, as it would take away the legitimization of the ruling political classes. In a curious reversal, a silent majority is no longer regarded as a confirmation of policy. Today to be silent is to be devious, to be a possible threat. Community-based artworks are a great way of keeping the talk going. The observation that in many interactive projects in art and architecture "talking" is actually a goal in itself hits the nail right on the head.[7] Prior to any other objective, providing a feeling of participation is the main thing at stake. Artworks lend themselves too easily to this agenda, without realizing that they are confirming the system instead of changing it. Playful, perhaps even a little subversive, they keep the consensus machine running.

At the same time, talking without listening has become the pervasive model for our society. "Talk to the hand" is now the standard attitude towards someone voicing an opinion that differs from your own. Because no one listens to you, you don't have to listen to anyone either. Opinion is no longer a matter of debate but something you are entitled to as a fundamental part of your identity. As a consequence, cultural differences run like fast-growing cracks through society. Fortunately, two generally accepted, albeit mutually exclusive strategies to counter this problem are available: either cultural differences are officially erased by forcing adaptation to the reigning culture – although it usually becomes clear that no one has a clue what that might be – or cultural conflict is avoided by giving each subculture its own schools, churches, networks, etc. Moreover, this form of avoidance has little or no effect on the conflict in the public sphere. Community-based artworks seem to function as a third way: they respect cultural differences, but by tying people

6. This implies the transformation of a system of social trust into one of permanent distrust. See: Dorien Pessers, "Vertrouwen van burger is verkwanseld, want de vorm wordt belangrijker dan de norm," *NRC Handelsblad*, September 23, 2006, p. 15.

7. Roemer van Toorn, "Aesthetics as Form of Politics," in: "(In)tolerance: Freedom of Expression in Art and Culture," op. cit., p. 44.

together in a communal project they try to iron out the wrinkles. But this cosmetic solution will never hold, because consensus is still the dominant model of thought.

At the risk of vulgarizing a complex theory, it might be interesting to look at some remarks the political scientist Chantal Mouffe has made on the topic of antagonism and the possibility of an agonistic approach and a heterogeneous public space. In an agonistic model, antagonistic parties recognize each other's legitimacy while simultaneously acknowledging that there is no rational solution to their conflict. As a consequence, public space, according to Mouffe, should not be viewed as the place where consensus is reached, but rather as a battleground for hegemony. A democratic way of living can only result when public space is regarded as heterogeneous, a space split up along dividing lines that are not always clear and are even permanently shifting.[8] Such a model opens the possibility for a different role for art in the public sphere, a role that by attaching more importance to autonomy might even seem a little old-fashioned. Instead of artworks that involve people in talking, which try to avoid conflict and that essentially provide what is expected from them, the agonistic approach could be said to call for works that do not comply but which instead introduce an element of antagonism by making public space more heterogeneous. What I mean is an art that does not function as a lubricant for society but rather as a moment of friction and misunderstanding. This does not imply a return of work that is completely unrelated to its time and place. It does mean, however, that the work speaks in its own voice, because by not being direct and clear it can represent a new, *agonistic* public interest. If Mouffe's approach is possible, it can only function when consensus is replaced by dissensus, when talking is replaced by listening, because to really disagree with someone you have to listen very, very carefully. The strange and incomprehensible babble of art could be the new training ground for a heterogeneous public sphere in which listening has once again become a way of living.

8. Chantal Mouffe, "Some Reflections on a Agonistic Approach to the Public," in: Bruno Latour and Peter Weibl (eds.), *Making Things Public: Atmospheres of Democracy* (Karlsruhe: ZKM, 2005), pp. 804–810.

DOCU
JMEN
NTARY
STRA

4. DOCUMENTARY STRATEGIES. It is not just global news but also detailed background information that comes to us through a daily stream of images, through television pictures, photographs in newspapers and magazines, and film documentaries. A photographic record lays claim to a particular degree of objectivity: it is, after all, an image that is captured in a neutral manner by means of a purely technical process. In art, too, photographic media have often been used recently to inform observers about abuses in society and other "real-life" subjects. In his contribution, *Vít Havránek* shows how in the last fifteen years artists with cameras in their hands have revealed considerable neglect in society. But how objective is this documentary evidence in fact? In their essays, *Kitty Zijlmans* and *Sophie Berrebi* investigate the relationship between documentary evidence and image manipulation in art. These "dialectic documents" play a game with the documentary onus of truth and show how close fact can be to fiction.

VÍT HAVRÁNEK
THE DOCUMENTARY METHOD
VERSUS THE ONTOLOGY OF "DOCUMENTARISM"

Since all I have to show of the initial text of my lecture is shredded paper and a ruined hard drive, the present text will try to be a reconstruction of its spirit and some of its arguments rather than a replica of my original words on the theme of "Documentary Evidence."

The aim of the text was to shed light on the connections between the "documentary" approach and its moral dimension, or rather: to conceive this dynamic relationship as an "ontology" of the documentary approach. I would like to start off by anchoring these observations in my own experience of the political and economic transformation my environment has recently undergone. During the 1990s, the inhabitants of Eastern European countries in transition, like the Czech Republic, witnessed an unprecedented domination of the public arena by economics. This transformation differed from those in other fields, not only in that it was a kind of invasion with which we had no previous experience, but also because it was a sudden foray. The economic instrumentalization of the public sphere, inaugurated in 1989 with the fall of the Berlin Wall, suddenly opened up a broad area that had no established forms of regulation or defense mechanisms. Along with the domination of the public sphere, a new ethic began forming people's work habits

and shaping their attitudes towards labor. These changes, which obeyed the rules of a new managerial "philosophy" – its system of values, quality assessments and methods – touched everyone, exercising an influence on them outside the work context as well (within the family microclimate as well as on the meaning and values of life).

In these transitional economies, new "philosophies" and values began to develop locally, mostly on the basis of new experiences with employment and unemployment. For the most part, their character has been, and still is, defined by a neo-liberal (more precisely: managerial) code of working behavior. Everyday life and activities were more and more markedly conditioned by a desire for profit. In this new economic environment, methods of profit-making became the primary means of giving value and significance to life.

"Documentarism" in Contemporary Art

In the fields of photography and film, to which the documentary approach is traditionally linked, one can readily find definitions of the various documentary genres. Yet within the complex of these genres it is rather difficult to find a critical definition of what I would call "documentarism," although a notion of the discernable grammar of the documentary language runs through the debate. "Documentarism" in film and photography could be described as a genre in which the director/artist transmits other people's knowledge, stances and experiences by articulating the medium and technology he or she uses. The decision to devote oneself to the documentary format entails accepting the condition that one's creativity is to be defined in direct connection with the socio-historical issues that are being documented; the relationship between the "documenter" (the person who is documenting) and the "documented" is what permits us to refer to a work as documentary. Thus, the decision to work in the documentary style places the *not-I*, that is to say other people, creators, works, social phenomena and so on, at the centre of the creative subject's thought and activities. In this practice, all metaphysical horizons and aesthetic operations arise out of the reality of a socio-historical matrix.

In the documentary visual arts, aesthetic decisions and creative operations in specific media have a socio-political dimension, and vice versa. In documentary it is impossible to consider form and aesthetics in isolation from the theme, and the relationship between them is defined in terms of ethical categories.

This interrelatedness compels artists to develop an ethic of formal

approaches in their work. Documentary works define an ethic of forms (such as "impersonal TV documenter," "activist documenter," "artistic documenter," etc.). Here I am not positing the subordination of aesthetics to ethics; I am interested instead in examining the connections between the two, and in understanding how ethical views may be implemented within a specific aesthetic and vice versa: how visual art attributes ethical values to particular forms.

In her essay "The Articulation of Protest" (2002), the German artist and media theorist Hito Steyerl compares two films about political-protest movements, shot in two different ways.[1] Steyerl concludes that the political message is contained in the actors' utterances but is articulated first and foremost in the very structure of the film. The grammar of the medium employed by the film director, and the degree of experimentation used, modify the political effectiveness of the testimony provided. The *écriture* with which the journalist treats the political dimension is analogous. The ethical responsibility bound up with the documentary approach also generates a retrospective application of ethical criteria when examining the history of the visual disciplines.

Hito Steyerl, "The ticulation of Protest," *ster* (Donostia-San bastian: Fundación dríguez, Arteleku, 02), pp. 34–41.

Ethics

We need to ask ourselves to what extent we can speak of an "ethical dimension to the artistic approach." Properly addressing this question would require a lengthy discussion, but it is evident that artists who use documentary methods either pose it directly or encompass it unwittingly in their writings and some of their works – as conservative and even hazardous this might seem at first glance. There is always a sense of danger associated with this question, derived from our experience with systems that use their power to place ethical requirements on art; there is a similar sense of danger in the fact that there is always the possibility of the inner workings of the art world laying down such a question as a criterion for assessment. Therefore, it should be clearly stated that "documentarism" is not based on the premise of art in general possessing an ethical dimension, but rather on the notion that "documentarism" adds an ethical dimension to the domain of art from the outside – from what might be called the idea of "pure documentarism" in photography or film. Such an idea has been present in photography ever since its discovery: its quality of "total mimesis," which could be less pathetically called "pure documentarism."

If we return to the concept of the documentary approach as a dialectical relationship between the artist, the themes documented and the way these are articulated in various media, the question can be seen to have two aspects.

The first entails tracking the relationship between the author and the documented subject. The contemporary documentary approach in the visual arts has buried once and for all the myth of the "disinterested" or "objective observer," a cliché ceaselessly trumpeted by the mass media. Thanks to their encounters with television, radio and the daily newspapers, as well as to their strong theoretical background (from media theory to media sociology), artists nowadays have no trouble defining their position as "engaged." In essence, this term simply labels an approach in which the observer's position is established as a conscious process.

The second aspect gives rise to the following consideration: if we define the position of the documentary director/artist as "not objective," the subjective assessment and graduated relationship the documenter enters into (is it a contract?) with the documented, along with the distance he or she takes with respect to his or her own medium (and not only film, video and photography, but also drawing), reveals itself as a key process. What distinguishes "documentarism" – and what interests us in it over and against the mainstream conception of the documentary approach – is the solidarity of the artist with the tradition of media critique that perceives the medium as a complex of power-political instruments. This tradition is manifested in the discourses of Walter Benjamin, Guy Debord, the Situationists, Jean-Luc Godard, Pierre Bourdieu, Vilém Flusser, Peter Sloterdijk and many other artists and intellectuals. It follows from this observation that it is the inseparable relationship between the documented and the active implementation of critical media studies (described by Hito Steyerl in the text cited above) that establishes the quality of *artistic* "documentarism."

Ontology

I have chosen the term "ontology" to label this relationship because of one of the leading forms of skepticism of recent times: what might be referred to as a mistrust of instrumental conceptualism. Post-structuralism reconsidered the relationship between systems of consciousness and systems of power. However, post-structuralist contributions to the ongoing theoretical discourse have themselves become institutionalized and dehumanized. If contemporary theory and art want to take them up again, they must do so based

Concerning the term
"biohistory": Foucault used
the term "biopolitics" to
note all political processes
that interfere with the
integrity (with regard to
health, hygiene, race, etc.)
of the individual body. To
use his terminology, the
need to posit biohistory as
an alternative to academic
political visions of
history has made itself felt
for some time now in all
spheres of contemporary
art. Biohistory entails the
search for testimonies
about the individual and
the traces behind the individual
leaves behind relating to
events that have taken place
within the artist's most
intimate sphere through
the questioning of his or
her family and friends.
Biohistory involves art in
an interface, which forms a
bridge between subjectively
experienced stories and the
great narratives of academic
history. Biohistory, like
Agamben's "form-of-life,"
spans the abyss between
the lives of individuals
and knowledge systems.
Biohistory somewhat
unexpectedly recasts the
significance of the family
in today's world, using it
as a basic ethnographic
construction by means of
which it reconstructs, or
deconstructs, the system of
knowledge about history;
see: Jan Mancuska, Absent
(Zurich: JRP Ringier, 2006).

on new and fresh considerations. Instrumental conceptualism is
currently undergoing scrutiny by means of subjectification and the
application of conceptual practices to the testimony and experienc-
es of the individual – though this is not a "universal" individual but
rather wholly concrete, singular persons (such as friends, mothers,
fathers, grandmothers, great-grandmothers and their destinies as
projected onto the coordinates of history).[2] The validity of the con-
ceptual is born from the experiences of individuals, on which the
success of any social, political or cultural concept rests. This is why
the documentary approach that interests us must be grounded in
the relationship between the artist and the subject, which is per-
ceived as a bearing, enduring and gauging of the political and so-
cial matrixes to which it is connected, or to which it connects itself.
Intervista (1998), a film by Anri Sala, was to a certain extent a mani-
festation of the tendency to anchor an individual testimony to a
series of historical events and political issues, embedded in a purely
subjective relationship to the person closest to the artist – in this
case, Sala's mother. Sala determined the operation of the personifi-
cation of history in a personal, close, irreplaceable experience that
is nonetheless communicable.

I here use the term ontology somewhat metaphorically – analytic
philosophy defines ontology as the "basis of the conceptual." I un-
derstand ontology to be a dynamic endeavor to find and actively
exploit the elements of instrumental conceptuality. This text's hy-
pothesis consists in showing that if the documentary approach has
no dialectical ties to the documented and to media criticism it is a
method which is as equally mainstream as instrumental conceptu-
ality in the art business or the advertising industry.

KITTY ZIJLMANS
DOCUMENTARY EVIDENCE
AND/IN ARTISTIC PRACTICES

Introduction

VPRO Gids,
August 22, 2006.

The film *Sex Traffic* (director David Yates, 2004) is a film about the sex trade, a contemporary form of the slave trade. Two Moldavian sisters, Elena and Vara Visinescu, assuming they are going to work in London where they believe they were promised a proper job, are instead sold to a bunch of ruthless pimps in Sarajevo. Here, a life of abuse and prostitution awaits them. As the commentary in the VPRO television magazine stated, one can read about the slave trade in (mostly) women who are tempted to come or who are kidnapped from Eastern Europe; one can read about the beatings, the fear, the hellish life of these women; and one can take in the numbers, the sheer quantity of people involved in the sex trade: each year approximately half a million women suffer this dire fate, and billions of Euros keep this illegal industry running.[1] What makes this film so powerful is not just that it is an exciting thriller but also that it is filmed in a style we associate with the documentary. The segments depicting the actual inspecting and selling of the girls are filmed in such a way that they resemble a "real" documentary. The result was that the film looked like "real life" in all its rawness and desolation.

One of the questions raised by the topic "documentary evidence" is the alleged "objectivity" of the daily stream of photographic information we receive, mediated by television images, photographic reproductions in newspapers and magazines, or film and video documentaries. Notwithstanding the fact that a photographic image is "captured" by means of a mechanical device of apparently neutral character, one can doubt its assumed naturalism and objectivity.

Both terms, "documentary" and "evidence," have a claim to truth, a claim to honesty, objectivity and veracity – "evidence" even more so because of its opposition to information provided by witnesses. But whichever way we look at it, "documentary" material is always first seen, selected and appropriated by someone else. Many artists are concerned with the relationship and the blurring of boundaries between "documentary evidence" and "image manipulation," between factual reports and imaginative recreations. In this essay I would like to discuss a number of artworks and art projects that play with these intervening strategies. The ideas of cultural critic Boris Groys regarding the contemporary art world's shift of interest from the artwork towards art documentation as a living activity may perhaps prove useful for a better understanding of the ambiguity of documentary film and photography as artistic strategies.

Documentary Evidence

The term "documentary" or "documentary film" is used to define a particular type of motion picture that shapes and interprets factual material for purposes of education or entertainment. A documentary does not show mere raw footage, it is a work that is *filmed*, cut and composed. It is the result of observation and a dual process of selection: first in the "real world out there," and second on the editing table (nowadays often on the computer). There is a tension between this intervention and the aforementioned double claim to truth, which results from the use of a mechanical device and the adjective "documentary" for both documentary film and documentary photography. The subjects, events and situations were not only "out there," but were also *seen* by a particular person – the filmmaker or cameraman. What the viewer takes as reality is in fact a reality seen by someone else; it is a second order observation. The Vietnamese author and filmmaker Trinh T. Minh-ha regards the discrepancy between the objectivity of a given situation and the subjectivity of the documentary filmmaker – or editor as a strategy: "Asserting its independence from the studio and the star system, documentary has its *raison d'être* in a strategic distinction. It puts the social function of film *on the market*. It takes real people and real problems from the real world and *deals with them*. It *sets a value* – on intimate observation and *assesses its worth* – according to how well it succeeds in capturing reality on the run 'without material interference, without intermediary.' Powerful living stories, infinite authentic situations. There are no retakes. The stage is no more and no less than life itself."[2] The documentary *Misère au Borinage* (1933)

2. Trinh T. Minh-ha, "Documentary Is/Not a Name," *October*, No. 55, 1990, p. 79, quoted from: Vivian Rehberg, "The Documentary Impulse," *Jong Holland*, Vol. 21, No. 4, 2005, pp. 10-14, here p. 12.

by the Dutch director Joris Ivens is a clear example of how real and staged life can become interchangeable. While filming the hardship and poverty of the coalminers in the Belgian Borinage in the early 1930s, the re-enacted demonstration by the miners carrying a painted portrait of Karl Marx grew into a real demonstration, involving not only local people but the police as well. The demonstration was taken to be a real one, immediately supported by villagers declaring their solidarity. Shots of this demonstration were used in the final film.[3]

In his essay "Art in the Age of Biopolitics. From Artwork to Art Documentation" Boris Groys unfolds an interesting theory about the role documentation plays in today's art world.[4] His ideas regarding the relationship between documents and documentation, art and biopolitics are complex and not always easy to follow. However, his basic assumption that practices of art documentation develop strategies for making something living and original from something artificial and reproduced also challenges the practice of documentary: does the same apply to documentary photography and film? Groys understands art documentation as a form of life, a duration, a production of history. Elaborating upon Walter Benjamin's concept of aura and copy, he views the distinction between original and reproduction as a merely topological and situational one. All the documents placed in an installation become originals and can, hence, be considered original documents of the life they seek to document. According to Groys, the distinction between the living and the artificial is exclusively a matter of narrative difference. Art documentation is thus "the art of making living things out of artificial ones, a living activity out of technical practice"[5] – for this reason his reference to biopolitics. To complicate matters even further, the context of the viewing/seeing is also a crucial aspect that needs to be considered.

At *Documenta 11* in Kassel in 2002 most people took the film *Nunavut, Our Land* (1994/95) to be a real-life documentary of Igloolik family life – some even wondered what an ethnographic document was doing in an art exhibition; it turned out, however, to be a series of thirteen half-hour episodes of an Inuit soap opera set in 1945.[6] Apart from being as much a documentary as it is fiction, the film is also a statement. In 1999, the Canadian Arctic territory became the world's largest First Nations self-governing jurisdiction, called Nunavut (= Our Land). In the hopes of preserving Inuit culture, some communities, such as the Igloolik, have battled the hegemony of US and Canadian English on television, stressing the

, Joris Ivens, *Autobiografie van en filmer* (Amsterdam/Assen: 1970), elaborated translation f: Joris Ivens, *The Camera nd I* (Berlin: 1969). See also: Kees Bakker (ed.), *Joris Ivens nd the Documentary Context* Amsterdam: Amsterdam University Press, 1999).

, Bois Groys, "Art in the Age f Biopolitics: From Artwork o Art Documentation," *Documenta 11_Platform 5. Catalogue* (Ostfildern-Ruit: Hatje-Cantz Verlag, 2002), p. 108–114.

, Ibid., p. 110.

, Igloolik Isuma Productions, *Nunavut, Our Land*, 1995. Filmmaker: Zacharias Kanuk. See also: *Documenta 11_Platform Catalogue*, op. cit., pp. 354–355; and *Documenta 11_ Platform 5: Kurzführer/Short Guide* (Ostfildern-Ruit: Hatje-Cantz Verlag, 2002), pp. 118–119.

importance of local language (Inuktitut) broadcasting. Inuit culture is largely based on oral traditions and there are many narratives of the Inuit past. As a result of modernization "the old ways" are disappearing; the only way to safeguard the past is through documentation. In the case of the film *Nunavut, Our Land* fiction is presented as "faction," as if these things had actually happened in the past. The film is a mixture of facts, fiction, performance and improvisation, which aims to maintain traditional Inuit culture.[7] The film may well show a younger generation how things were done traditionally, but it also represents precisely what the non-Inuit audience takes to be genuine Inuit life. By showing this soap series as a documentary the image of a pure and untainted culture is sustained. The context of the *Documenta* exhibition, however, disrupted this reading: a number of monitors presenting episodes from the series simultaneously enabled us to walk from one episode to another, picking up fragments of "Inuit life," constructing, so to speak, our "own" image. Here, I think, Groys' notion of biopolitics can be applied. Within the space of the art exhibition, the documentation of Inuit life in the form of a soap opera designated precisely the unsteady balance between life as fact and life as a narrative. It presented life as an activity, by means of layering facts, stories, memories and histories. The strategies employed by Zacharias Kanuk, the maker of *Nunavut*, refer to the lifespan itself, or as Groys puts it: "the shaping of life as a pure activity that occurs in time." Life can be documented but not shown; as Groys remarks: "Life in a concentration camp can be reported – it can be documented – but it cannot be presented for view."[8]

Groys' observation concerns the impossibility of actually *showing* "what has really happened" in "real life," let alone in war zones, massacres, ethnocides. In the film and photo work *Out of Blue* (2002), Zarina Bhimji takes us to the breathtaking landscape of Uganda, but at the same time confronts us with the numerous places of elimination, extermination and erasure of the (history of) black Ugandans slaughtered by the armed forces of Idi Amin. Furthermore, many Asian (like Bhimji's family) and African residents were expelled from Uganda in 1972. Returning to the country after almost thirty years brought her face to face with the impossibility of coming to terms with "what had happened"; she returned to the landscape of the Uganda of her childhood, its architecture and airports, but also its graveyards, military barracks, police cells and the prisons of Idi Amin's reign of terror. Bhimji: "I have chosen to give historical facts as a background to my photographs and my

7. American filmmaker Robert Flaherty's film *Nanook of the North* (1921) has had a great influence in shaping the Western view of "Eskimo" life. The critique from later Inuit communities, as well as from critical theory, is that it was filmed from a Western ethnographic perspective and within Western narrative conventions; similarly, it represents the Inuit community as some kind of timeless, noble race that exists in isolation from outside influences. *Nunavut, Our Land* plays with references to this film. To some extent it also uses the same strategies, evoking memories to a past history that exists mainly in narratives, and seeking to preserve "the old ways" and challenge (dominant) cliché images.

8. Groys, op. cit., p. 110.

first film because for me, at present, in this work, history serves the present. What is not recorded does not exist."[9] What Bhimji has recorded, however, is not a narrative of Uganda's recent history, but a fragmented Uganda made up of past and present facts and memories. The work presents a labyrinth of displacement, yet it has the impact of a "living experience". The film is impressive to say the least. It overwhelms the viewer not only because of its visual quality; what makes it so deeply moving and at the same time disturbing is the intense soundtrack that accompanies it. The audio reveals what cannot be shown, the birdsong disturbed by threats and echoes of a great horror. The work is an attempt to recollect past history and experience, to make it true, truly "happened." ("If not recorded, it does not exist.") The historical facts of Idi Amin's cruel regime are not specifically visible in the landscape, but they are all the more present nonetheless. The history of the recent past is reported via shots of the landscape alternated with buildings, places where we can only infer the horrible things that must have happened there. There are no people in the film, just places and sounds. The Dutch artist Armando has referred to such places as "guilty landscapes," since they have witnessed atrocities but do not show them. This discrepancy also dominates in Bhimji's film: although it cannot show "what has happened" it still can document it, and hence make it live again.

Archives

Documentation and the archive are mutually related. Archives consist of documents; they are places where public records or historical documents are preserved. An archive is a repository or collection of information. While from the nineteenth century onward the archive was regarded as a paragon of objectivity, today its positivist claim and alleged neutrality are under attack. An archive represents a selection; its documents are assembled, sorted out and categorized, and these systems of organization, with their underlying principles and hierarchies of structuring and arrangement, are hardly neutral. The elements of any documentation or archive have first been decontextualized and then re-grouped. Such ordering systems are inclusive as well as exclusive: what has been selected, by whom, and to what purpose? In this respect, archives are also exercises of power. Similar to the play with documentary strategies, the concept of "archive" has found foothold in contemporary art.[10] An example, again seen at *Documenta 11* (rarely before had the exhibition so lived up to its name as in 2002), is The Atlas Group's *Hostages*



. Bhimji in: *Documenta _Platform 5. Catalogue*, op. it., p. 552. Zarina Bhimji was born in 1963 in Uganda o a family of Indian mmigrants, and has lived n England since 1974. See lso: *Documenta 11_Platform 5: urzführer/Short Guide*, op. cit., p. 34-35.

. See also: Boris Groys, *Unter Verdacht: Eine hänomenologie der Medien* Munich: Hanser Verlag, ooo). Here, Groys sets an archived reality" against he "truly existing reality." Groys: "Die Archive, ie Museen sind die ergleichsräume, in denen ine andere Neutralität, ine andere Homogenität errschen – eine Neutralität nd eine Homogenität der Unsterblichkeit. In Archiven verden Dinge gesammelt, u denen man sich bekennt, on denen man meint: Diese Dinge sollen nicht vergehen, ie sollen dauern, sie ollen vor dem Tod gerettet verden, sie dürfen das chicksal aller Dinge nicht eilen. Dadurch entsteht rst die Möglichkeit, iese Dinge miteinander u vergleichen, denn ergängliche Dinge kann nan nicht miteinander vergleichen. Wichtig ist llein die Entscheidung die auch eine durchaus ersönliche Entscheidung ein kann – zugunsten der Unsterblichkeit bestimmter Dinge, Gefühle, Attitüden. Eine solche Entscheidung ffnet zuallererst den Horizont dessen, was vir Kultur nennen."



series. In 1999, the Lebanese artist Walid Ra'ad founded The Atlas Group, an imaginary foundation for the research and documentation of the contemporary history of Lebanon. The Atlas Group's documents are organized and preserved in *The Atlas Group Archive*, containing "found," commissioned and self-produced files. Ra'ad presents The Atlas Group mainly through lectures, films, photography exhibitions and documents from the group's archives, but also as installations in museums.[11] This fictional archive criticizes both the feigned objectivity of historical discourse and the supposed autonomy of artistic creation. For The Atlas Group, the truth of the archived documents does not depend on their factual accuracy. It is "not concerned with facts if facts are considered to be self-evident objects always-already present in the world. [...] Facts have to be treated as processes. How do we approach facts not in their crude facticity but through the complicated mediations by which facts acquire their immediacy? [...] We are not saying that the assembling of facts, data and information about the experiences, situations and objects of 'The Lebanese Civil War' is not essential. But we are saying that a history of 'The Lebanese Civil War' cannot be reduced to the totality of these self-evident facts."[12]

In *Hostage: The Bachar Tapes* (18 min., 2000) the "Western hostage crisis" is examined through the video testimony of Souheil Bachar, one of the files from *The Atlas Group Archive*. In the 1980s and 90s, the world tensely watched the kidnapping and imprisonment of Western men by Islamic militants in Lebanon. In collaboration with The Atlas Group, Souheil Bachar recorded a fictional testimony as the only Arab hostage at the time of the crisis. His imprisonment lasted ten years. For three months he was imprisoned together with five American men, who *were* kidnapped in this period. In two of the total of fifty-three tapes Souheil Bachar recalls the cultural and sexual aspects of his imprisonment. Tapes #17 and #31 are the only tapes approved for showing outside of Lebanon.[13] Bachar has been inscribed into the real drama that was then going on: he is shown with the five American men standing in front of a newspaper sporting the headline "Reagan Tries to Silence Reports of Iran Arms Deal," and much more. There is no way of telling that a sixth person has been inserted into the factual event of the hostage-taking. The viewer watches a film that might just as well have been an entirely true recording of these events. One never knows for sure, particularly when the fragments are shown as part of a television news broadcast. Yet the fact that we are looking at them in an art venue may incite doubt and curiosity about what is actually going on.

11. Walid Ra'ad/The Atlas Group. See: *Documenta 11_ Platform 5. Catalogue*, op. cit. 180-183; see also: *Documenta 11_Platform. Kurzführer/Short Guide*, op. cit., pp. 26–27.

12. The Atlas Group/Walid Ra'ad, in: Frits Gierstberg, et al (eds.), *Documentary Now! Contemporary Strategies in Photography, Film and the Visual Arts* (Rotterdam: NAi Publishers, 2005), pp. 121–122.

13. See: *Documenta 11_Platform 5. Catalogue*, op. cit., p. 181.

Walid Ra'ad's films interrogate the documentary genre and how information is handled. No distinct point of view is taken, nor is there a coherent critique or a declaration of any sort, except perhaps that information and documentation are never neutral, objective givens but rather narratives based on a selection and re-grouping of data and presented with an aim, a direction.

I would like to finish with a description of an art practice in which the recovery of archives serves yet another purpose: the retrieval and preservation of history and memory. The aim of the Iranian photographer and researcher Parisa Damandan is to save and conserve a large number of Iranian photo archives, ranging from early photographs of mainly women (unexpectedly posing boldly and unveiled) to middle-class life in Isfahan in the period 1920–1950, and from portraits of Polish refugees (more than 300,000 ended up in Iran during the Second World War) to the collections of negatives belonging to photo studios that were destroyed in the devastating earthquake in the city of Bam on 26 December 2003. Learning the news of the disaster, Damandan set herself the task of trying to save at least part of Bam's valuable cultural heritage: its photographic history. While literally digging in the ruins, Damandan recalls, "a woman came to me, while I was digging alone. She asked me if I could help her to try and find several strips with negatives. She explained that her two sons had been killed by falling rubble. Ironically, one of them had married the day before the earthquake. She hoped I could help her find the negatives of the wedding ceremony, which he had rushed to get to the shop – the one I was digging out – just before closing time."[14] It was the only thing left to her. As mentioned before, the "Bam Photographic Rescue Project" is not an isolated case. It is part of a larger program to retrieve collections of photographic negatives (both glass and celluloid) representing an Iranian history in which no one else seems to be interested, including the government.[15]

These collections represent fragments of the Iranian past and present; they preserve parts of a little known and seemingly forgotten past, for example portrait photographs showing a modern Iran before the Islamic Republic, but also personal and historic photographs of the city of Bam. All these are documentary evidence, but they are reinstated by means of an artistic practice. These random collections also represent another strand of documentary evidence: the act of recovery and safe keeping. These archives and documentations certainly work in art spaces; they provide strategies for making something living from something artificial and reproduced.

14. Parisa Damandan was born in Isfahan, Iran in 1967. See for a report on Bam: www.aidanederland.nl/bam.

15. According to Damandan, there is no governmental department that takes any interest in this cultural heritage, nor are there any other organized efforts for conserving, studying and exhibiting it. Over the space of more than a decade Damandan has collected over 20,000 glass plates, all labeled with well-known brand names like Kodak, Agfa-Gevaert, and in the classic formats of 4 x 6 cm. up to 18 x 24 cm. They depict a great variety of social groups and professionsas well as many unveiled women. Recently, FOAM, a photography museum in Amsterdam, presented the exhibition *Portrait Photographs from Isfahan 1920–1950*, in collaboration with the Prince Claus Fund. For further information see: www.princeclausfund.org/nl/what_we_do/publications/PrinsClausFondsPortrait PhotographsfromIsfahan 1920-1950inFoam Amsterdam.shtml.

SOPHIE BERREBI
DOCUMENTARY
AND THE DIALECTICAL DOCUMENT IN CONTEMPORARY ART

Introduction

, "Art-ethical processing
lants churning out
ptions and potentials for
hipping in, action and
nvolvement in the world,"
n: Sarat Maharaj, "Xeno-
pistemics: Makeshift Kit
or Sounding Visual Art
s Knowledge Production
nd the Retinal Regimes,"
n: *Documenta 11_Platform 5:
atalogue* (Ostfildern-Ruit:
latje-Cantz Verlag, 2002).

. Massimiliano Gioni,
This Wild Darkness,"
Manifesta 5 (Barcelona:
ctar, 2004, p. 29).

A recurring phenomenon in recent years has been the introduction into contemporary art exhibitions of documentary films and photographs made not only by artists, but also by people known primarily as photographers and filmmakers. This phenomenon, seen in a number of large-scale international exhibitions and smaller thematic shows, seems to bear witness to an urge to "show things as they are," to present documents conceived as indexes of the real in preference to self-referential, autonomous works of art. In the context of *Documenta 11*, one of the curators, the art theorist Sarat Maharaj, spoke of works of art as "epistemological engines,"[1] while Masssimiliano Gioni, one of the two curators of *Manifesta 5*, which took place in Donostia – San Sebastian in 2004, evoked "Filmmakers and artists who aim at posing questions, at responding in an oblique way to large world issues in politics and culture."[2] In London and Cologne the exhibition *Cruel and Tender* (Tate Modern and Ludwig Museum, 2003) presented a survey of art and documentary photography under the sign of empathy and emotions that suggested photography was simply a window open onto the world. These exhibitions, and others, reveal a tendency towards ascribing to the documentary a privileged position within the art context of reflecting upon the realities of the world. One of the characteristics of, and, I would argue, problems with this enthusiasm for documenting the real, compiling evidence and displaying truth is its apparent disinterest in formal issues. The forms these documentary works take seem most often to be a neglected issue. In the

following pages I will use the issue of form to critically discuss the absorption of documentary forms and genres into contemporary artistic production, and propose that an alternative to "documentary art" may be found in the work of artists making what I will call "dialectical documents," works that adopt the form of documentary but simultaneously reflect on the conventions and legibility of the documentary itself.

It is true that documentary photography and film were never defined according to specific formal rules. The filmmaker and critic John Grierson, for example, spoke of nothing more specific than a "creative treatment of actuality" when he coined the expression "documentary film" in 1926; and the photographer Walker Evans never translated his ambivalent but suggestive phrase "documentary style" into anything formally concrete when he began using it in the 1930s.[3] Nevertheless, certain conventions or, to borrow a term from photography historian Olivier Lugon, signs,[4] have come to be associated with documentary production: in photography the conventions of "straight photography" – clarity of the image, "frontality" of the subject depicted, working in series – predominate, alongside makeshift and more amateur-looking testimonial kinds of images. These also exist in documentary film, where the shaky camera inherited from *cinema vérité* and direct cinema has become a familiar style. So familiar in fact that in a paradoxical way their claim to neutrality and transparency has rendered almost unnoticeable the formal characteristics of those works of art embracing the documentary aspect.

A Degree Zero of Form?

The result is a homogenizing of forms that suggests that formal issues are not important. The look of those exhibitions incorporating documentary works tends, in fact, to vary very little, and often consist of rows of framed photographs and television monitors, of successions of black boxes in which films are projected. Hence *Documenta 11*'s nickname "the 400-hour Documenta" – a reference to the time allegedly necessary to view every film included in the exhibition in its entirety.

These displays result in a different kind of perception of the works on view. If it is not possible to spend 400 hours at the *Documenta*, then one can do little more than savor the ambience or grasp sound bites while walking amidst the talking screens. The presentation conveys the feeling that information circulates without it ever getting anywhere; as the critic Tom Holert has recently noted: "No

3. John Grierson, *New York Sun*, 8 February 1926. Cited in: Olivier Lugon, *Le Style documentaire d'Auguste Sander à Walker Evans 1920–1945* (Paris: Macula, 2001), p. 14. According to Lugon, Walker Evans first mentions the phrase "documentary style" in 1935, (p. 7).

4. Lugon: "signe documentaire [...] elle tend vers un statut d'image-type [...] de chaque objet, elle donnerait l'image générique qui résumerait et annulerait toutes les autres," op. cit., p. 177.

matter how critical, important or shocking the images or sounds, they are arranged and presented in a manner that takes no account of their power to fascinate and to provoke."[5]

The trademark formal neutrality, the subdued style, also works to suggest to viewers that they can get closer to the subject and become involved in it, become a witness rather than a spectator. And so it is not surprising to find that the enthusiasm for documentary has converged with another phenomenon, namely the development of so-called *bricolage* or DIY art. Significantly, *Documenta 11* presented alongside documentary photographs and films a number of sprawling, seemingly unfinished installations, such as those of Thomas Hirschhorn, Ivan Kozaric and Dieter Roth. Roth's *Large Table Ruin – 1970–1998*, which consists of a large accumulation of objects and furniture from his studio space, stuck together and piled up on tables, works as a metaphor for the artist's creative process. There is no finished work to be found, only bits and pieces that testify to some kind of creative activity. These works function on the principle of the fragment; they seem to be perpetually in progress and to document their own making – as Jean-Luc Godard used to say about film. Like documentary films, *bricolage* installations take the viewer to the center of the event, conveying an impression of intimacy and immediacy. You can watch things as they happen.

5. Tom Holert, "The Apparition of the Documentary," in: *Documentary Now! Contemporary Strategies in Photography, Film and the Visual Arts* (Rotterdam: NAi Publishers, 2005), p. 156.

Despite their apparent unobtrusiveness, the discrete forms of documentary are far from neutral. A case could be made, for example, for their role in the globalization of art: to what extent does the recourse to documentary act as a booster of globalization? The question is worth asking in reference to an exhibition such as *Documenta 11*, which brought together works from all continents, revealing a homogeneity previously unseen. Perhaps the difference between this exhibition and the earlier "global" projects of Jean-Hubert Martin (for example, *Les Magiciens de la Terre*, presented at the Centre Pompidou and La Villette in 1988, which marked the first attempt to present a global perspective on contemporary art, and his more recent *Partages d'Exotismes* of 2002) was that *Documenta 11* cleverly included, in some notable cases, filmmakers rather than artists. A case in point is filmmaker Amar Kanwar, whose documentary films are shown on television in India. In Kassel, his full-length documentary *A Season Outside* (1997) was presented on a large screen in a darkened room of its own.

Further, one may also wonder whether this "attraction to the documentary" is the result of artistic or curatorial practice. Are there really an increasing number of artists turning to the documentary

format for their work, or is the phenomenon a consequence of curators bringing into the exhibition context filmmakers and photographers for whom this change of venue may mean a different circuit, a different mode of production or presentation but one that does not fundamentally alter the content of their work. Amar Kanwar, for example, has explained that a minor change of presentation is sufficient for his work to change status. It is enough to paint the walls of the rooms in which his films are shown a different color in order to turn his TV documentary into an art installation.

This fluidity of the presence of documentary in art as style, format or genre makes its relevance difficult to pinpoint. For this reason, it seems to me that we need to take a step back from the *documentary* in order to consider the question of the *document*, the basic unit of documentaries, which has a historical presence in the discourse of art. In other words, addressing the issue of the document makes it possible to anchor the discussion about documentary in the particular context of art history, rather than, for example, in the context of film or media history.

Etymologically speaking, a document is defined as something that serves to instruct. It may be a text, an image; an object either found or constructed that is used for purposes of identification, education, evidence or archival record.

Documents recur in the context of art production in a variety of guises. A document may define a work of art strictly by its legal properties, as is the case with the ready-made. A document may act as a stand-in for a work of art that is no longer there, as in the case of a performance, of which it is the only trace.

Evidence

One of the most striking historical examples of the use of documents in art occurred in the project led by the artists Mike Mandel and Larry Sultan entitled *Evidence*, which took the form of a book publication and an exhibition at the San Francisco Museum of Modern art in 1977. The project brought together the results of research the two artists had undertaken over a three-year period, collecting photographs from archives of over 100 American government agencies, educational institutions and corporations, such as the General Atomic Company, the San Jose Police Department and the United States Department of the Interior.

Out of these archives, Mandel and Sultan assembled a careful sequence of 59 pictures for the book, which they presented without captions. Stripped of any description or indication of origin, these

images, made within the purest conventions of photographic documentary as objective records of activities and situations, test results, crime scenes and so forth, became absurd, gaining a life of their own by virtue of the selection and montage. The project met with some criticism from the museum world; for example, the curator of the Fogg Art Museum at Harvard objected to the artistic presentation of the images, in particular their framing, because this transformed them into works of art, thereby removing them not only from their original context, but also from the sociological perspective he believed they were intended to present in the exhibition.

Evidence offered up documentary photography in its most elementary form and demonstrated how the conventions of clarity and frontality and the use of black and white could fail to convey any information whatsoever once the captions had been removed and the context had changed. The effect was accentuated by the contrast between the highly demonstrative images, originally staged and framed solely with the purpose of pinpointing a certain reality, and the total obtuseness that resulted from their reconfiguration in the exhibition and book project. Furthermore, *Evidence* revealed the instability of the document as immutable record. As the photographer and theorist Joan Fontcuberta has said: "*Evidence* pulverized the very notion that photography was the proof of something, the support of some evidence. Because we should have asked ourselves: Evidence of what? Perhaps evidence only of its own ambiguity. What remains, then, of the document?"[6]

Joan Fontcuberta,
"Evidence of What?",
*Fantastic: The Harvard
Photography Journal*, Vol. 9,
online publication:
www.hcs.harvard.edu/
~fj/evidence.htm.

Jean-Francois Chevrier,
"Documentary, Document,
Testimony," in: *Documentary
Now! op. cit.* (Rotterdam: NAi
Publishers, 2005), p. 48.

Dialectical Documents

What remains, then, is that the document changes, once it has been appropriated in the context of art. A range of oppositions is opened by this reconfiguration, including that between neutrality and subjectivity, transparency and opacity, art and non-art. The document, like the image in general (as defined by Walter Benjamin) becomes dialectical. One of the central characteristics of the document is that it is always a thing in itself and, at the same time, always refers to something else. As Jean-François Chevrier has elegantly put it: "the document provides facts and is a fact in itself."[7] This dialectical mode of functioning means that when appropriated by artists the document becomes a work of art without actually abandoning its earlier status and identity. The document's dialectical nature was exploited by the Surrealists, particularly in the pages of the journal *Documents*, edited by Georges

Bataille, Michel Leiris and Carl Einstein between 1929 and 1931; and later on by conceptual artists like Douglas Huebler and Robert Smithson, who created works that documented particular events. In recent years, a number of artists have been working along this paradigm of the dialectical document. They have deconstructed the processes by which the documentary seeks to convey information whilst nonetheless resorting to its conventions. In an exhibition I organized in Paris in 2004 entitled *Documentary Evidence*, I sought to bring together several artists of different generations who seemed to be involved in a critical reinterpretation of the forms of documentary via a particular use of the document. The expression "documentary evidence," referring to the idea of the document as proof, aimed at conveying the ironical posture shared by these artists regarding the issue of evidence expressed through documentary means.[8] Their works also engaged in a reflection on the traditions, the modes of presentation and conservation of the documentary genre, including the photographic archive, the magazine page and the framed photograph, as well as the hand-held video and the fragment of paper re-photographed for preservation purposes. Although each work in its particular way opted for a "straight" aesthetic, each also manipulated the document in such a way as to show its absence of meaning. The American artist Lisa Oppenheim lifted photographic negatives from an old newspaper archive to reprint their damaged, unreadable surfaces (*Damaged: Photographs from the Chicago Daily News, 1902–1933*, 2003). In another series of works, *Panorama, New York* (2002) she excavated documentary images of New York from the archives of the Farm Security Administration and photographed the extra-diegetic space as it exists today. Adopting the plain style of the earlier documentary image, she slightly shifted the angle of the photograph, allowing to appear precisely what the original photographer had sought to conceal. This gesture destabilized the idea of truth and certainty associated with documentary photography, demonstrating that there is always another photograph that is possible in place of the one that has been preserved. Furthermore, these "panoramas" suggested the instability of the photographic document by creating – through the juxtaposition of found and created image, of old and new – a temporal disjunction and geographical continuity.

Focusing on the printed page and resorting also to found images, the German artist Alexandra Leykauf re-photographed magazines and book pages that had printed images full page for maximum readability – a readability that was eventually impaired by the

8. Galerie chez Valentin, Paris.

fold in the middle of the page. The Los Angeles-based Christopher Williams presented catalogue-like views of the mythic Hasselblad photo camera, only that it was a copy of a Kiev 88. Finally, the French artist Jean-Luc Moulène paid homage to the tradition of the Surrealist document by presenting a found object: a tree stump photographed as a botanical sample and as a match to the instable figure of the duck-rabbit, whose identification is itself the result of a subjective perception.

In these various projects original documents are reworked and manipulated, as if they were rough material ready to be used and transformed. In being manipulated and reworked, the documents lose their quality of certainty and truthfulness; they become obsolete. But perhaps this obsolescence is already present in the way one document can always give way to another, one that will provide, we hope, a more stable truth than the one before. Artists, in any case, seem to feel freer than ever to appropriate and manipulate documents. The obsolescence of the document may turn it – as Rosalind Krauss has argued was the case for photography – into a theoretical object; that is: that an entity called "the document" could be identified throughout Modernism as something ever-shifting.[9] In acknowledging such past practices as those of Surrealism and Conceptual Art and their use of equivocal documents, those artists working in the manner described above seem to suggest that it might be possible to reconstruct a genealogy of the dialectical document throughout Modernism. But that leaves the question of the documentary's obsolescence once artists have appropriated it. It is a question that may also merit close examination.

Rosalind Krauss,
Reinventing the Medium",
itical Inquiry, Vol. 25,
o. 2, Winter 1999, p. 290.

MONEY

5. MONEY. The 1980s were known for the *booming art market*, followed by a total collapse of that same market in 1990. What has happened to the relationship between art and the market since then? It could be said that the almost total absence of painting from the international art circuit in the 1990s had everything to do with this crash at the end of the 80s. When art fails to fetch decent prices, artists might just as well switch to producing works that are attractive to art institutions (installations and the like) or to propagating a political message (for example, by means of interactive art or documentary photography), aiming to achieve a "higher objective" than earning money. In his contribution, *Olav Velthuis* explores the interesting contrast that can be discerned between the commercial art world of the 1980s, with its superstar artists like Jean Michel Basquiat, Jeff Koons and Julian Schnabel, and the "sacred world of pure art" in the 1990s. In his article, *Marc Spiegler* focuses on the second half of the 1990s and the first years of the twenty-first century, the time of the so-called New Economy, when the market picked up again and we can see a return to commercially attractive painting. Spiegler, however, is greatly concerned about what will happen to this market in the near future.

OLAV VELTHUIS
THE ART MARKET IN THE 1990S
RECONCILING ART AND COMMERCE

Introduction

. Olav Velthuis, *Talking Prices: Symbolic Meanings of Prices on the Market for Contemporary Art* (Princeton: Princeton University Press, 2005).

. Richard Armstrong, Richard Marshall and Lisa Philips, *1989 Biennial Exhibition. Whitney Museum of American Art* (New York: W.W. Norton, 1989), p. 10.

"They are humble, very humble. This generation of artists is stunned by what happened in the 1980s: big careers, lots of money, thousands of paintings, and then ... splash. These artists are not looking for thousands of dollars, they are looking for a future." When I interviewed contemporary art dealers in New York and Amsterdam during the late 1990s for a book about the art market[1] this is how one of them characterized the new generation of contemporary artists that emerged after the art market crashed.

At the time of the crash, in 1990, many galleries had to close up shop; prices at auction plummeted; and artists' careers stagnated or came to a sudden end. Most of the art dealers I interviewed during the late 1990s did not interpret the crash as a catastrophe, however, but rather as a form of purification. Indeed, they clearly distanced themselves from the overtly commercial practices of the art world of the 1980s, a time when artists presented themselves, and were presented as, superstars, symbolized by the high and sharply rising prices their works fetched on the art market. As the authors of the catalogue text for the 1989 edition of the Whitney Biennial described the era: "We have moved into a situation where wealth is the only agreed upon arbiter of value. Capitalism has overtaken contemporary art, quantifying and reducing it to the status of a commodity. Ours is a system adrift in mortgaged goods and obsessed with accumulation, where the spectacle of art consumption has been played out in a public forum geared to journalistic hyperbole."[2]

The Market's Corrupting Force

Speaking of the decade that lay behind them, these art dealers identified the corrupting or contaminating forces that the humanities – whether Modernist or Post-modernist, conservative or progressive, formalist or post-structuralist in outlook – had presented in a universal critique of the art market. And whenever art dealers identified practices that reminded them of the 1980s the rule was to condemn them. One Amsterdam dealer, for example, complained that he saw artists rise "like a rocket, and subsequently [go] down again like a meteor [...]. The burn-out speed is very high and the majority of younger artists do not realize that. I can show you [copies of] *Flash Art* or *Metropolis M* [a Dutch art magazine] from some years ago that mention people I never hear about anymore." An American art dealer commented on the career of Jenny Saville, whose paintings of Rubenesque women were priced at around $100,000 during her first solo exhibition in New York: "That girl is twenty-nine years old. If she is not going to make it, she is never going to have a career ever. That's like live and die, these are live and die prices, motherfucker. We are going to kill your ass, or you are going to make it, let's see. You want to be famous? We are going to make you famous or you are going to be unknown tomorrow. Then you are not even going to be an artist. You are going from a 150 grand down to fifteen, and that is a lot of humble pie. I don't know if most artists could handle that".

At the time I was conducting my interviews, apart from Saville a group of young British artists were also becoming very popular, attracting widespread media attention and receiving high prices for their work. In many interviews with New York dealers, the way the career of these artists had developed was commented on in pejorative terms. Dealers maintained that the superstar prices for these artists would ruin their integrity and would make them "end up in trouble." As one emerging dealer remarked: "When I was an undergraduate, a friend of mine became this huge success in London. He won the Turner prize [...] but when I went to see him in 1994 or 1995 he was that burnt out alcoholic, bitter, old, horrible art-world prune. You know, he became so hot, and then it was like ... Pffft." By contrast, those who established their reputation in the 1990s said they preferred to work with reclusive artists who shun rather than seek public attention. They were not "lifestyle people," the New York art dealer Barbara Gladstone remarked. These dealers made sense of their own art world in terms of a narrative that revolved around the values of prudence rather than stardom, modesty rather than excess.

The Negation of the Economy

The discourse of art dealers in the 1990s was structured along a series of such oppositions, reminiscent of what the French sociologist Pierre Bourdieu has called "the negation of the economy":[3] between the sacred world of art and the profane world of commerce, or between overtly commercial (and therefore illegitimate) market practices on the one hand and legitimate market practices in which the commodity character of the work of art is to some extent suppressed on the other (see figure 1 for a schematic representation).[4]

Figure 1. *Structural oppositions in dealers' discourse*

Illegitimate practices	Legitimate practices
Superstar decade (1980s)	Prudent scene (1990s)
Auction houses (parasites)	Art galleries (promoters)
Back room	Front room
Speculative acquisitions	Right motives

3. Pierre Bourdieu, *The Field of Cultural Production: Essays on Art and Literature* (Cambridge: Polity Press, 1993).

4. Arjun Appadurai, "Introduction: Commodities and the Politics of Value," in: Arjun Appadurai (ed.), *The Social Life of Things: Commodities in Cultural Perspective* (Cambridge: Cambridge University Press, 1986), pp. 3–63.

5. Appadurai, op. cit., p. 21; Jean Baudrillard: *For a Critique of the Political Economy of the Sign*, (trans. by Charles Levin) (St. Louis/Missouri: Telos Press Ltd., 1980).

For example, the art dealers I interviewed reproached auction houses for being exclusively profit-oriented and for being greedy. One dealer remarked: "I think the real problem with the secondary market is the auction houses. They are the ones that really conflict with the galleries when it comes to promoting the artists. All they do is live off the artist. [...] They may be necessary in another format, but as far as helping the artists they are really the parasites of the art world. They are just turning it over and making a buck." Another dealer argued even more aggressively: "It is a parasitic culture. [...]. They have no loyalty to the long-term integrity of the art world. I think it is disgusting".

Social scientists have called auctions "tournaments of value" or "status contests." At stake in such tournaments is not only an economic transaction but also the establishment of the artists' rank and the status and fame of the collectors who can afford to buy their work.[5] A SoHo art dealer, active on the secondary market, characterized the public nature of auctions in a similar vein: "Millions of people are seeing it. [...] Put it on the block and you do a Miss Popularity contest." Another art dealer said: "Once an artist has been subjected to auctions, his work is no longer discussed for its merits or its ideas, all discussion centers on the prices it achieved or didn't achieve, fifty thousand or two thousand. If those prices are high it's just as bad as when they are low. Young artists

deserve a grace period in which what they do can be viewed as a work of art, not as a price tag."[6]

It is this association of artworks with status, snobbism and public spending which art dealers claimed to be wary about. Dealers contrasted their own covert business strategies with the aggressive sales tactics of the auction houses. They held auction houses responsible for the fact that collectors are constantly reminded of the economic value of the work they own. An American dealer characterized the atmosphere of the art market as follows: "The whole market is a lot more aggressive, there is no such thing as an indecent proposal since the auction houses are doing it 24 hours a day, 365 days a year. If you are a collector, you get a call or a letter [asking] if you want to sell. They come to your house and say: 'this is this much, that is that much.' So all the collectors are constantly living with values as much as they are living with art. It is much more extreme in America than in Europe."

What these comments hint at is that dealers and auction houses during the 1990s were engaged not only in a business competition over the collectors' money but also in a definitional struggle.[7] Whereas auctions defined artworks as commodities, dealers sought to repress this commodity status and to define them to some extent as cultural goods.

A Goffmanian Distinction

Apart from distancing themselves from the superstar decade of the 1980s and from the parasitic enterprise of the auction houses, dealers in the 1990s negotiated tensions between art and commerce by means of a Goffmanian separation of the front and back rooms of their gallery spaces.[8] The front of the gallery usually contains one or more exhibition spaces. These spaces are almost invariably "white cubes," without ornamentation or furniture. References to commerce, such as price tags next to individual artworks, a cash register or a device for electronic payment are conspicuously absent. The white cube is constructed in opposition to the back room: if the front room – the most visible and museum-like part of the space – suppresses the commercial character of the gallery, the back room, by contrast, is constructed as a commercial space; in other words: art and commerce are juxtaposed physically in the architecture of the contemporary art gallery.

The back room makes visible the permanent capitalist information streams that galleries both tap into and to which they contribute. Information regarding the whereabouts of artworks sold by the gal-

6. Laura de Coppet and Alan Jones, *The Art Dealers: The Powers Behind the Scene Tell How the Art World Really Works*, (2nd ed.) (New York: Cooper Square Press, 2002), p. 313.

7. Charles W. Smith, "Markets as Definitional Mechanisms: A More Radical Sociological Critique." Paper presented at the Inside Financial Markets. Financial Knowledge and Interaction Patterns in Global Financial Markets, Constance, 2003.

8. Erving Goffman, *The Presentation of Self in Everyday Life* (London: Penguin, 1956 [1990]).

lery in the past is stored in archives, as are the price lists of past shows. Information related to the careers of artists the gallery represents (books, newspaper clippings, magazine articles, catalogue texts, press releases) is meticulously tracked, and is either stored on floor-to-ceiling shelves, in computer databases, or as paper archives. Commercial deals are negotiated and arranged between the dealer and collectors in a separate viewing room.

If the gallery is involved in secondary market activities, auction catalogues and annual price guides published by art-price information firms such as ADEC stand on the shelves. Apart from computers, telephones, a fax and a copier are the most essential "tools of the trade" for directors and gallery assistants alike. This is where secondary market operations are conducted: the profitable trade in high-priced artworks made by a variety of established, often deceased, artists who in most cases had never been represented by the gallery. In New York, estimates of the percentage of secondary market sales I heard during interviews ranged from twenty-five to sixty percent of total revenue.[9]

Nevertheless, as I noticed during my interviews, most dealers felt reluctant to talk about this part of their business; the secondary market, as we saw above, is rather stigmatized: it makes the gallery resemble a commercial establishment rather than a cultural "institution." In other words: the secondary market violates the dealer's self-assigned role as promoter of artists and a patron of art. As one of them said: "You are not really cutting edge if you would touch something that is established. [...] You want to be perceived really ... pure. And you are only pure if you do primary. If you do secondary you are not pure." Indeed, dealers who run their gallery successfully without having recourse to the secondary market tend to take pride in the fact. Conversely, the reputation of a dealer may be tarnished when too much time and energy is devoted to resale. Larry Gagosian, for example, a New York dealer known for his aggressive secondary market activities, was accused by his colleagues of "degrading the business" and "bringing the habits of a souk rug seller to a refined trade."[10] Even a director at one of the world's largest dealerships told me: "Interestingly enough, it is not something we pay too much attention to. We are mostly interested in primary dealing, meaning from the studio. [...] we prefer not to do the trading." Nevertheless, during the tour of the gallery he gave me after the interview, I spotted secondary market artworks by modern masters such as Jasper Johns and Robert Rauschenberg which the gallery was offering for sale.

9. See: Velthuis, op. cit.

10. Philip Delves Broughton, 'Damien's one of the good guys," The Daily Telegraph, March 10, 2000.

RIGHT ABOUT NOW | MONEY | Olav Velthuis | The Art Market in the 1990s

I also came across different strategies used to counter this stigmatization of the secondary market trade. The New York art dealer David Zwirner, whose main gallery is located in Chelsea, separated his primary and secondary market activities to some extent by opening another gallery on Manhattan's wealthy Upper East Side; this gallery, co-owned by the Swiss dealer Ivan Wirth, is exclusively devoted to the secondary market."Dealers also told me they used the revenue of secondary market sales to finance the promotion of innovative, experimental art. They said that were they to restrict their business to the primary market they could hardly keep their doors open: an art dealer who feels committed to promoting new and innovative art in the front room can only do so by creating revenue from secondary market activities in the back room. "You don't survive on the shows," as one dealer put it bluntly. "The primary market is small, and it is much more the labor of love [...] So if I want to do a money-losing show in the gallery, I could support it by selling a painting of Gerhard Richter, or something of Bruce Nauman."[12]

The opposition between the sacred world of art and the profane world of commerce is not only homologous with an opposition between the 1980s and the 1990s, between contemporary art galleries and the auction houses, and between the front and the back spaces of the gallery, but also with a distinction dealers make between two types of acquisition motives. Collectors, they said, who buy for the "right" reasons are those who claim to be motivated by the love of art and who act accordingly. They think about art as an "intellectual pursuit"; they have "dialogues" with the work, want to get together with the artist, and follow the gallery in its artistic choices; they travel to openings of shows in which the artist is represented, and have an interest in the artist's career. Moreover, these collectors are willing to buy work that is difficult to commodify, such as installations. Also – and this is crucial for art dealers – these collectors would not consider reselling works they had bought, even when such a resale would be profitable. In the United States, collectors who buy for the right reasons ideally donate (part of their collection) to museums, or, in rare cases, fund a museum of their own. Such donations, like direct sales to museums, are attractive because of the credibility or legitimacy they lend to an artist's oeuvre as well as to the gallery itself; indeed, the number of works that artists and galleries managed to sell to museums, either directly or indirectly, was a source of pride for them.

Another reason for art galleries to be pleased with collectors who donate work to museums is that the work of art, once part of a

11. Robert Knafo, "Upward Mobility: SoHo Stalwart David Zwirner is Staking a Claim on the Upper East Side," ARTnews, October 1999, pp. 62–64.

12. Other galleries, in the Netherlands as well, may have one or two best-selling artists on the primary market, which make up for losses made on the sale of work by other artists.

museum collection, becomes, in the terms of anthropologist Igor Kopytoff, a "terminal commodity": unless the museum decides to deaccession the work, which happens only rarely, it will never again enter the commodity phase.[13] The reasons why dealers are so concerned about collectors' motives was summarized as follows by an Amsterdam art dealer I interviewed: "I believe it is important to place the work well, it is like putting your kid in the right hands, or if you have a pet and you place it with a good person."

By contrast, the "wrong" reasons for buying works of art are those that have to do with investment, speculation, status, or, to a lesser degree, decoration. In the hands of both status seekers (who see the price as something admirable in the work) and speculators, the artwork fails to rid itself of its commodity character after leaving the commodity phase. This was deplored by dealers, who claimed to "want the work to function properly, to provide a good context for it, and to prevent it from becoming an object of financial speculation [...], from getting in touch with money again," as one Dutch art dealer phrased it. Another stated: "You can tell a speculator very quickly. [...] Just the kind of questions they ask, and what they ask for. It is almost like they are wearing a sign. A speculator would come and look at your gallery program and ask for the two things that are most sure to increase in value. [...] When we see each other, they know exactly what I think of them, and they know they can't buy here, no matter what they want to buy."

Conclusion: Response to the Skeptic

Some critics may misread this essay as an unjustified apology for a world of commerce, permeated by cultural corruption and held hostage by a worldwide monopoly of a small group of powerful dealers, superstar artists and filthy rich collectors. "Art and money have exchanged roles: money becomes 'divine' by being 'translated' into art; art becomes commonplace by being translated into money," as art critic Donald B. Kuspit argued in an interview with the magazine *Art in America*.[14]

What the many critiques of the art market formulated by the humanities have in common, however, is a rather naïve opposition between the market and morality,[15] or between commerce and culture.[16] Countering such oppositions, the anthropologist Fred Myers rightly argues in his book on the circulation and commodification of Aboriginal art: "What needs to be recognized and explored further is the market, not as a separate domain, but as a structure of symbolic transformation. It does not necessarily erase all the

3. Igor Kopytoff, "The Cultural Biography of Things: Commoditization as Process," in: Appadurai, op. cit., p. 75.

4. "Critics and the Marketplace," *Art in America*, Vol. 76, No. 7, July 1988, p. 109.

5. Roy Dilley, "Contesting Markets. A General Introduction to Market Ideology, Imagery and Discourse," in: Roy Dilley (ed.) *Contesting Markets: Analyses of Ideology, Discourse and Practice* (Edinburgh: Edinburgh University Press, 1992), pp. 1–34.

6. Jean-Christophe Agnew, *Worlds Apart: The Market and the Theater in Anglo-American Thought, 1550–1750* (Cambridge: Cambridge University Press, 1986).

distinctions embodied in objects [...]. It is not always the case that the market's domination is complete: other systems of value may coexist, and their meanings may be reconstructed in relation to the presence of market practices. We must imagine that commodities and commoditization practices are themselves embedded in more encompassing spheres or systems of producing value. Such systems not only recognize the existence of distinct regimes of value but combine and reorganize the activity from these various contexts into more complex mediations."[17]

The point is that many of its critics fail to recognize that the art market (or any other market, for that matter) is a cultural phenomenon in and of itself, and that this culture is prone to change. Indeed, the art dealers I interviewed claimed that the culture of the art market in the 1990s differed significantly from the culture of the 1980s. They did not deny that commerce can contaminate art, but identified this contaminating force in the 1980s, and sought to distance themselves from that culture in their own time.

This is not to say that these dealers always succeeded in doing so. In fact, their discourse was at times full of contradictions and often did not coincide with their own market practices. Or, as Bourdieu has argued, the negation of the economy, in which the dealers of the 1990s excelled, serves to accumulate a form of capital, symbolic capital, which provided them with prestige. This symbolic capital, in turn, could in the long run be transformed into economic capital.[18] The first years of the new millennium, when the art market boomed as if the 1980s had returned, will most likely show this not too long from now.

17. Fred R. Myers, *Painting Culture* (Durham: Duke University Press, 2002), p. 361.

18. Bourdieu, op. cit.

MARC SPIEGLER
IS THE NEW
ART MARKET
THE NEW "NEW
ECONOMY"?

See: www.youtube.com/
atch?v=R7o6isyDrqI.

See: www.youtube.com/
atch?v=BnQMq5wtZcg.

In the world of American television advertising, there are no seconds of time more expensive than those broadcast during the Super Bowl, the championship game of American football, when civil society in the United States essentially comes to a halt. The history of Super Bowl ads includes such remarkable commercials as "1984," the Apple Computers one-minute-movie that was shown only once and yet nonetheless managed to forever define Apple as Winston Smith fighting Microsoft's Big Brother.[1]

The most bizarre Super Bowl ad ever broadcast, aired in January 2000 at the height of the "New Economy" Internet-business boom, opens with a long camera shot of a banal suburban garage. Striding in from off-screen, a chimpanzee ambles across the street and into the structure. The camera comes closer as the monkey jumps atop a trashcan, then dances and waves his hands to a cha-cha-cha beat. Sitting on rickety folding chairs, two aging dolts in mismatched shirts and oversized glasses sway alongside him. After twenty seconds of these antics, the commercial's tagline fills the screen: "Well, we just wasted two million bucks. What are you doing with your money? E*trade 1-800-ETRADE-1"[2]

What do a monkey and two morons in a garage have to do with the art world? For many observers that E*trade ad marked the apex of a madness that had built for half a decade, epitomizing how mind-bogglingly weird things had become. And to me, the current art

market is starting at times to feel a little too similar to that period. So when I was asked to lecture in Amsterdam on the topic of "Art and Money" the parallel seemed too obvious to ignore.

At the time of the E*trade ad, my practice as a journalist was roughly split between writing about the art world and writing about the New Economy as it was unrolling in Europe. It was a wild moment. Companies were started with ease – Kurt Andersen, the co-founder of the Inside.com media group, once remarked that raising money then "was easier than getting laid in 1969." Technology firms that had never shown profits were valued more highly than long-established market leaders in other industries: less than ten years old, America Online bought Time Warner, one of America's most historically powerful media companies. Millions of dollars were spent to promote unknown companies such as fashion mavens Boo.com, using lavish global advertising campaigns.

Trying to write rationally about this phenomenon while using the normal terms of economic discourse – profits, losses, and ROI (Return On Investment) – proved difficult. There were simply too few mental footholds for journalists trying to explain the rationale behind things like the E*trade ad. Because in the New Economy era, nothing really stood up to close scrutiny. Not the business plans. Not the (in)experience of the people founding companies. Not the growth projections. And yet for a few years everything cruised along smoothly. No, more than smoothly – ecstatically! As if everyone in the industry was on some sort of permanent serotonin IV-drip. Anyone who raised doubts was met with a condescending half-smile, and found himself buried beneath a jargon-larded attack on their reactionary notions, such as "sustainable growth" and "profits."

Of course, we all know how this ended. The January 2000 Super Bowl broadcast featured commercials from seventeen dot-com companies; in 2001 just three bought advertising. The Old Economy math proved to be right. It seems in fact that one cannot lose money forever and stay in business. Many dot-com companies disappeared in a single year, leaving behind them corporate autopsies featuring hubris as the prevalent cause of death.

I stopped writing about the New Economy and turned my attention entirely to the art world. It was a totally different milieu, where the money comes from discretely done deals not Initial Public Offerings. Where the digital was (and often still is) more distrusted than embraced. And where greater emphasis is put upon a work's

uniqueness than its "scalability" to millions of users. And yet ...
and yet despite those stark differences, as I travel around the art
world to various events, and track the careers of international art-
ists, I often have an acute sense of déjà vu. Sometimes I see it in
the little things, like invitations to openings, which seem to grow
more high-production every season. Where once a postcard suf-
ficed, I now often receive a menu-sized invitation printed on thick
cardboard (Hauser & Wirth of Zurich and London) or even a whole
self-produced magazine devoted solely to the gallery's artists (*Bing*,
from Galerie Emmanuel Perrotin in Paris).

At times, the rapid expansion of the art world manifests itself
across a whole city. In December 2005, 431 galleries set up shop in
Miami during Art Basel Miami Beach, spread across seven fairs.
A few months later, 330 galleries filled booths in New York during
the Armory Show week. Amazingly, in both places most galleries
seemed to be selling steadily; many were even forced to re-hang
their booth after first-day sales emptied their walls of works.

Just as tech companies rapidly developed global ambitions, many
young dealers are now opening second spaces in other cities, often
barely a few years after launching their first enterprise. Galleries
are springing up constantly, everywhere from Beijing to Hoxton to
Chelsea to the Marais. And let's not forget all those galleries sited
in totally out-of-the-way places yet nonetheless succeeding by
selling work both at fairs and online. Remember that even at the
height of the 80s boom you could visit all the important galleries in
New York within a single weekend and it becomes clear that we are
living through a radical expansion of the contemporary art market.
When I talk to most experienced people in the art world – be they
long-term collectors or dealers raised in their parent's gallery – they
seem both bamboozled and befuddled. All their certainties about
how the art market works – based around quality comparisons
– have totally evaporated. Granted, the pricing of art is always de-
batable. As Olav Velthuis points out in *Talking Prices* (2005),[3] dealers
have long used "pricing scripts," methodologies for justifying pric-
es based upon relative value (compared to the artist's peers who are
older or younger, more or less established, etc.) and thus situating
the artist within art history, or at least the art market. But right
now, to many art world veterans, it feels like those scripts have
been torn up and the new breed of dealers are conjuring up prices
extemporaneously.

That cognitive dissonance hits hardest when it comes to younger
artists whose prices have risen the fastest. In the New Economy

. Olav Velthuis, *Talking Prices:
Symbolic Meanings of Prices on
the Market for Contemporary
Art* (Princeton: Princeton
University Press, 2005).

paradigm, the driving force was the constant search for what author Michael Lewis called "The New New Thing."[4] To some extent that paradigm has long ruled in the art world, where by definition any avant-garde turns *ancien garde* within a few years, replaced by a *newer* avant-garde. But that cycle of renewal used to be reflected first in the changing interest of critics and curators; the market followed several steps behind. Today, however, collectors and dealers frequently are the most fervent chasers of the artistic "New New Things," touring the studios of graduate schools while looking for potential acquisitions and new additions to their gallery's roster of artist.[5]

Not so very long ago, such young artists were modestly priced in order to help build their collector base. Now the notion that emerging artists are affordable sounds ludicrous. There are many examples I could cite, but one of the latest is Natalie Frank, who sold out a recent Chelsea show[6] at prices ranging from $8,000 to $16,000. At the time, Frank was half a year away from receiving her Master of Fine Arts from Columbia University. Frank was also part of "School Days," Manhattan dealer Jack Tilton's show of students cherry-picked from the M.F.A. studios at Yale, Columbia and Hunter College and sold to world-class collectors at prices essentially comparable to those of artists with long track records for producing high-quality work.

Thus, just as with the New Economy's stock prices, the current market for young contemporary artists reflects a signal shift in the buyer mentality – a shift from focusing on proven ability to gambling on potential success. While walking around Chelsea the weekend before Art Basel Miami Beach 2005, I was informed by several dealers that "$20,000 is the new $10,000" – meaning that $20,000 is what you charge for an artist whose first show (or two) had met with critical and sales success. The dealers said it with a smile, as if recognizing the phrase's flippancy. But it was no joke. A week later at the *New Art Dealers Alliance* show in Miami – featuring some of the hottest young galleries from New York and the rest of the world – the prices were markedly higher than the year before. In this sense, the current art boom bears another similarity to the New Economy's height when the market capitalization of companies such as AOL, eBay and Amazon suddenly made them worth more on paper than industry giants – venerable companies such as Sony or General Motors. Consider the most recent Christie's London auctions: one of the most sought-after paintings was by Matthias Weischer, the grand market-darling of the super-hot Leipzig School

4. Michael Lewis, *The New New Thing: A Silicon Valley Story* (New York: WW. Norton & Company, 1999).

5. This has a distinctly distorting effect on the teaching process. Last year, American critic Jerry Saltz wrote: "In a group crit [critique] at Hunter College, I was blathering to a student about how his work was skilful, yet kitschy. Throughout, he maintained a benevolent grin. The next day I learned that he had just signed with Leo Koenig." Citation from "Dire Diary," *Village Voice*, April 25, 2005.

6. Nathalie Frank, "Unveiling," January 26 – March 11, 2006 at Briggs Robinson Gallery, New York.

painters. Setting a new personal auction record, Weischer's *Untitled* (2003) sold for £220,800 – forty percent more than *Sound*, a strong work by Bridget Riley, one of England's greatest female painters. Riley was already famous when she painted *Sound* in 1973 – the same year Weischer was born.

Another example is Brazilian artist "Assume Vivid Astro Focus," AKA Eli Sudbrack, who became an overnight star with his contribution to the 2004 Whitney Biennial. Sudbrack made a full-room installation with a Brazilian-disco vibe that included drag queens, serial substance abuse and soft-core porn. The installation was sold in a very interesting manner: not as a single installation but as variously editioned elements, including the floor and wallpaper; the work thus grossed $600,000, minimum, several times more than one would pay for a major installation by established stars such as Richard Long or Mona Hatoum.

Over and over, when comparing the prices of younger artists and older ones, the only conclusion one can draw is that the two groups exist in markets that have little relationship to each other, simply because the dealers of the younger ones are so much more aggressive – and their collectors so much less price-sensitive.

Of course, the hot art milieu has also spurred the market of some mid-career artists, often in the form of sudden jumps in their auction prices. Sometimes those jumps are easily explained – through a major retrospective (Andreas Gursky at MoMA) or switching to a new gallery (John Currin, from Andrea Rosen to Larry Gagosian). In other cases, however, market insiders suspect manipulation by a small group of veteran dealers and collectors. The alleged manipulation works more or less like this: first, collect a critical mass of the artist's work; second, get someone in the group (or even better, an unwitting client) to buy one of the works at auction for a previously unimaginable sum (abracadabra ... "The market has spoken!"); third, liquidate the rest of the inventory via private deals, at the new price level established at auction.

One frequently alleged example of such a practice is Elizabeth Peyton. In 2001 her painting of legendary New York dealer Colin de Land sold at auction for $77,300. Five years later, it sold for $856,000. What had happened? De Land died in 2003, but while death is often great for an artist's market (Jean-Michel Basquiat is the example par excellence), the death of an artwork's subject does not explain a 1,000-percent increase in five years. Much more important for this price jump was the sale of Peyton's John Lennon

RIGHT ABOUT NOW | MONEY | Marc Spiegler | Is the New Art Market the New "New Economy"?

portrait for $800,000, a massive increase that caught everyone involved by surprise, fuelling the rumors of market gaming.

Who benefits from such alleged manipulations? Not the artists or even their galleries, but rather the established insiders who have cornered their oeuvre. Likewise in the New Economy, the insiders – the venture capitalists providing initial funding, the banks handling the IPOs, the advertising companies developing concepts like the E*Trade monkey – made tons of money from those newly arrived in the tech market and hoping to get rich quick.

What such insiders need for this tactic to work is outsiders – specifically, outsiders with more money than experience in the marketplace. In the art world that means people willing to pay masterpiece-level prices for mediocre paintings by artists with hot names. And clearly, a lot of the market's newer money lacks historical perspective. Some collectors apparently think an *Artforum* cover picture means the artist so honored has established a place in the art historical canon. But if you actually pick up old copies of *Artforum*, you will be struck by how many former stars have faded out of sight, extinguished in the art world's skies.

Just as during the New Economy the number of people trading in stocks soared, the influx of new collectors has been stunning. To many in the art world, this larger market augurs greater stability. This seems quite logical but is in fact highly debatable. Sociologist Wayne Baker once tracked trading on the Chicago futures exchange and found that as the number of actors trading in a particular commodity rose, the social controls that kept the market orderly eroded. Likewise, the art market has now grown too big for its old gentleman's club practices, as evidenced by the recent flurry of lawsuits involving New York art dealers and galleries. In other words, bigger markets are not automatically bullet-proof.

Many of the newer players have an arguably destabilizing influence. In the dot-com era, one of the common media archetypes was the new investor, the cab-driver-turned-day-trader, scanning his screen at an internet café and making thousands of dollars in an afternoon through rapid trading. Granted, the financial resources needed to trade in art exclude most cab drivers. But today's art market equivalent is the private dealer-collector, scouring ArtNet and eBay for arbitrage opportunities, or trying to get work cheap and then "flip" it into auction a few seasons later. One dealer recently told me his brother commonly buys artworks purely in the hope that selling them a year later might pay for a new Lamborghini. To combat such tactics, many dealers now try to institute "resale

7. Interestingly, when one starts trying to buy work that does not yet exist, one is essentially signalling a preference for the artist's work to stay static since the attraction is to past production.

8. *Art Forum Berlin – Talks*, October 1, 2005, panel discussion: "Investment-Grade Art: Bonanza or Fiasco?" with Wim Delvoye, Ian Charles Stewart and Max Hetzler, moderated by Marc Spiegler.

9. Throughout the entire New Economy epoch, Tulipmania was a recurrent theme although without any apparent effect as a cautioning omen.

10. Since I have only tracked the art market during this extended boom, I sometimes question my judgment. So I call on my friends with more experience in the art world. They tend to have the same wariness as I do when confronted with all the theories detailing how the paradigms have totally changed since the last art-market bust. "Maybe it is a major economic shift, like the postwar period where America stole the art world from Paris," one collector confided to me. "But when people say a crash can't happen again because of that, I think of the New Economy in 1999."

agreements" under which collectors are forced to offer an artwork back to the gallery at "market value" (always tricky to ascertain) before consigning it to auction.

Of course, not all speculators are alike. The smart ones dig constantly for new information and focus like snipers on artists who seem set to surge from "barely known" to "scarcely available." (In recent years these artists would have included Kai Althoff, Marcel Dzama, Wilhelm Sasnal and Tal R, alongside the entire Leipzig School group. For such hot artists it is not uncommon to have waiting lists several dozen names long.[7] Such speculators trade in names, not art, and dealers often encounter "collectors" trying to buy pieces by artists whose work they cannot recognize even when standing in front of them.

The other approach is more machine-gun style, nicknamed "spray and pray." I distinctly remember meeting New York dealer Marisa Newman at NADA in 2005. Looking slightly shocked, she told me: "One collector explained to me that he sees the artworks in NADA as high-risk investments. He said if you buy ten of these artists, one will take off." And the other nine? Their work goes into cheap storage, in hopes of a distant comeback.

For speculators who do not trust their instincts, new art-based investment funds are emerging every quarter. Many fail to really take off, but the Fine Art Fund from London has apparently done well. And, while it mostly focuses on much older work – its definition of "contemporary" includes dead artists such as Warhol and Pollock – its director Philip Hoffman publicly revealed[8] that in 2005 the fund had bought one planned work (he declined to reveal the artist's name) and then resold it at a forty percent profit, all before it was actually produced. When people start buying and selling unsold artworks, it is hard not to think of Holland's Tulipmania, where bulbs still in the soil traded hands at astounding prices.[9]

To many experienced players in the art market, thus, the current situation sometimes feels just as fragile as the New Economy once did. There are simply too many galleries selling too much mediocre art to too many collectors for too much money. The only thing that can sustain such a system is the constant influx of new collectors. And at some point, logically, these will run out.[10]

For all the seeming portents of doom that this New Economy/art market parallelism implies, however, this hardly means the entire art world is destined for a future flameout. Because while there is unquestionably an art-market bubble, there is no reason to think

the market will halt when that bubble goes slack. After all, the tech crash did not kill Amazon, eBay or Google. If anything, it cleared space for them to grow. Yes, when the New Economy bubble burst there was a period when even excellent business ideas had a hard time finding proper funding. And in the same way, during a slow-down in the art market even some excellent galleries and artists could suffer.

However, art plays a growingly irreversible role in the identities of people, groups and even cities. And, while new money has played a huge part in the last decade's development, historically speaking it is weaker art markets that have tended to be yield better art – there is less pressure on artists to produce, fewer temptations for them to sell out, and they are dealing only with those galleries willing to ride out the hard times. So whether the current art market corrects, crashes or contracts, it will not take the art world down with it, not any more than the New Economy's seeming evaporation spelled the end of the Internet.

CURA
ATING

6. CURATING. Since the beginning of the 1990s there has been a significant shift in the position of the freelance curator. Where formerly the independent exhibition-maker was someone who concentrated primarily on developing alternative exhibition models, nowadays it appears that a number of itinerant curators consider themselves part of a select band of "star curators," responsible for the creation and interpretation of large-scale, international art projects. What are the implications of this trend for contemporary art practice? *Jennifer Allen* reveals that a question like this is not easy to answer, as the concept of the "curator" is a vague one and the traditional division of roles between commerce and independent critical presentation has become confused. Whereas Allen is critical about this blurring of the boundaries, *Beatrice von Bismarck* recognizes in it a positive and significant potential. Von Bismarck believes that, from the artist's point of view, curating presents an attractive opportunity to break free from producing a well-defined set of objects that are then contextualized and interpreted by others.

JENNIFER ALLEN
CARE FOR HIRE

I come to curating as a bystander, although not an entirely inno-
cent one. As a contemporary art critic, I have seen more than my
fair share of curated exhibitions – whether solo or group shows
– and I have even written evaluations of a few. That is not a sar-
donic aside; my reviews address primarily shows without curators
(the artist installs her own work without calling herself a curator),
although such shows are becoming rarer. Due to the brevity of a
review, the critic's priority remains the artist's work not the cura-
tor's, especially in a group show; biennials and retrospectives are
another matter, although they should not be. Most curators would
likely agree with me that the review has not expanded with the role
of curators and the need to evaluate their increasingly visible efforts
alongside the artworks. While looking at these efforts, I never had
the desire to become a critic "slash" curator, unlike many of my col-
leagues who have made the leap over from the critical reception to
the curatorial production of exhibitions. That is likely why I have
been asked to comment on curating for this volume: not to offer my
theory of curating, nor to evaluate the curating of particular exhibi-
tions, but to discuss the state of the profession from an outsider po-
sition. From interested observation instead of direct experience.
A few words on professional differences, lest these be understood
as inimical: my decision to stick on the reception side of the ex-
hibition – along with the public – is not a critical resistance to the
production side but rather a respect for the specificity of the profes-
sional tasks on both sides, along with a recognition of the immense
work that goes on before anyone sees a show – critic or public. In-
deed, the overwhelming tasks involved in producing an exhibition
keep me from expanding my professional title with a slash towards
curating. When I write a review, I deal mostly with the artworks in
the exhibition and then with editors (the former intensively; the
latter hardly at all). Writing catalogues and essays always involves
a more intense contact with artists and curators than writing a

review. Apart from a few fact checks, there is not much going on behind the scenes of a review, at least from the critic's perspective, since the critic usually does not administrate the magazine. I do not meet up with my editors in person, let alone decide on illustrations, typesetting and layout for the published review that the public sees. By contrast, there is a lot going on behind the scenes of an exhibition, beyond the curator's central task of deciding what artworks will be shown and where: institutional hierarchies, local politics, gallery policies, fund-raising and more fund-raising, shipments, insurance, production budgets, loan agreements, technicians, installation crews, guards, public relations and press work, and the list continues mercilessly. Then, there are the inevitable problems, which make a typo in a published review seem like a trifle: the municipal permission that did not come through for a public sculpture, the government funding that will materialize only when the exhibition is over, the artist who could not get a visa, the overlapping soundtracks of two neighboring video installations by two now-unhappy artists, the artwork that just will not hang the way it is supposed to hang, the late catalogue essay (that is likely me).

In English, the origins of the verb "curate" reflect this enlarged field of responsibility. To curate comes from the Latin *curare*, to care. While the curate is a clergyman in charge of a parish, the curator is responsible for the care of something, a charge: superintendent, manager, custodian, person in charge of a museum, keeper of a zoo, the member of a board who looks after a property or the superintendent of a university. A curator can also be the guardian, legal or otherwise, of a minor or a mentally ill person. Historically, curators have had many charges: parishes (and souls), buildings, gardens, properties, businesses, collections, animals, land, knowledge, people who cannot take care of themselves. In short, curators take care of things that do not belong to them; they extend the care of themselves to the care of someone else's property, public or private. As the guardians of minors and madmen, curators must act in the best interests of their wards – a role that clearly often involves acting against the explicit wishes of these wards. Whatever the charge, it is not an easy job – somewhere between virtual ownership and virtual subjectivity. The French *commissaire d'exposition* (which might be translated as "exhibition commissioner") emphasizes not the act of caring but the appointment by a higher authority for the specific job of making an exhibition: a temporary task within a hierarchical institutional framework, often with a public calling. In French, the curator is related to the auctioneer (*commis-*

saire-priseur) who has a similar temporary and institutional role, albeit tied to the auction house and to the market. The German *Ausstellungsmacher* – "exhibition-maker" – seems to get down the basics without revealing their content. However prosaic, the expression, like rainmaker, remains rather short on practical details – a mysterious aura that many curators cultivate about their practice, as we shall see below.

The freelance curator – not philology – is the focus of this commissioned essay, although I cannot entirely put aside philological concerns when answering the assigned question: the freelance curator used to be a vital critical force, pursuing alternative exhibition models. However, since the 1990s, an exclusive group of star curators travel around the world organizing large-scale international exhibitions that no longer challenge existing exhibition models but rather integrate contemporary art into mainstream culture. What is the meaning of this development for contemporary art practice, and in what direction will curatorial practice further advance? This is a complex set of arguments and questions, which I will attempt to address from my bystander position.

Initially, the word "freelance" seems to reflect the temporary nature of the commissioner's task: a temp, who happens to put in lots of overtime. But the term – a "free lance" for hire – also names a medieval mercenary for the Crusades, which is a rather unfortunate connection given the Christian calling of the curate and the international expansion of the contemporary art exhibition apace with the global spread of religious bellicosity. Freelance has also been used to describe the politician who breaks away from the party or the journalist who breaks away from a newspaper, although it is hard to imagine any curator without political alliances and press relations. Whatever the emphasis, there seems to be a conflict between freelancing and curating, at least on philological terms. The freelancer's lack of permanent institutional links goes against the duration and the dedication to someone else, or to collective property, which are implied by curator's care. It is hard to take care of something, or someone, as an outsider without a lot of resources and without a lot of time.

Putting these issues aside, I shall begin by answering the second question: curatorial practice seems to be advancing in the direction of the exit sign. Since 2004, many curators – with or without permanent positions – have left the world of contemporary exhibition-making for academic positions at art schools within colleges and universities, especially institutions of higher education in the

United States. An article by Jordon Kantor on the phenomenon of curators going back to school[1] – Kantor himself decamped from a curatorial post at New York's Museum of Modern Art (MoMA) to a teaching job at the California College of Arts in San Francisco – lists several such high-profile departures: Russell Ferguson, former chief curator at the Hammer Museum of the University of California, Los Angeles, has become head of UCLA's Department of Art; Lawrence Rinder left the Whitney Museum of American Art in New York to head graduate studies at the California College of the Arts; closer to home, Saskia Bos, the long-term director of Amsterdam's De Appel and the founder of its international Curatorial Training Program, is now dean of the School of Art at New York's Cooper Union; Okwui Enwezor, a former independent star curator and artistic director of *Documenta 11*, has since become dean of academic affairs and senior vice president of the San Francisco Art Institute; Robert Storr, another star who took on the 52nd Venice Biennale, abandoned his curatorial position at MoMA to work as dean and professor at Yale University's School of Art. The most recent decamp is Maria Lind, who left Stockholm's International Artist Studio Program in Sweden (IASPIS) for the Center for Curatorial Studies at Bard College, where she will direct the graduate program for its masters degree in curatorial studies.

While allowing for different individual motivations, Kantor identifies three main factors behind the relocations: "the meteoric rise of the contemporary art market; a shift in the role of the curator within large institutions; and the evolution of museums toward a more administrative model (at least in the United States)."[2] Spurred by the market boom that began in the mid-90s and continues to spiral upwards, these trends seem to echo the shift from "alternative exhibition models" to "mainstream culture" noted above. Kantor cites some innovative laboratories for showing contemporary art within larger institutions known for their older permanent collections – like MoMA's "Projects" space for contemporary artists, created in 1971– spaces that eventually lost their marginal experimental status to become elite market indicators. Initially created to expose emerging living artists to a larger audience, such experiments ended up minting international art stars chased by private collectors, with whom, ironically, the museums must now compete when acquiring the artist's works for their permanent collections. For Kantor, collaborating with collectors and wooing donors – tasks formerly executed by the museum director – have increasingly fallen upon curators as one of the shifts in their institutional role. Kantor cites

1. Jordon Kantor, "Back to School: Jordon Kantor on Curatorial Returns to the Academy," *Artforum International*, Vol. XLV, No. 7, March 2007, pp. 129–130.

2. Ibid., p. 129.

Storr, who describes curators as spending more time with collectors and dealers than in artist studios. Another shift is the need for constant travel to keep up with a global art world, with its over eighty biennials and still counting. Finally, the administrative museum model born in the US – Kantor cites the Guggenheim franchise – has forced many museums to run like businesses, with curators expected to strengthen a profitable brand. And taking care of business is not restricted only to the US. Hans Ulrich Obrist, co-director of exhibitions and programs at London's Serpentine Gallery, notes that Harald Szeemann's list of "the curator as generalist" from the early 90s did not give fundraising a big role. "But since the second half of the nineties," explains Obrist, "fundraising has become the essential task of a curator, at least fifty percent of my work today has do with fundraising."[3] In these circumstances, it is no wonder that many curators have begun to view the isolated ivory tower of the art academy as a haven, dedicated only to artists making art.

Hans Ulrich Obrist interviewed by Paul O'Neill, in: Contemporary: Special Issue on Curators, No. 77, 2005, p. 94.

To return to our first question: the meaning of this mini-exodus for contemporary art practice is that curators' efforts, perhaps the efforts of the most innovative curators, will materialize with a marked delay. If curators used to take care of the present, many are now taking care of a budding future by teaching artists in training or other curators in training. Today's curating will take place tomorrow. It is an interesting, if not odd, spin on the avant-garde, which suggests that new curatorial ideas cannot be directly tested on the public but must be placed in a kind of time capsule for a few years – or more – of pedagogical incubation. Given contemporary art's unchecked expansion and these curators' retreat from that expansion, one may also wonder just how viable their ideas will be for the next generation of artists and curators currently under their tutelage. After all, if one curator's fundraising activities can rise from next to nothing in 1990 to an essential task in 1995 then what will happen to the class of 2010 taught by curators who left active duty around 2005? Their retreat will leave space for other curators and for younger curators, who face the same challenges without the benefit of accumulated experience. Another possibility – also raised by Kantor – is that the ivory tower of the academy will lose its status as a haven and be invaded by the very forces that these curators have sought to leave behind, from collectors to branding. Despite the curators' best intentions, their retreat may turn into an invasion, from an incubating avant-garde into a market avant-garde. How could a former artistic director of Documenta or the Venice Biennale not bring their influence and contacts with them? Indeed, Storr's

RIGHT ABOUT NOW | CURATING | Jennifer Allen | Care for Hire

move from MoMA to Yale may increase his studio visits, but collectors and dealers have long haunted the halls of Yale's School of Art and instantly ripened the fruit maturing there simply by picking it themselves. Moreover, to add dozens of art schools to art's "mustsee" international agenda of eighty-plus biennials, endless fairs, gallery shows and museum highlights seems like a nightmare, for both critics and curators. Then again, who would *not* be interested in making the trek to Bard to see what Lind is doing?

Those would be my quick reactions to the two questions. But there are many issues that need to be examined more closely. Or "unpacked," as curators are wont to say. First, let us reconsider the polarization of the freelance curator as vital critical force, which seems to be good, and the star curator as a mainstream integrator, which seems to be bad. It is not my polarization, nor would I agree that contemporary art becoming part of mainstream culture is an entirely negative phenomenon, let alone a reactionary one lacking any vital critical potential (consider the German media presence of Jonathan Meese, the public monuments of Thomas Hirschhorn or the monumental media scandals instigated by Maurizio Cattelan and by Santiago Sierra). Popularity, and certainly pop culture, are not the same as populism. But let us keep on unpacking the freelance curator's bags. Although I have not been given any names, I assume that the late and great Harald Szeemann would occupy the pole of the Ur-freelancer. As the legend goes, Szeemann famously broke away from the institution in 1969 by resigning his directorship at the Kunsthalle Bern when a commission voted to reject a Joseph Beuys exhibition.[4] That same year he founded his *Agentur für geistige Gastarbeit* – the Agency for Intellectual Foreign Labor, although this translation does not capture the historical resonance of the related term *Gastarbeiter*, the guest workers, who, in the case of the Turkish male laborers imported to West Germany during the same period to abet the *Wirtschaftswunder* (economic miracle), were expected to leave when the job was done. By casting the freelance curator as a temporary foreign guest, Szeemann mapped out a resolutely international freelance curatorial territory (true freelancers would have to work outside their native countries). Moreover, Szeemann completely reversed the curator's traditional role as a caretaker (while inadvertently creating a new charge for the museum curator). As Susan Crean noted in a 1986 study on Canadian freelancers, "The independents have separated the work of preparing exhibitions from the task of keeping collections."[5] As a guest, the freelancer should be taken care of during his stay – very much

4. For the complete biography, see: Hans-Joachim Müller, *Harald Szeemann: Exhibition Maker* (Ostfildern-Ruit: Hatje Cant Verlag, 2006).

5. Susan Crean, "The Declaration of Independents How Freelance Curators are Turning Canadian Galleries inside out," *Canadian Art*, Vol 3, No. 4, December 1986, p. 87. In Canadian English, a gallery can be a museum or a commercial gallery; Crean refers to the former.

like an artwork on loan in the exhibition – and might even expect some hospitality for his work, perhaps from the full-time staff at the hosting institution, curators and others.

Whether *Ur*-freelancer or guest worker, Szeemann was also undeniably a star who gave a new visibility – a mainstream visibility, often rife with lively public debates – to a professional who had remained almost resolutely behind the scenes of the art exhibition. Who can forget the 1972 black and white photograph of Szeemann as the "chief," surrounded by admirers and cameramen, sitting on the artist Anatol's "throne" at *Documenta 5*, which Szeemann directed?[6] While Szeemann demonstrated that star power could go hand in hand with vital criticism, many other independents became critical forces without sitting on a throne. Consider another example of a museum break-away from the same period: Peggy Gale, who left the Art Gallery of Ontario in Toronto in 1973 to become an independent curator "slash" critic specializing in video – then a new medium that was marginalized by museums and criticism. "I started writing because I got angry about the inadequate state of critical writing about video," recalls Gale. "I figured I should jump in."[7]

Like Szeemann, Gale had no choice but to leave the museum to work with the artists and the art that interested her. Yet by giving visibility to video instead of her own curatorial role, Gale managed quite remarkably to combine the independence of freelancing with the duration of caretaking; she seemed to operate not in a museum of obsessions but in a virtual video museum. Her long-term commitment to the medium has been crucial to its acceptance and indispensable for its history.

For both Szeemann and Gale, the problem was the conservative stodginess of the art institution. In the 60s and 70s, the institution – not the market or the mainstream – made full-timers into independents. As a bureaucratic institution, the university – where curators are taking refuge today – was not an obvious choice back then. Bruce Ferguson left his curatorial position at Ottawa's National Gallery in 1980 "largely because of the inability to function as an active curator. There was tremendous pressure to do nothing more than administration and bureaucratic work, which means that you become more and more removed from the artistic milieu and from the sources of cultural energy."[8] Ferguson's comments – made in 1986 – echo Storr's desire in 2007 to spend more time in artist's studios than with collectors and dealers. To get closer to art, curators once left museums; today, they might leave exhibition making altogether. That does not bode well for either exhibitions or art.

. Müller, op. cit., p. 37.

. Crean, op. cit., p. 86.

. Ibid., p. 87.

Before examining the curators who have decided to stick to exhibition making, let us look at another professional trajectory. As a star curator can be a critical force – even with a mainstream reach – an institution can also provide forceful criticism. Nicolas Bourriaud and Jérôme Sans, two freelance critics "slash" curators, ended up as the founding co-directors of the Palais de Tokyo in Paris. One might conclude that Bourriaud and Sans, by moving from independence to an institution, took a more conservative path than their predecessors Szeemann and Gale. Yet the overwhelming majority of France's 1,845 state-employed curators have diplomas from the prestigious Institut national du patrimoine (INP); since the minister of culture plays a major role in appointing directors to major public institutions, the chosen candidates tend to have long-term relations with the ministry. Bourriaud and Sans had neither. Their move from independence to institution is quite revolutionary, at least in France. However one views the Palais de Tokyo, its public success was crucial in putting contemporary art back on the national political agenda.[9]

Who are the stars? Again, I have not been given any names, but if I judge from *Contemporary* magazine's special issue on curating, many of the chosen twenty-two have stellar status if not mainstream appeal: from Daniel Birnbaum to Obrist; from Adam Szymczyk to Laura Hoptman; Jens Hoffmann and Beatrix Ruf.[10] While working as independents, most have institutional jobs. Birnbaum, who co-curated *Airs de Paris* for the Centre Pompidou in 2007, is rector at the Städelschule and director of Portikus in Frankfurt am Main; Szymczyk is co-curating the 5th Berlin Biennial with Elena Filipovic in 2008 while directing the Kunsthalle Basel. Indeed, these stars are not freelancing but moonlighting. The only true independents – in the *Contemporary* issue – seem to be Isabel Carlos and Edi Muka (Maurizio Cattelan is moonlighting from his artist job). In contrast to the earlier generation of Szeemann and Gale, contemporary curators who remain active in the field have no problem combining an institutional position with independent curating; they do not have to leave the institution to work with the art and artists that interest them. I am not sure how to judge this major generational shift. Perhaps institutions have become more open, less bureaucratic, lighter on internal conflicts, more attune to new developments in art (and the market), than they were thirty years ago. Perhaps it is impossible to live from freelancing in 2007. Maybe the moonlighting shows are the laboratory experiments of these curators, although few would admit that their institutional em-

9. The Palais de Tokyo – created as an independent association, not as an national institution – became so popular that the ministry of culture attempted to take it over by transforming its status to a *musée national*; with that move, then-minister Jean-Jacques Aillagon (a former Pompidou chief who now heads both Château Versailles and François Pinault's private collection at the Palazzo Grassi in Venice) would have named Bourriaud's and Sans's successor. See my: "Coup Debat: Jennifer Allen on the Palais de Tokyo in Transition," *Artforum International*, Vol. XLIII, No. 7, March 2004, p. 80. The attempt was unsuccessful, and the association's board named Marc Olivier Wahler as successor. The latest development is that the Centre Pompidou will expand to the unused part o the Palais de Tokyo building See: "Lancement du projet d'un nouvel espace d'art contemporain à Paris," *Agence France-Presse*, April 2, 2007.

10. See: *Contemporary: Special Issue on Curators*, op. cit.

ployers are not open to experimentation. Their forays outside the institution might be a way to combine travel and research with exhibition making. A way to new venues (Obrist co-curated the time-based group show *Il Tempo del Postino* with Philippe Parreno at the Manchester Opera House in 2007). Or a way to collaborate and to pool information with other curators, if not to strengthen international, inter-institutional links (for example, Birnbaum co-curated *Uncertain States of America* with Obrist and Gunnar B. Kvaran at the Astrup Fearnley museum in Oslo in 2005). Or even a way to give a political show the strength of international resonance (*Uncertain States of America* being an example). Perhaps this generation has learned how to combine the work of preparing exhibitions with the task of keeping collections, to combine innovation with care. While moonlighting, they make exhibitions and take care of them over time, almost as virtual museums (consider Hou Hanru and Obrist's *Cities on the Move*, a traveling venture that began in 1990).

These would be some positive interpretations of this generational shift. The negative readings are a bit disturbing. Art institutional culture spreads – not with its caretaking capacities but with its older problems of bureaucracy and its newer problems of donors, dealers and collectors. A smaller group of curators – that "exclusive group" traveling around the world and organizing all of the large-scale exhibitions, especially biennials – keep on meeting and pooling their information until the pool of artists gets smaller and dries up into an exclusive group of artists. There is less risk-taking; a few new artists suddenly appear all over the globe like an explosion – an almost instantaneous international visibility that just cannot be inducive to exploration but must rather promote the same old successful formula. There is less time for curators to meet with artists. Even less time to do curating well, to take care of the most basic public elements of the show, such as the final installation of the artworks (at the 2nd Moscow Biennial in 2007, Birnbaum, Kvaran and Obrist's co-curatorial effort *USA: American Video Art at the Beginning of the Third Millennium* – an apparent spin-off of *Uncertain States* – was roundly criticized for its installation; many of the thirty videos were shown with their sound turned off as there were no separation walls in the exhibition space)." Curators may inadvertently become part of a branding scheme, as the curator's institute and the host institute feed off each other's symbolic value (while commercial and corporate sponsors as well as private collectors and commercial galleries feed off both). The curator's home institution – or its major funder – prevents its curatorial star from doing a controversial show

1. See: Harry Bellet, "À Moscou, faible Biennale l'art," *Le Monde*, March 3, 2007, and: Samuel Herzog, "Ärger im 21. Stockwerk," *Neue Zürcher Zeitung*, March 4, 2007.

RIGHT ABOUT NOW | CURATING | Jennifer Allen | Care for Hire

because the show might shine badly on the home institution and the funder (worse, the curator aims for total safety on the road for fear of any bad publicity). Curators might end up inadvertently participating in the privatization of public culture by lending out the prestige of their public institution's name as they moonlight with their curriculum vitae in hand for private collectors, corporate collections, commercial galleries or art fairs (some of the brave new curatorial opportunities that have emerged since the 90s). In these worst-case scenarios, curating – and by extension exhibitions and art – become more mainstream in the worst sense of institutional conservatism.

That brings us back to mainstream culture. I have distinguished between popularity, pop and populism; I used mainstream and market interchangeably; and I just linked mainstream to institutions. Sloppy. Ultimately, I am not sure how to understand the mainstream, or how to measure its growing and shrinking presence, especially in the context of a global culture. In the 60s and 70s, when the art world's internationalism was far less global, it was likely easier to identify the mainstream in art and culture and to break away.[12] What is mainstream today? *Frieze* magazine making an art fair? When Gwyneth Paltrow and Claudia Schiffer show up? Or when their photographs appear in Artforum.com's "Scene and Herd" gossip column? Is it mainstream for Marc Quinn to sculpt Kate Moss, a favorite of both tabloids and high fashion? Or when the tabloids report on an artist's adventures, such as the late Jörg Immendorff's cocaine and prostitution fest in 2003; on an artist's work, such as Sierra's installation *245 Kubikmeter* of truck exhaust fumes in the synagogue in Stommeln, Germany in 2006; or on the price of an artwork, such as a Peter Doig painting auctioned for 11.1 million dollars at a Sotheby's sale in London in February 2007? Even curators can make headlines: Marion True from the J. Paul Getty Museum for allegedly trafficking antiquities in Greece; the team of Mai Abu ElDahab, Anton Vidokle and Florian Waldvogel from the cancelled *Manifesta 6* for getting sued by officials from the Greek Cypriot side of Nicosia, where they had planned to open a school that would cross the Green Line. Mainstream might exist beyond the press, in the ubiquity of E-flux, where many exhibitions are visited virtually (although we do not have an e-museum that could function like YouTube and make anyone a curator). English is the main language of the global art world, but who knows if that helps or hinders communication? The mainstream could be in visitor statistics, which increased in the UK after the entrance fees to public

12. The nation-state used to wield more power in the arts, through both funding and censorship – a power that has been taken over by corporate and commercial interests, especially in the US and the UK. See: Chintao Wu, *Privatising Culture: Corporate Art Intervention since the 1980s* (London/New York: Verso, 2002). During the Cold War, art was an ideological weapon – that could fight everything from capitalism to communism, from the bourgeoisie to misogyny – and then a commodity; today, the commodity role dominates and does not preclude ideological and political critique.

13. See: Marc Roche, "Les musées britanniques veulent prendre des couleurs," *Le Monde*, December 13, 2005. As Roche reported in 2005, people of color made up 30 percent of London's population, but only 6 percent of curators in the city's museums and galleries. "There are none at the National Gallery, Portrait Gallery or Tate Modern," wrote Roche. "None at the ICA, Serpentine and Barbican. There are ten from the 230 at the British Museum, but they are all working in the departments dedicated to primitive art, as is also the case at the V&A (8 from 95)."

14. Christoph Tannert and Ute Tischler (eds.), *Men in Black: Handbook of Curatorial Practice* (Frankfurt am Main: Revolver, 2004). Promising is the recent publication: Paul O'Neill (ed.), *Curating Subjects* (Amsterdam: De Appel, 2007).

15. See: Tannert, "Curators as Technicians," in: Tannert and Tischler, op. cit., pp. 135–136.

16. See: *Contemporary: Special Issue on Curators*, op. cit., Subsequent quotes are taken from this issue, which is divided into chapters on each curator.

museums and galleries were eliminated by the government (4.1 million visitors in 2005 at the Tate Modern alone). A big show like Enwezor's *Documenta 11* got 650,000 visitors over 100 days in 2002. But 4.1 million and 650,000 visitors – whether good or bad mainstreaming – are nothing against the astronomical sales for movies and music. The astronomical figures in the art world are the auction prices at Christie's and Sotheby's contemporary sales. Mainstream might be an expanding globalism – an auction in Dubai, a fair in Mallorca, a new biennial anywhere – which could reinforce the existing powers, or really change the players. The Arts Council of England's training program "Inspire" – which seeks to increase the number of visible minorities holding curatorial and management positions at British museums and galleries – might succeed in making such changes and prove that the mainstream actually lies in the origins of curator's body.[13]

I do not have the answers. But I did not get many answers about curating either in the course of research for this essay, despite the institutionalization of the profession through the many curatorial training programs that emerged in the 80s and 90s, from the École du Magasin to the Whitney Program, to name only two. Among curators, there is little consensus about what curating is. During a visit to Amsterdam in 2005, I asked the students at De Appel's Curatorial Training Program for a definition; they told me that they were learning to live with no sleep. Reading compendiums of curators' statements – from the lighter *Contemporary* special issue on curating to the much weightier *Men in Black: Handbook of Curatorial Practice* (2004)[14] – I did not get any insider secrets or practical tips: fixing a scratched frame, getting a quick visa, how to deal with irate guards, missing funds or even late essays. Curators tend to explain what they do either by referring to specific exhibitions they curated or by making rather abstract statements about art, publics and politics. Curating exists either as an example or as an abstraction; there seems to be no general theory about the practice. In *Men in Black*, the only person to mention the word "hammer" was Christoph Tannert, who offered of a rather handy list of tools needed for setting up an exhibition (good tip: fishing line!).[15] In *Contemporary*, the only curators to discuss physical space were Isabel Carlos, who said that she would not organize a traveling show because she would not be able to show the same artworks in different spaces, and Hou Hanru, who explained how he plans out an exhibition.[16] RosaLee Goldberg was the only curator interested in one medium, namely performance. And Udo Kittelman was the

only traditional curator: taking care of the permanent collection at Frankfurt's Museum für Moderne Kunst. Many evoked other professions to explain their own: Franceso Bonami, the author; Dan Cameron, the researcher; Yuko Hasegawa, the catalyst and intermediary; Jens Hoffmann, the theatre director. Even on the issue of time there was no consensus: Birnbaum wants to "understand the immediate contemporary time," while Suzanne Cotter wants to put "timeless" works into a dialogue, and Obrist seeks to fight against the "homogenization of time" by creating time zones within one show. Indeed, from my bystander perspective, the practice of exhibition-making seems much like rainmaking. Who knows exactly how they do it? Sometimes it works; sometimes it does not; but you always hope that it will; and you know when it does.

BEATRICE VON BISMARCK
UNFOUNDED EXHIBITING
POLICIES OF ARTISTIC CURATING

It has become a standard and accepted practice in the cultural field since the 1990s (at the latest) for artists to take over various tasks that were once the reserve of the curator. This not only includes producing texts, but also encompasses the conception of exhibitions themselves, as well as their design and accompanying programming. But the strategies pursued here vary decidedly. The blurring of the boundaries between what were once separate professional tasks can allow for the successful establishment of new or hitherto barely noticed artistic approaches, encourage the development of collective work structures, or create expanded options for critical, discursive or institutional analyses. Positions as widely varied as those of Andrea Fraser, Damian Hirst, Goran Dordevic, Julie Ault, IRWIN, Christian Philipp Müller, or Andreas Siekmann and Alice Creischer mark in an exemplary way the broad spectrum of curatorial artistic practice. Furthermore, art critics and theorists, philosophers, literary scholars and sociologists are also pushing their way into this terrain, which for many years had been reserved for the discipline of art history. And, at the same time, from the academic side border incursions into the realm of art take place repeatedly. However, to conclude that this trend towards blurring boundaries means that artists and curators are able to freely exchange tasks with unlimited ease, that any role can be adopted by any actor in the artistic field, ultimately falls short. That would suggest an arbitrariness in the formation of the professions in the art field, and not only ignores the specifics of the artistic approaches from

which, in historical retrospect, these mutual role transgressions resulted, but also the hierarchies, exercises of power and status ascriptions that could be negotiated with these transgressions. It thus neglects a potential in artists' curatorial work of using self-reflexive approaches to disturb the dominant relations in exhibitions between locations, objects, exhibitors and publics. The following will explore the shifting and thus also politically relevant perspectives that intersect in the aesthetic, semantic, social and economic aspects of curating.

For this purpose first another look back: the ease with which artists now transgress into the realm of the curator had its origins in two key developments from the late 1960s. On the one hand, Conceptual Art and so-called Institutional Critique directed the focus from an object-based art to an art rooted in ideas, art with a relational and discursive constitution. In a 1989 article summing up the historical role of Conceptual Art, Benjamin Buchloh said that this movement subjected the relationships among author, work and audience to a radical redefinition, a redefinition that destabilized both the hierarchical position of the closed, unified work and the privileged position of the author.[1] One consequence of this approach was that the activities and contexts that participate in the production of meaning were made a component of artistic practice. It was as part of this development that the appropriation of curating took place. In this way, Marcel Broodthaers, Hans Haacke, Michael Asher or Daniel Buren thus broadened their activities to include selecting, compiling, arranging, presenting and transmitting the work of other artists, cultural goods and public or institutional spaces. From a critical distance, they confronted the criteria of curatorial practice that were standard until that time, with their own guidelines as alternatives. In so doing, the exhibition space itself became integrated into the artistic engagement. Decisive for the treatment of the exhibition space is that it is conceived as doubly contextualized, in both a physical as well as a social framework. As Juliane Rebentisch points out, this reflects the insight already formulated by Adorno that every experience of an artwork is related to a location in both a literal and a metaphorical sense: an insight that for art today is on the whole not up for negotiation. Advanced artistic practice today thus always proceeds in an "installative" fashion, keeping the surrounding space in mind.[2] The essential decisions on making art visible and the positions from which these decisions are made, the criteria that lie at their foundation, as well as the forms of address they imply, are now

1. Benjamin H.D. Buchloh, "Conceptual Art 1962–1969: From the Aesthetic of Administration to the Critique of Institutions," *October*, No. 55, 1990, pp. 105–43.

2. See: Juliane Rebentisch, *Ästhetik der Installation* (Frankfurt am Main: Suhrkamp Verlag, 2003), p. 232.

up for disposition – also at the hands of artists – and flow into context-related techniques.

On the other hand, parallel to this, in the course of the rapidly increasing activities in the art field of the 1960s and its differentiation, a new profession began to form: that of the freelance curator. The prototypical example here is the Swiss curator Harald Szeemann. Ever since leaving Bern's Kunsthalle in 1969, he has worked exclusively as a freelancer on a project-by-project basis in a structure he called an "agency for intellectual guest workers [Gastarbeiter]." In 1972, he was the first *Documenta* curator in the history of the exhibition to set an overarching theme, thus providing guidelines to which the invited artists had to subordinate themselves. Szeemann thus created a position for himself in a field where exhibitions still consisted of individual artistic objects, but generally had become the "works" of their curators. The later hype built up around this, setting in at the latest in the 1990s with the "exhibition auteur," is tellingly accompanied by the de-professionalization of the curator, as Nathalie Heinich and Michael Pollak have shown.[3] For the curator, schools, which since then have seemingly been sprouting up everywhere, are not the primary source of the cast chosen to organize the most prominent freely-curated exhibitions. Instead, it has been figures like Hans Ulrich Obrist or Roger M. Buergel, who came from other professions and precisely did not follow a normative curating career, who have attained the most prominence in the area.

The potential for conflict among agents encountering one another in the same area of operation ignites around the question of who can claim to produce meaning. Artists argue against the organizers of thematic large exhibitions or exhibition-makers stylized as "super-artists," that they are being denied the power to determine the appearance and the contextualization of their works. Curators have become far too important in relation to artists – this was the initial tenor of a lecture series organized by the artist Susan Hiller in Newcastle in 2000. This tendency, it was argued, should now be resisted by once again placing artists "at the center."[4] The discussion continues a debate already initiated by Harald Szeemann's 1972 *Documenta*: while several artists responded to the dominant position of the curator in setting the theme by withdrawing their participation, others protested publicly by publishing letters or articles, by conceiving their own contribution to the exhibition as a critical commentary, or – as in the case of Daniel Buren – by transforming the exhibition itself into the battleground of a struggle over

, Nathalie Heinich and Michael Pollak, "From Museum Curator to Exhibition Auteur: Inventing a Singular Position," in: Reesa Greenberg, Bruce W. Ferguson and Sandy Nairne (eds.), *Thinking about Exhibitions* (London/New York: Routledge, 1996), p. 238.

. Sune Nordgren, "The Producers: Contemporary Curators in Conversation, 9th March, 2000, University of Newcastle, Department of Fine Art. James Lingwood and Sune Nordgren in conversation, chaired by Professor John Milner," in: Sarah Martin and Sune Nordgren (eds.), *The Producers: Contemporary Curators in Conversation* (Gateshead: BALTIC, 2000), p. 21.

definitional power. For the relationship between artist/curator, Buren's positioning became a kind of historical turning point, as he defined it as competing and dynamic, and in so doing also as a productive one. He showed how the authority hitherto ascribed to both artists and mediators was the result of relationally determined processes of aesthetic, discursive and social acts, thus providing the critique of those authorities as it had been exercised in art since the 1960s, with a model of equal negotiating status. With the even color stripes, typical of his work, which Buren installed in various rooms beside and behind the other artworks on display, his contribution to the catalogue, and the compilation of a bibliography that consisted solely of texts that he played a role in creating, Buren undertook an act of self-empowerment on numerous levels. He appropriated tasks that belonged to the curator's core area of activity, and in so doing transformed both those exhibiting with him as well as the exhibition as a whole into an object and part of his work. Buren's *Documenta* contribution theatrically displayed the various techniques that are bundled in exhibiting, along with their conditions, thus re-appropriating the definitional participation that other protesting artists had already thought lost.[5]

Ultimately, this controversy represented yet another variation in the debates circling around the crisis of the author, in which the dominant role of the "creator" in producing meaning in a work was asserted anew. The dissolution of the unified artist-subject and the freeing of artistic work to engage in social, economic and discursive systems of reference is emblematically embodied by the figure of the curator and his always already relationally defined role, which is per se structured by a multiple bind, since not only the exhibiting artists need to be satisfied, but also the institution as employer, patron and financer - not to forget the various possible audiences of the show. Whereas in a situation of clear professional differentiation, the curator position is supposed to serve the ends of artistic expression, seeking the best-possible mode of presentation for a posited prior meaning of the object, the blurring of curatorial and artistic realms dissolves both the unity of the artwork as well as that of the artist subject. Furthermore, they exemplify a transformed definition of artistic work that goes beyond the replacement of the triumvirate of "author, art work and creative act" by that of "producer, work and production" which took place in art in general after 1960. Here, the figure of a manager of information, objects, locations, money and people begins to establish itself, a figure whose work consists in connecting, and whose multifaceted

5. For more on Daniel Buren's work at *Documenta 5*, see: Beatrice von Bismarck, "Der Meister der Werke. Daniel Burens Beitrag zur *Documenta 5* in Kassel 1972," in: Uwe Fleckner, Martin Schieder and Michael Zimmermann (eds.), *Jenseits der Grenzen: Französische und deutsche Kunst vom Ancien Régim bis zur Gegenwart* (Cologne: DuMont 2000), pp. 215–29.

product can be described as a set. The term "set" links two meanings: things that – for a limited amount of time – are considered to belong together on the one hand, and associations with the realm of theater and film on the other, that is to say: the stage or place prepared for the mise-en-scène. It is no accident that the subject position constituted here also exhibits similarities to the performing arts, since it corresponds to the tasks, authority and status of the theater or film director in multiple ways: his or her activity consists essentially in staging the given conceptual guidelines with the help of the personnel and material media he or she organizes. Stylized as "auteur," he or she thus marks the last bastion against the loss of authority of the artist-subject, indeed mobilizing its mythical functions once again.[6] The filmic "auteur" condenses the reclamation of the status of the author as expressed in post-minimal, site-specific artistic modes of working, like those of Bruce Nauman or Richard Serra.

But it should also be remembered that film directors and curators differ quite fundamentally on one point: in the case of the latter, no final remaining products are produced. In contrast to works of film, which take on a material form that surpasses their presentation or projection, a form that can turn it into a collected, stored and tradable good, a curatorial product exists for only a limited time, to then again disintegrate into its individual components, which only then can once more be traded. More like a theater director, the curator allows a temporary constellation to emerge in which spatially and temporally structured layers of meaning are brought to confront one another. While often only limited to one or just a few presentations, the analogy between theater performance and art exhibition exposes the processual moment that inheres in curating. As in the theater, the stages of emergence and presentation are addressed in this way, as are the relational dynamics during development and performance. On this basis, the two decisive aspects that are at issue in the competition between artists and curators can be set in relation to one another: on the one hand, the status of those who claim the power to produce meaning and, on the other, the techniques used to produce that meaning.

The primary issue in this competition for the authorial position in the curatorial realm is the artist's or curator's respective scope of action. In the 1998 Leipzig exhibition *Weather Everything*, the French curator Eric Troncy hung a pictorial object by Bazile Bustamante on a wall decorated with Warhol wallpaper, and grouped various female figures by Duane Hanson, Katharina Fritsch, and Helmut Newton

, See: Diedrich iederichsen, "Künstler, uteurs und Stars: Über nenschliche Faktoren 1 kulturindustriellen erhältnissen," in: Gregor temmrich (ed.), *Kunst / ino*, yearbook (Cologne: ktagon, 2001), pp. 43–56.

RIGHT ABOUT NOW | CURATING | Beatrice von Bismarck | Unfounded Exhibiting

along an axis of vision.[7] If one reduces this procedure exclusively to the combinatory act it exhibits similarities to Buren's combinatory act at *Documenta 5*, placing artistic objects in contexts that not only counter the white cube's logic, but define it in an emphatically relational way, even if by way of tensions and contrasts. But Troncy's arrangements are also engaged in an antagonistic relation to artists that fortifies authorities rather than making them negotiable. The attitude is one of saying "I" as a curator, refusing to stand in the service of the works exhibited and instead providing a "personal" alternative design.[8]

The defensive reactions triggered by such a position deny curators with a non-artist background the right to this kind of reinterpretation. It picks up the critique already formulated at the 1972 *Documenta* and continues it in a form of re-hierarchization that consists, for example, in the emphatic refusal of artists to be called curators. It mirrors, above all, a form of attributing status in the artistic field, which, regardless of the acts performed, decides upon the scope for maneuver. The relationship between curators and artists can thus be described as analogous to the relationship between priests and prophets as defined by Pierre Bourdieu. The priest, according to Bourdieu, possesses authority by virtue of his office, and exercises control over access to the means of producing, reproducing and distributing the sacred by belonging to the church. He defends and maintains the existing doxa and sees himself as a mediator between God and humanity.[9] Applied to the field of art, the mediators take on "gate-keeper" functions in their role as "priests," watching over the possibilities of producing, presenting and distributing art, mobilizing the valid set of values and rules in judging art as art, and consider themselves as agents between art and the audience. But whoever tips the balance of this mediating position and dares to transgress to the side of art producers violates the rules. In the religious field, this would correspond to the transformation of priest to prophet. Here, power stems not from the office but from the individual's personality and charisma. He or she is interested in producing and distributing "new sacred goods," something that can also serve to discredit the old. The group of initiates that gathers around him, as befitting the process of sacralizing former sacrilege, can develop from a sect to a church and thus become the new administrators of the true doctrine.[10]

If institutional and charismatic power are played out against one another in the two positions of priest and prophet, curator and artist, this means for the current situation of curatorial practice

7. The exhibition *Weather Everything*, along with another show curated by Troncy in Le Magasin, Grenoble – *Dramatically Different* (1997) – is documented in: *Weather Everything* (Leipzig: Galerie für Zeitgenössische Kunst, 1999).

8. See in this sense the introduction that Eric Troncy had printed in the accompanying volume to the conference: "If in the beginning of the 1990s, the curator could behave as a simple producer, he may now be in the position to say 'I', and manipulate artwork in order to produce a very personal vision of art." (*Die Kunst des Ausstellens / The Art of Exhibiting*, International Conference, Stuttgart, 2001)

9. See: Pierre Bourdieu, *Das religiöse Feld: Texte zur Ökonomie des Heilsgeschehens* (Constance: Universitätsverlag Konstanz 2000), pp. 78–81.

10. Ibid., pp. 79–82.

, In contrast to the
priest, Bourdieu writes
in the prophet's accrual
of authority: "They need
to realize the original
accumulation of religious
capital by constantly
achieving and re-achieving
an authority that is subject
to the constantly fluctuating
regularities of the
relationship between the
offer of religious services
and the religious demands
of a special category of
layperson." (Ibid., p. 78.)

2. Ibid., p. 80.

3. These relations form
the background for the
conference organized in 1994
in Services, an exhibition
held in the Kunstraum,
Universität Lüneburg. See:
Helmut Draxler, Andrea
Fraser, "Services: A Proposal
for an Exhibition and a
Topic for Discussion," in:
Beatrice von Bismarck,
Diethelm Stoller and Ulf
Wuggenig (eds.), Games,
Fights, Collaborations: Das Spiel
von Grenze und Überschreitung.
Kunst und Cultural Studies in
den 90er Jahren (Ostfildern-
Ruit: Hatje-Cantz Verlag,
1996), pp. 196–197; "Services:
Working Group Program
at the Kunstraum der
Universität Lüneburg."

4. See: Yann Moulier
Boutang, "Vorwort," in:
Toni Negri, Maurizio
Lazzarato and Paolo Virno
(ed. by Thomas Atzert),
Umherschweifende Produzenten.
Immaterielle Arbeit und Subversion
(Berlin: ID, 1998), p. 13.

in the artistic field that especially free curators, due to their lacking institutional anchorage, need to rely on personal charisma by which they acquire authority in a processual manner.[11] Like the prophets, this entails allying oneself more closely to the object of mediation than to the mediating authority or the audience. If prophets are characterized by the fact that they are not, like priests, humanity's advocate before God, but rather the mediator of God to humanity,[12] something analogous can be said about curators: they are less advocates of the various art audiences vis-à-vis artists and art but rather the agents of art and artists in public.

In turn, artists can, through their curatorial activities, participate in the institutional securities and claims that are otherwise denied them in project-based work.[13] For the limited time of the preparation and realization of the exhibition, their work undergoes a treatment that makes it comparable to institutionally administrable procedures, and thus worthy of a compensating honorarium. And they find themselves again in the "priestly" role of "gate-keeper," allowing them to decide on the access, contextualization and positioning of works and fellow artists. All the same, this change of roles is not without its own sacrifice: while curators take on the artist's precarious working situation, artists in curatorial roles often lose their special status as beyond the everyday and hence charismatic.

The conflicts around the economic and symbolic compensation of artists' curatorial work make the profits of the mutual exchange outweigh the downsides only when the roles taken are held in process. The oscillating between various duties and requirements as well as the flexible expansion and transformation of one's own activities make it possible to understand the ascription of the "prophet" status as something mobilizable, ready for action. The prerequisite for this is divorcing the tasks from the roles and their conscious and variable re-articulation. For that, curating can in a very basic sense be described as the practice of establishing contexts and constellations among objects, persons, sites and contexts. Preliminary conceptual work, selection, combination, presentation and discursive mediation intersect with one another. Within artistic practices, they take the place of material production and can thus be compared with those forms of labor that for Maurizio Lazzarato mark post-Fordist economic structures. Meant here are activities in the so-called secondary service sector, like management, organization, consulting, publishing and teaching, activities that rely on knowledge and skills in using information and culture.[14] The over-

proportional increase in this area of labor and its structures over the past few years must also be seen in relation to the increased attention that has been paid to curatorial activities since the 1990s, for it is here that intersections result between the cultural and economic fields, which also play a key role in the current social position of artists. In the model function attributed to the artist in terms of economic labor conditions, these "immaterial" activities wind up being linked to concepts such as freedom and self-determination, but also to self-administration and self-optimization.[15]

These "economistic" appropriations ignore the fact that these activities are acts of transformation: the processing, reprocessing or revising of existing information or cultural goods, and their translation in terms of media and context. Functionalization according to economic criteria of efficiency thus constantly runs the danger of being undermined or counteracted by possible parallel conceptualizations; for curatorial practice bears the potential for allowing the overlapping of meanings to such a degree that they exhibit a kind of resistance. Just as artistic objects are able to maintain an element of their original, context-determined significance in an exhibition, even if they are subject to a "clearinghouse" effect, which – as Allan Sekula described for collections of photography – tears them from their traditional contexts of meaning,[16] various meanings of the site also overlap with one another. This exemplifies what Juliane Rebentisch attributes to sculptures and "installative" interventions: that they constantly constitute a space of "their own," in which they aesthetically "grant and fill [einräumen]" their public or institutional space, making it "legible through themselves."[17] Curatorial acts intend to bring the various determinations of the individual elements with which they work into relation with one another, and in so doing do not create any fixed images or stills, but for their part generate processual events that are set in motion by way of relational tensions and crises, acts of reception, or the mobility of what is collected.

In this way, for example, with *Outdoor Systems, Indoor Distribution* (2000) Julie Ault and Martin Beck transformed the exhibition space of Berlin's Neue Gesellschaft für bildende Kunst (NGBK) into a field of experimentation in which they explored the conditions of emergence, characteristics and effects of space. This staging was conceived as exemplary, "as if the space itself would be a testing ground for how certain spaces can be constructed, and how that process can be shown within the format of an exhibition."[18] Urbanist and architectural constructions of space were brought to

15. See: Ulrich Bröckling, "Totale Mobilmachung: Menschenführung im Qualitäts- und Selbstmanagement," in: Ulrich Bröckling, Susanne Krasmann and Thomas Lemke (eds.), *Gouvernementalität der Gegenwart: Studien zur Ökonomisierung des Sozialen* (Frankfurt am Main: Suhrkamp, 2000), pp. 142 and 157.

16. See: Allan Sekula, "Reading an Archive," in: Brian Wallis (ed.), *Blasted Allegories: An Anthology of Writings by Contemporary Artists* (New York/Cambridge MA)/ London: 1987 [1993]), p. 117. (Selected passage from: "Photography between Labour and Capital," in: *Mining Photographs and Other Pictures, 1948–1968* (Halifax: 1983).

17. Rebentisch: op. cit., p. 262.

18. Julie Ault and Martin Beck, "Exhibiting X: Methods for an Open Form," in: idem (eds.), *Critical Condition: Ausgewählte Texte im Dialog* (Essen: Kokerei Zollverein, 2003), p. 380.

intersect with various modular forms of exhibition display; utopian fantasies found themselves confronted with the reality of their execution; structures, intensions and functions of the exterior space grew wildly into the space of the NGBK. With a multiplicity of presentation techniques, Ault and Beck guided visitors through the space, setting the audience into discursive as well as physical motion. In so doing, the linkage, overlapping and interpretation of various contexts served not least to interrogate quite fundamentally the conditions and possibilities of exhibiting. They thus allowed the realms of outside and inside, contoured both by society and more specifically by the art field, to interpenetrate one another, just as they placed their own role between artistic and curatorial speaking positions, between production and immaterial labor. The NGBK served as a site of struggle, a field of action and an object of study at one and the same time.[19]

In 2003–2004, Christian Philipp Müller practiced this process-oriented form of dealing with the roles and tasks potentially tied to the curatorial in different stages. The multiplication of functional interlacing and references is already implied in the title of the three-part exhibition on the work of the couple Hans and Marlene Poelzig: *Im Geschmack der Zeit: Das Werk von Hans und Marlene Poelzig aus heutiger Sicht (In the Taste of the Time: A Contemporary View of the Work of Hans and Marlene Poelzig)*. This title not only indicates that Poelzig's way of working was very pragmatically oriented to the respective aesthetic preferences of his surroundings, but also that the exhibition sought to illustrate the various references from which the changeability of style derive. As the exhibition traveled from Berlin to Frankfurt am Main to Basel, Müller placed the material in various spatial situations that each stood in a specific relationship to Poelzig's work: the apartment house in Berlin's Weydinger Straße 20 on Rosa-Luxemburg-Platz and the former administrative headquarters of IG Farben AG in Frankfurt am Main stood for the architect's different orientations over the course of his career, while in Basel's Architekturmuseum a form of historical distancing stepped in place of the biographical references. In each of the three exhibitions, Müller rearticulated the physical and functional characteristics of the space, altered the selection and arrangement of the material, changed the character of the overall impression, and declared the conditions under which the exhibitions in each case came to be a subject of the exhibition. In the course of the three stages, Müller subjected his own position to continuous transformation, placing himself first in the role of the artist commissioned

19. On the execution of the exhibition in a publication format, see: Julie Ault and Martin Beck, *Outdoor Systems, Indoor Distribution* (Berlin: NGBK, 2000).

to realize a project, then as a member of a team complemented by academics and project leaders and, finally, in the role of a curator treating historical material. The different modes of work done, the roles taken on, and the various forms of presentation within the project intersect to form a dynamic web of relations between artists and curators, which leads to the project's independent, critically employed free space of interpretation.[20]

When Susan M. Pearce terms exhibition materials "objects in action" that carry meaning, take it on and alter it continuously,[21] she is describing a form of dynamic that results from the curatorial practices as practiced by Ault/Beck and Müller. Such a practice that accounts for the movement that can emerge through different audience groups and by the forms of addressing them[22] as well as in spatial re-contextualizations or variations in constellation, by way of display, accompanying programs, or reformatting as a catalogue, ultimately represents a continuation of site-specific modes of working. But it also goes beyond this, placing the accent even more emphatically on processuality, contingency and the generation of space. Here is where we can locate the critical potential that Marion von Osten attributes to her own curatorial activity[23] – a potential that Michel de Certeau calls "criminal." The space-generating physical and discursive movements he engages in maneuver between the codes and serve to temporarily combine various things, to then separate them again. The space that they generate over and over again is, for its part, formed and saturated by conflict programs and contractual agreements[24] that can again offer an occasion for new formations. In the curatorial practice of artists, this ability is located in an un-clarifying of the norms that decide on the status of those participating in the production of meaning, in the expressly transitory creation of significance and the performance of its processes.

20. On the exhibition project, see: Christian Philipp Müller, *Im Geschmack der Zeit: Das Werk von Hans und Marlene Poelzig aus heutiger Sicht* (Amsterdam/Berlin: Verein zur Förderung von Kunst und Kultur am Rosa-Luxemburg-Platz, 2003).

21. Susan M. Pearce, *Museums, Objects and Collections: A Cultural Study* (London: Prentice Hall, 1992, pp. 210–211).

22. On the aspect of addressing various publics and their effects, see for example: Irit Rogoff, "How to Dress for an Exhibition," in: Mika Hannula (ed.), *Stopping the Process?* (Helsinki: NIFCA, 1998); Miwon Kwon, "Public Art as Publicity," in: Simon Sheikh (ed.), *In the Place of the Public Sphere?* (Berlin: b-books, 2005).

23. Marion von Osten, "A Question of Attitude: Changing Methods, Shifting Discourses, Producing Publics, Organizing Exhibitions," in: Sheikh, op. cit., p. 158.

24. See: Michel de Certeau, *The Practice of Everyday Life*, (trans. Steven Rendall), (Berkeley: University of California Press, 1984), here: pp. 117 and 129.

This article was first published in: Matthias Michalka (ed.), *The Artist as ...*, Nuremberg/Vienna: Museum Moderner Kunst/Stiftung Ludwig, 2006, pp. 33–47.

ACKNOWLEDGEMENT

Acknowledgements

In early 2005 two Amsterdam art institutions, W139 and the Stedelijk Museum Bureau Amsterdam (SMBA), decided it was time for a critical review of the significant trends in the art and theory of the past fifteen years. It quickly became clear that this project could only be realized in collaboration, so the Stedelijk Museum and the department of modern art at the Universiteit van Amsterdam were approached. The collaboration with the university was a particularly alluring prospect, as the organizers were aware that the project offered a great opportunity to revive the dialogue between the practice of art and its academic study – a dialogue that had fallen silent of late.

The collaboration initially resulted in a series of lectures, entitled *Right about Now: Art and Theory since the 1990s*. The lectures were held monthly from November 2005 to June 2006 in the university auditorium, located in the center of Amsterdam, and were aimed at a broad audience. An international group of speakers, both old hands and newcomers, all experts in the fields of art journalism, art history and related disciplines, made highly interesting contributions to the discourse in relation to the different themes of the series. The lectures were very well received and attracted large audiences, and plans to edit the most successful lectures for publication in order to make them accessible to an even broader public soon took shape. The organizers – Jelle Bouwhuis, Ann Demeester, Xander Karskens, Mischa Rakier and Margriet Schavemaker – are proud that these plans have finally come to fruition and hope that the publication will encourage critical reflection on the developments in the art and theory of the recent past, for interested laymen and seasoned art professionals alike.

The *Right about Now* lecture series and the publication would never have come about without the financial support of the Mondriaan Foundation and the Prins Bernhard Cultuurfonds. In addition, the organizers would like to thank the following people and institutions: the entire organization of W139 (in particular Jowon van der Peet), the trainees Judith Vrancken and Katja Sokolova, the designers of the superb flyer, poster and website Julia Born and Laurenz Brunner, translator Lynne Richards, copy editor Rachel Esner, photographer Cassander Eeftinck Schattenkerk, graphic designer Esther Krop, and Astrid Vorstermans of Valiz Publishers.

They cannot be praised highly enough for their enthusiasm and commitment to the project. Finally, and this goes without saying, the organizers are most grateful to the authors who contributed to this publication in such an interesting and often quite challenging way – our thanks go to all of you.

Margriet Schavemaker and Mischa Rakier

INDEX

A

CON
TRIBU
TORS

Jennifer Allen

is a critic living in Berlin, writing for *Artforum*, *Metropolis M* and many other art journals. She recently compiled the publication *Atelier van Lieshout* (Rotterdam: 2007).

Sophie Berrebi

is assistant professor of modern and contemporary art and the theory of photography at the Universiteit van Amsterdam. She is co-director of the research project *Photography, Film and Displacement* at the Amsterdam School for Cultural Analysis (ASCA) and is currently working as a postdoctoral fellow of the Getty Foundation, researching the book-length project *Jean Dubuffet and the Culture of Modernism*. She was curator of the exhibition *Documentary Evidence* (Paris, 2004).

Claire Bishop

is assistant professor of art history at Warwick University. She is also visiting professor in the Curating Contemporary Art department at the Royal College of Art, London, and has taught at the University of Essex and Tate Modern. Bishop was an art critic for the London *Evening Standard* (2000-2002) and regularly contributes to art magazines, including *Artforum*, *October* and *Tate Etc*.

Beatrice von Bismarck

is an art historian and professor at the Hochschule für Grafik und Buchkunst Leipzig, where she also works as joint director of the /D/O/C/K project. She is also associate director of the Kunstraum of the Universität Lüneburg, which has hosted a number of contemporary art projects, including *Interarchiv* (1997-1999) with Hans-Peter Feldmann and Hans Ulrich Obrist, and the ongoing project *Die Ökonomische Kette* with Peter Weibel.

Maaike Bleeker

is a professor of theatre and dance at Universiteit Utrecht. In her various publications, such as *The Locus of Looking: Dissecting Visuality in the Theatre* (Amsterdam: 2002) and *De theatermaker als onderzoeker* (Amsterdam: 2006), she investigates the role of bodily experience in the perception of contemporary installations art and theatre.

Jeroen Boomgaard

is assistant professor of modern and contemporary art at the Universiteit van Amsterdam and professor of Art and Public Space at the Gerrit Rietveld Academy. Boomgaard is the author of *The Magnetic Era: Video Art in the Netherlands 1970-1985* (Rotterdam: 2003) and publishes regularly in *De Witte Raaf*.

Nicolas Bourriaud

worked as joint director of Palais de Tokyo in Paris from 1999-2005. He is the founder of the magazine *Documents* (1992-2000) and author of *Relational Aesthetics* (Dijon: 1998) and *Postproduction* (New York: 2001).

Deborah Cherry

is a professor of modern and contemporary art at the Universiteit van Amsterdam and editor of the magazine *Art History*. Her publications include *The Edwardian Era* (London: 1987), *Treatise on the Sublime* (London: 1990), *Painting Women: Victorian Women Artists* (London: 1993), *Beyond the Frame: Feminism and Visual Culture* (London: 2000), and *Speak English* (Glasgow: 2002). She is currently completing a study of contemporary installation art.

Hal Foster

is Townsend Martin Professor of Modern Art at Princeton University and a regular contributor to the international art magazine *October*. He is the author of *The Return of the Real: The Avant-Garde at the End of the Century* (Cambridge: 1996) and most recently of the joint effort *Art since 1900: Modernism, Antimodernism and Postmodernism*, with Rosalind Krauss, Yves-Alain Bois and Benjamin Buchloh (London: 2005).

Vít Havránek

is a Prague based curator, writer and director of Transit, an initiative for contemporary art. He is co-curator of *The Need to Document* (Basel, Lüneburg and Prague, 2005), a project focusing on underlying motivations and the salient features of the documentary attitude in art. Havránek has published regularly in such magazines as *Detail*, *Textes sur l'art* and *Art Press*.

Marc Spiegler

is a former political reporter based in Zurich. He writes extensively on the art world's controversies, networks and market places for magazines such as *Artnews*, *Art Review* and *The Art Newspaper*.

Olav Velthuis

has worked as assistant professor of sociology at the Universität Konstanz and was a visiting scholar at Princeton University and Columbia University. He is the author of *Imaginary Economics* (Rotterdam: 2005) and currently writes on economics for the daily Dutch newspaper *De Volkskrant*.

Kitty Zijlmans

is professor of contemporary art history and theory at the Universiteit Leiden. She is particularly interested in on-going intercultural processes and the globalization of the (art) world.

Editors

Mischa Rakier

studied fine arts at the Hogeschool voor de Kunsten, Arnhem and De Ateliers, Amsterdam, and art history at the Universiteit van Amsterdam. He works as an artist, freelance critic and curator, and publishes regularly in various art magazines such as *HTV* and *Jong Holland*. Rakier co-organized the lecture series *Right about Now: Art and Theory since the 1990s*.

Margriet Schavemaker

teaches modern and contemporary art at the Universiteit van Amsterdam. She has written a dissertation entitled *Lonely Images: Language in the Visual Arts of the 1960s* (Amsterdam: 2007) and has been (co-)organizer of a variety of international conferences (*Art and the City*, Institute of Culture and History, Universiteit van Amsterdam, 2006). Schavemaker co-organized the lecture series *Right about Now: Art and Theory since the 1990s*, which formed the starting point for this publication.

Colophon

Editorial board of lecture series: Jelle Bouwhuis, Ann Demeester, Xander Karskens,
Mischa Rakier, Margriet Schavemaker www.rightaboutnow.nl
Compilation and editing: Margriet Schavemaker, Mischa Rakier
Authors: Jennifer Allen, Sophie Berrebi, Claire Bishop, Beatrice von Bismarck, Maaike Bleeker,
Jeroen Boomgaard, Nicolas Bourriaud, Deborah Cherry, Hal Foster, Vít Havránek, Mischa Rakier,
Margriet Schavemaker, Marc Spiegler, Olav Velthuis, Kitty Zijlmans
Graphic design: Esther Krop, Amsterdam
Copy-editing: Rachel Esner (texts), Marieke van Giersbergen (notes, index), Amsterdam
Translation Dutch-English: Lynne Richards
Photography: (cover and portraits pp. 15, 16, 26, 43, 44, 58, 71, 72, 86, 93, 94, 100, 108, 119, 120,
130, 141, 142, 156) Cassander Eeftinck Schattenkerk
Paper: Munken Lynx 120 g/m² (inside), Gemini 240 g/m² (cover)
Fonts: Typotheque, Den Haag
Lithography and printing: NPN Drukkers, Breda
Binding: Hexspoor, Boxtel
Publisher: Valiz Publishers, Amsterdam www.valiz.nl

This publication was made possible by the generous support of:
Prins Bernhard Cultuurfonds, Amsterdam www.cultuurfonds.nl
Mondriaan Foundation, Amsterdam www.mondriaanfoundation.nl

SMBA, Stedelijk Museum Bureau Amsterdam www.smba.nl
Stedelijk Museum Amsterdam www.sma.nl
UvA, Universiteit van Amsterdam www.uva.nl
W139, www.w139.nl

NUR: 646, 651
ISBN-13: 978-90-78088-17-2
Printed and Bound in the Netherlands

- Available in the Netherlands, Belgium and Luxemburg:
 Centraal Boekhuis, Culemborg; *Scholtens*, Sittard and *Coen Sligting Bookimport*, Amsterdam, NL,
 sligting@xs4all.nl, fax +31-(0)20-6640047
- Available in Europe (except Benelux, UK and Ireland), Asia and Australia:
 Idea Books, Amsterdam, NL, idea@ideabooks.nl, fax +31-(0)20-6209299 www.ideabooks.nl
- Available in the United Kingdom and Ireland:
 Art Data, London, UK, orders@artdata.co.uk, fax +44-208-742 2319 www.artdata.co.uk
- Available in the USA:
 DAP, New York, dap@dapinc.com, fax (+1) 212-6279484 www.artbook.com